The
POET
and
the
MURDERER

The
POET
and
the
MURDERER

A TRUE STORY OF LITERARY CRIME
AND THE ART OF FORGERY

SIMON WORRALL

DUTTON
Published by the Penguin Group
Penguin Putnam Inc., 375 Hudson Street, New York, New York 10014, U.S.A.
Penguin Books Ltd, 80 Strand, London WC2R 0RL, England
Penguin Books Australia Ltd, Ringwood, Victoria, Australia
Penguin Books Canada Ltd, 10 Alcorn Avenue, Toronto, Ontario, Canada M4V 3B2
Penguin Books (N.Z.) Ltd, 182–190 Wairau Road, Auckland 10, New Zealand

Penguin Books Ltd, Registered Offices: Harmondsworth, Middlesex, England

Published by Dutton, a member of Penguin Putnam Inc.

First printing, April 2002
10 9 8 7 6 5 4 3 2 1

 REGISTERED TRADEMARK—MARCA REGISTRADA

LIBRARY OF CONGRESS CATALOGING-IN-PUBLICATION DATA
Worrall, Simon.
The poet and the murderer : a true story of literary crime and the art of forgery / Simon
Worrall.
p. cm.
ISBN 0-525-94596-2 (alk. paper)
1. Hofmann, Mark. 2. Forgery—Utah—Salt Lake City. 3. Forgery of manuscripts—Utah—
Salt Lake City. 4. Dickinson, Emily, 1830–1886—Forgeries. 5. Murder—Utah—Salt Lake
City. I. Title

HV6684.U8 W67 2002
364.15'23'0979225—dc21 2001053878

Printed in the United States of America
Set in Weiss
Designed by Ginger Legato

To my parents, Nancy and Philip;
and to my beloved wife, Kate

CONTENTS

The
POET
and
the
MURDERER

"The Heart wants what it wants—or else it does not care—"

Emily Dickinson

"We have the greatest and smoothest liars in the world, the cunningest and most adroit thieves, and any other shade of character that you can mention. . . . I can produce Elders here who can shave their smartest shavers, and take their money from them. We can beat the world at any game."

Brigham Young

Introduction

It was a cold, crisp fall day as I walked up the driveway of the Emily Dickinson Homestead in Amherst, Massachusetts. A row of hemlock trees along the front of the house cast deep shadows on the brickwork. A squirrel scampered across the lawn with an acorn between its teeth. Entering by the back door, I walked along a dark hallway hung with family portraits, then climbed the stairs to the second-floor bedroom.

The word *Homestead* is misleading. With its elegant cupola, French doors, and Italian facade, this Federal-style mansion on Main Street, which the poet's grandfather, Samuel Fowler Dickinson, built in 1813, is anything but a log cabin. Set back from the road, with a grove of oaks and maples screening it to the rear, and a large, concealed garden, it was, and is, one of the finest houses in Amherst.

The bedroom was a large, square, light-filled room on the southwest corner. One window looked down onto Main Street. From the other window I could see the Evergreens, where Emily Dickinson's brother, Austin, and her sister-in-law, Sue Gilbert Dickinson, had lived. Halfway along the east wall was the sleigh bed where the poet had slept, always alone, for almost her entire life. She was less than five and a half feet tall, and the bed was as

small as a child's. I prodded the mattress. It felt hard and unyielding. In front of the window looking across to the Evergreens was a small writing table. It was here that Dickinson wrote almost all of her poetry, and the nearly one thousand letters that have come down to us. Poems came to this high-spirited, fiercely independent redhead in bursts of language, like machine-gun fire. She scribbled down drafts of poems, mostly in pencil, on anything she had to hand as she went about her daily chores: the backs of envelopes, scraps of kitchen or wrapping paper. Once she used the back of a yellow chocolate-box wrapper from Paris. She wrote a poem on the back of an invitation to a candy pulling she had received a quarter of a century earlier. The painstaking work of revision and editing was done mostly at night at this table. Working by the light of an oil lamp, she copied, revised, and edited, often over a period of several years, the half-formed thoughts and feelings she had jotted down while baking gingerbread, walking her invalid mother in the garden, or tending the plants in the conservatory her father had built for her, and which was her favorite place in the Homestead.

I stood by the table imagining her working there, with her back to me, her thick hair piled on top of her head, the lines of her body visible under her white cotton dress. Then I hurried back down the stairs, crossed the parking lot to where I had left my car, and drove the three quarters of a mile to the Jones Library on Amity Street. There was a slew of messages on my cell phone. One was from a gun dealer in Salt Lake City. Another was from the head of public relations at Sotheby's in New York. A third was from an Emily Dickinson scholar at Yale University named Ralph Franklin. I did not know it at the time, but these calls were strands in a web of intrigue and mystery that I would spend the next three years trying to untangle. It had all begun when I came across an article in *The New York Times*, in April 1997, announcing that an unpublished Emily Dickinson poem, the first to be discovered in forty years, was to be auctioned at Sotheby's. I did not know much about Dickinson at the time, except that

she had lived an extremely reclusive life and that she had published almost nothing during her lifetime. The idea that a new work by a great artist, whether it is Emily Dickinson or Vincent van Gogh, could drop out of the sky like this, appealed to my sense of serendipity. *Who knows,* I remember thinking, *maybe one day they will find the original manuscript of* Hamlet.

I thought nothing more about the matter until four months later, at the end of August, when I came across a brief four-line announcement at the back of the "Public Lives" section of *The New York Times.* It reported that the Emily Dickinson poem recently purchased at auction at Sotheby's for $21,000, by the Jones Library in Amherst, Massachusetts, had been returned as a forgery.

What sort of person, I wondered, had the skill and inventiveness to create such a thing? Getting the right sort of paper and ink would be easy enough. But to forge someone else's handwriting so convincingly that it could get past Sotheby's experts? That, I guessed, would be extremely hard. This forger had gone even farther. He had written a poem good enough for it to be mistaken for a genuine work by one of the world's most original and stylistically idiosyncratic artists. Somehow he had managed to clone Emily Dickinson's art.

I was also curious about the poem's provenance. Where had it come from? Whose hands had it passed through? What had Sotheby's known when they agreed to auction it? The illustrious British firm of auctioneers was much in the news. There were stories of chandelier bids and gangs of professional art smugglers in Italy and India. Had Sotheby's investigated the poem's provenance? Or had they known all along that the poem might be a forgery, but had proceeded with the auction in the hope that no one would be able to prove it was?

To find out the answers to some of these questions I called Daniel Lombardo, the man who had bought the poem for the Jones Library in Amherst. What he told me only heightened my curiosity. A few days later I packed a bag and headed north from

my home in Long Island toward Amherst with a copy of Emily Dickinson's poems on the seat beside me.

It was the beginning of a journey that would take me from the white clapboard villages of New England to the salt flats of Utah; from the streets of New York to the Las Vegas Strip. At the heart of that journey were a poet and a murderer. Finding out how they were linked, how one of the world's most audacious forgeries had been created and how it had got from Utah to Madison Avenue, became an all-consuming obsession. In my search for the truth I would travel thousands of miles and interview dozens of people. Some, like Mark Hofmann's wife, spoke to me for the first time on record. But I quickly discovered the "truth," where Mark Hofmann is concerned, is a relative concept.. Whether it was his friends and family, or the dealers and auction houses who traded in his forgeries, all claimed to be the innocent victims of a master manipulator. Who was telling the truth? Was anyone? It was like pursuing someone through a labyrinth of mirrors. Paths that promised to lead out of the maze would turn into dead ends. Others that appeared to lead nowhere would suddenly open, leading me forward in directions I had not anticipated. Nothing was what it seemed.

Ahead of me, but always just out of reach, was the forger himself. William Hazlitt's description of Iago, in Shakespeare's *Othello*—"diseased intellectual activity, with an almost perfect indifference to moral good or evil"—applies in equal measure to the man who once said that deceiving people gave him a feeling of power. Mark Hofmann was not just a brilliant craftsman, a conjuror of paper and ink who fabricated historical documents with such technical skill that some of the most experienced forensic experts in America could find no signs of forgery. He was a master of human psychology who used hypnosis and mind control to manipulate others and even himself. He was a postmodernist hoaxer who deconstructed the language and mythology of the Mormon church to create documents that undermined some of the central tenets of its theology. He was successful because

he understood how flimsy is the wall between reality and illusion and how willing we are, in our desire to believe in something, to embrace an illusion. When the web of lies and deceit began to unravel, he turned to murder.

We are drawn to those things we are not. Journeying into Mark Hofmann's world was like descending into a dark pit where all that is most devious and frightening in human nature resides. In the course of that journey I would hear many strange things. I would hear of golden plates inscribed with Egyptian hieroglyphs, and lizards that talked; of angels and Uzis. I would see the corruption beneath the glittering surface of the auction houses, hear lies masquerading as truth, and the truth dismissed as lies. I would encounter detectives and dissident Mormons; forensic documents experts and cognitive psychologists; shapeshifters and frauds. After three years spent trying to unravel the riddle posed by one of the world's greatest literary forgeries, I feel that I have come as close to the truth as I can possibly get. It is for you, the reader, to decide what it means.

The Poet and the Murderer

*H*e thought he had gone under deep enough, but as he followed the curve of the letter *m*, he felt a momentary tremor like the distant rumbling of an earthquake. It began deep in his cerebral cortex, then traveled along his nerve ends, down his arm, into his hand, until finally it reached his fingers. The tremor lasted only a microsecond, but it was long enough to cause a sudden tightening of the muscles like a rubber band stretching. As he reached the top of the first stroke of the letter *m*, and the pencil began to plunge back down toward the line, he had felt his hand tremble slightly.

Laying down the pencil, he began to slow his pulse. He relaxed his breathing and counted in patterns of seven as he pulled the oxygen in and out of his lungs. He imagined warmth circulating around his body like an ocean current, and he concentrated on funneling it into his fingertips. As the world contracted to a point between his eyes, he took a fresh sheet of paper and began to visualize the shape of each letter until he could see them laid out on the page in sequence, like an image projected on a screen.

He had spent days practicing her handwriting: the *h* that

toppled forward like a broken chair; the *y* that lay almost flat along the line, like a snake; and that distinctive *t*, which looked like an *x* turned sideways. As he felt himself go deeper into the trance, he began to write. This time he wrote fluently and without hesitation, the letters spooling out of his unconscious in a continuous, uninterrupted flow. It seemed as though she was inside him guiding his hand across the page. As he signed her name, he felt an immense rush of power.

He got up and stretched. It was three in the morning. Upstairs, he heard the baby begin to cry and his wife's footsteps as she went to comfort him. Crossing the darkened basement, he took down a plastic bag from a shelf where he had hidden it the day before, behind a pile of printing plates. After removing a length of galvanized pipe, he drilled holes into the skin of the cast iron end cap, threaded two wires through the holes, and attached an improvised igniter onto the wires. Then he packed gunpowder into the pipe and threaded on the remaining end cap. In the morning he would drive out to Skull Valley to test the bomb. He got out the two battery packs he had bought some days before at Radio Shack and took down an extension cord from a bracket on the wall. Then he packed everything into a cardboard box. He laid the box next to the poem. It was no great work of art, he thought. But it would do.

Emily Dickinson for Sale

Daniel Lombardo, the curator of Special Collections at the Jones Library in Amherst, Massachusetts, had no idea, as he set off almost twelve years after the events of that night, to drive the fifteen miles to Amherst from his home near West Hampton, that the shock waves from that bomb were about to shake the foundations on which he had built his life.

It was a glorious day in May, and as he made his way over the Coolidge Bridge in his Del Sol sports car, with the top down and his favorite Van Morrison album playing on the tape deck, life felt about as good as it could get. Lombardo loved his job at the library. He was writing a book. He was playing the drums again. His marriage was fulfilling. As he dropped down over the hills toward Amherst, he thought about the announcement he was about to make to members of the Emily Dickinson International Society who had traveled to Amherst from all over America for their annual meeting. If things worked out as Lombardo hoped they would, if he could raise enough money, he was going to be able to make a lasting contribution to the community he had come to call home.

Lombardo vividly remembered the moment when he had

first seen the poem. He was sitting at his desk on the top floor of the Jones Library, a large eighteenth-century-style house built of gray granite in the center of Amherst, leafing through the catalog for Sotheby's May 1997 sale of fine books and manuscripts. Lombardo knew that original, unpublished manuscripts by Dickinson were as rare as black pearls. Indeed, it had been more than forty years since a new Dickinson poem had been found. In 1955 Thomas H. Johnson, a Harvard scholar, had published a three-volume variorum edition, fixing the Dickinson canon at 1,775 poems. But because of the unusual way that Dickinson's poems have come down to us—she published almost nothing during her lifetime and was extremely secretive about what she had written (after her death many poems and letters were destroyed by her family)—there has always been a lingering feeling that new material may come to light. The year before, two unknown Dickinson letters had suddenly been found. Who was to say that new poems were not out there, hidden in a dusty attic in Nantucket or the back of a book in a decaying New England mansion?

The poem was listed in the Sotheby's catalog between a rare 1887 edition of Charles Dickens's *Pickwick Papers*, bound in green Morocco leather, and an original watercolor cartoon of Mickey Mouse and Pluto. The catalog described it as an "autograph poetical manuscript signed ('Emily')." The juxtaposition with Mickey Mouse would have delighted Dickinson, thought Lombardo, as he took out an Amarelline liquorice from the tin he had brought back from a recent trip to Sicily and settled back to read the poem.

It was written in pencil, on a piece of blue-lined paper measuring eight by five inches. On the top left corner was an embossed insignia. And the poem was signed "Emily." In red ink, at the top right corner of a blank page attached to the poem, someone had also written, "Aunt Emily," in an unidentified hand:

> *That God cannot*
> *be understood*

Everyone agrees
We do not know
His motives nor
Comprehend his
Deeds—
Then why should I
Seek solace in
What I cannot
Know?
Better to play
In winter's sun
Than to fear the
Snow

With his elfin features, bushy, russet-brown beard, and shoulder-length hair, Dan Lombardo looks like one of the characters in Tolkien's *The Hobbit*. He weighs one hundred pounds and stands five feet two inches tall. Getting up from his desk, he walked over to the imposing, cupboardlike safe standing in the corner of his office. It was taller than he was, made of four-inch-thick steel, and had a combination that only he and the library's director knew. Inside it were manuscripts worth hundreds of thousands of dollars. Spinning the wheels of the combination lock until the door clicked open, Lombardo took out several Dickinson manuscripts and laid them on his desk.

One was a letter from 1871. The other was a poem called "A Little Madness in the Spring," which Dickinson had sent to a friend, Elizabeth Holland, in 1875. Written on the same kind of notepaper, in a similar hand, it bore an uncanny resemblance to the poem in the Sotheby's catalog. It was even written in pencil and signed "Emily":

A little Madness in the Spring
Is wholesome even for the King
But God be with the Clown—

Who ponders this tremendous scene—
This whole Experiment of Green—
As if it were his own!

Lombardo compared the handwriting. Emily Dickinson's handwriting changed radically during her lifetime. Yet the handwriting from within each period of her life is generally consistent. Lombardo was not an expert, but the handwriting in both poems looked the same. The tone and content of the poems seemed similar as well. The high-water mark of Dickinson's poetry had been reached the decade before. By the 1870s the flood of creativity that had given the world some of the most heart-powerful and controlled poems ever written in the English language had begun to recede. Dickinson was in her forties. Her eyesight was failing. Her creative powers were declining. Many poems from this period are just such minor "wisdom pieces" as this one seemed to be.

The fact that the poem was signed on the back "Aunt Emily" suggested to Lombardo that it had been written for a child, most probably Ned Dickinson, the poet's nephew. In 1871 Ned would have been ten years old. He lived next door to her at the Evergreens, and Dickinson, who never had children of her own, adored him. The feeling seems to have been reciprocated. Ned frequently ran across from the Evergreens to visit his brilliant, eccentric aunt. On one occasion he left his rubber boots behind. Dickinson sent them back on a silver tray, their tops stuffed with flowers.

Perhaps this new poem was a similar gesture, thought Lombardo. He knew she had sent Ned other poems that playfully questioned religious beliefs, like one sent him in 1882. It was also written in pencil and signed "Emily":

The Bible is an antique Volume—
Written by faded Men
At the suggestion of Holy Spectres—

Subjects—Bethlehem—
Eden—the ancient Homestead—
Satan—the Brigadier—
Judas—the Great Defaulter—
David—the Troubadour—
Sin—a distinguished Precipice
Others must resist—
Boys that "believe" are very lonesome—
Other Boys are "lost"—
Had but the Tale a warbling Teller—
All the Boys would come—
Orpheu's Sermon captivated—
It did not condemn.

The possibility that it had been sent to a child added to the poem's charm. The image many people had of Dickinson was of a lonely, rather severe New England spinster who spent her life immured in the Homestead, under self-elected house arrest; the quintessential artistic genius, driven by her inner demons. It was how the public liked its artists. The poem showed another side to her that Lombardo felt was more truthful. Instead of the Isolata of legend, she appears as a witty, affectionate aunt sending a few quickly scribbled lines of verse across the hedge to her adored nephew.

Lombardo was particularly excited by the new poem because, although the Jones Library has a fine selection of manuscripts by another former resident of Amherst, Robert Frost, including the original of "Stopping by Woods on a Snowy Evening," it had only a few manuscripts by the town's most famous daughter. Almost all of Emily Dickinson's letters and poems are at two far wealthier institutions: Amherst College, and the Houghton Library at Harvard University. Since becoming curator of Special Collections in 1982, Lombardo had devoted himself to building up the Jones Library's collection of her

manuscripts. The chance to buy a poem that the world had never seen was a unique opportunity.

After looking at the handwriting Lombardo did a cursory check of the paper. For this he consulted the classic two-volume work *The Manuscript Books of Emily Dickinson*, by Ralph Franklin, a Yale University scholar widely regarded as the world's foremost expert on Dickinson's manuscripts. The poem in the Sotheby's catalog was written on Congress paper, which was manufactured in Boston. It was lined in blue and had an image of the Capitol embossed in the upper left-hand corner. According to Franklin's book Dickinson had used Congress paper at two different periods in her life: once in 1871, and again in 1874. The poem in the Sotheby's catalogue was dated 1871. Lombardo told himself that it was absurd to think of buying the poem. The Sotheby's estimate for the poem was $10,000–$15,000. But Lombardo was sure this would climb to as much as $20,000. The Jones Library had only $5,000. But in the days that followed, he became more and more excited at the prospect of acquiring the poem. He felt strongly that Dickinson's works belonged in the town where she had created them. As William and Dorothy Wordsworth are to Grasmere, in England, or Petrarch is to Vaucluse, in France, Emily Dickinson is to Amherst: an object of pride and an industry. Each year thousands of Dickinson's fans, from as far away as Japan and Chile, make the pilgrimage to the Homestead. Cafés offer tins of gingerbread baked to her original recipe. Scholars fill the town's bed-and-breakfasts and patronize its restaurants. The poet's grave is always decked with flowers.

Some years earlier Lombardo had had the idea of throwing a birthday party for Dickinson. On December 10 children from the town and surrounding area were invited to the Jones Library to wish the poet many happy returns and play games like "Teapot" and "Thus Says the Mufti," which Dickinson herself played as child. Dressed in period clothes—a top hat, burgundy-colored waistcoat, and leather riding boots—Lombardo would

tell the children about the poet's life, and how it connected to the town.

Lombardo did not have children himself, so he always enjoyed the occasion. At the end of the party one of the other librarians would appear from behind a curtain, dressed in a long white pinafore dress, black stockings, and black shoes. Of course, the older children knew it was just the librarian, dressed up in funny clothes. But he could tell by the light shining in the eyes of some of the younger children that they really believed it was Emily Dickinson herself. That's what Dan liked to think, anyway.

He had acquired several Dickinson poems before, but they were not new poems, like this one. To acquire it would be the crowning event of his career. The fact that the Jones Library was a public library, not a university, where ordinary people could go in and see the poem, made him even more determined. By chance the annual meeting of the Emily Dickinson International Society was scheduled to take place at the Jones Library, and Lombardo decided to use the occasion to launch an appeal. The meeting took place in the large meeting room, a beautiful wood-floored reception room with a fireplace at one end of it. People had come from all over the United States. After a lunch of sandwiches and potato chips Lombardo gave a brief presentation on the poem and outlined what a marvelous opportunity this was for the library. As soon as he had finished his speech, a Dickinson scholar from Case Western Reserve University stood up and pledged $1,000. Others excitedly followed. A retired doctor who had traveled down from Kankakee, Illinois, to attend the meeting pledged $1,000. It was like a spark going around the room. Graduate students who could barely afford to pay their rent offered $100. By the end of the meeting Lombardo had pledges for $8,000. With the Jones Library's $5,000 he now had $13,000.

Some of the scholars at the meeting privately doubted the quality of the poem. It seemed too trite, too simplistic, even for a first draft. But no one voiced their reservations. Everyone was

swept along on a wave of euphoria. "We are all starting on a great adventure together," Lombardo thought.

He had no doubts about the poem's authenticity. After all, it was being auctioned by the illustrious house of Sotheby's, from whom he had bought several other manuscripts for the Jones Library. Over the weekend, however, he did one more thing to authenticate the poem: he called Ralph Franklin at Yale University's Beinecke Library. Franklin is the world's leading expert on Dickinson's "fascicles," the improvised books she made by sewing together bundles of poems. Franklin's *Manuscript Books of Emily Dickinson* is the definitive word on the subject. After her death Emily Dickinson's fascicles were unbound and the poems pasted into scrapbooks, and Franklin spent years laboriously reconstructing the original order of the poems. Franklin told Lombardo that he had been aware of the poem since 1994, and that he was planning to include it in the new edition of his book, due to be published in late 1997. For Lombardo it was a gold seal of approval and he spent the rest of the weekend on the phone, trying to raise more money. News of the poem had gone out on the Internet, and pledges poured in. It helped that the stock market was in the longest bull run in its history. Several donors gave dividends from their investments.

By Sunday night Lombardo had raised $17,000. A meeting of the Friends of the Jones Library, a local support group, the day before the auction, brought even more money. One donor, a retired physicist from Alexandria, Virginia, called to say he wanted to double his donation. By Monday evening—the auction was the next day—Lombardo had $24,000. Less the commission that Sotheby's would take, this meant that Lombardo had $21,000 to bid. For the first time, as he went to bed that night, he felt he had a real chance of being able to buy the poem.

It was a hot summer night. There was no moon and barely a breeze. Outside in the garden a raccoon scratched at a trash can. Next to him his wife lay on her side, breathing quietly. Lombardo closed his eyes and tried to sleep. But he could not stop

thinking about the auction. He was a small-town librarian up against some of the wealthiest academic institutions and collectors in the world. Everyone in Amherst would be watching him. He could one day leave his work behind and feel that he had made a real contribution to his community. At the same time he was gnawed by a feeling of insecurity that he might let everyone down.

For most of his life Lombardo had felt like an outsider. As a young man he used to say to his friends that all he really wanted to do was have time to read and hike. He wasn't completely serious. There were plenty of other things he liked doing, but there was some truth in his claim. Books were his passports to the world, a place where his imagination could roam free. Hiking was his way of staying connected to the earth. Walking along a back-country path, surrounded by trees, and water, and light, and animals, he felt both humbled and enlarged. Humbled, because in comparison with the vastness of the universe he felt like the tiniest atom. Enlarged, because he knew he was part of the great continuum of life. His hero in high school had been Henry David Thoreau. Lombardo must have read *Walden Pond* fifteen times. If he went hiking, he usually took his well-worn copy with him. It was more than a book. It was guide to life, and he dreamed of living the spare, simple existence that Thoreau had lived.

As he lay in bed, worrying about what the next day would bring, he remembered an incident from his boyhood in Wethersfield, Connecticut. Lombardo had grown up in an Italian-American family. His father, Jimmy, who had come to America from Sicily as a child, had been the town barber. Everyone knew and liked Jimmy. He was the sort of warm, happy-go-lucky man that everyone would stop and greet as he walked down the street.

Lombardo adored his father. On summer evenings he would sit on the back stoop listening to him playing the mandolin, singing the Sicilian love songs with which he had courted his mother on the other side of the world. When, at the age of five,

he heard that his father had been elected president of the local barber's union, Dan assumed that he had been elected president of the United States.

There was, however, another side to his father that Dan came to know about only later: a dark, fatalistic side that he had carried with him to the New World from his native Sicily; a feeling that, however good life might seem at the moment, the drought would come, you would lose the farm and spend the rest of your life eating beans. He suffered from depression, and could not wait for the summer to come each year so he could return to Sicily and play his mandolin under the stars, in cafés that looked over the Mediterranean. One year, Jimmy came home from Sicily and suffered a breakdown and was diagnosed with bipolar disorder.

The discovery of his father's breakdown traumatized Lombardo. If he had been so wrong about his father, how could he be sure that anything was what it appeared to be? This sense of dissonance between his own perceptions of the world and how things really were, the feeling that he was never quite sure what was real and what was not, undermined his ability to direct and manage his life.

Like most nonconformists in the sixties, Lombardo grew his hair long and rebelled. He learned to play the drums. At the University of Connecticut he immersed himself in the works of Thoreau and his contemporaries, like Ralph Waldo Emerson and Emily Dickinson. Dickinson's withdrawal from the world of getting and spending had chimed with the zeitgeist of the sixties and with Lombardo's own search for meaning in his life. He tried teaching, but the rigidities of the school system alienated him. After a brief time spent in Puerto Rico, and a stint on a commune in Massachusetts, he found the life he had been looking for at the Jones Library.

At the time of his arrival, in 1982, the Jones Library's rich collection of literary and historical manuscripts was languishing in obscurity, the victim of budget constraints. The books, photo-

graphs, and manuscripts were poorly catalogued, and dispersed over nine rooms on two floors. Lombardo lobbied long and hard for funding. Working with an architect, he then oversaw the restoration of the second floor of the Library where the Special Collections were housed. Lombardo wanted to make the people of Amherst feel that the Special Collections department was not just for scholars and academics but belonged to everyone. He helped design a large exhibition space and a reading room with armchairs and Persian rugs on the floor. Using old photographs and other archive material, as well as their manuscripts, he organized permanent exhibitions on both Emily Dickinson and Robert Frost, which became destinations for travelers and school groups, as well as scholars.

He wanted people to experience these writers not as the remote historical figures of academic study but as flesh-and-blood people who had lived and worked in the town, just like them. He began to write a weekly column in the *Amherst Bulletin* about every aspect of the history of the town. It was not the usual quaint version of local history. Lombardo was interested in the nitty-gritty of life, not the poetic illusion. He described the lives of prostitutes and the abuse of opium. He wrote about the entertainers who had passed through the town and the conditions in the surrounding factories. Readers loved these stories and clipped them from the paper. When Garrison Keillor came to Amherst to broadcast *Tales of Lake Wobegone,* he wove several of Dan's stories into his monologues.

Meanwhile, Dan went on improving the Special Collections section. He oversaw the installation of state-of-the-art climate-control systems; equipped a paper conservation studio; and ushered in the digital age by computerizing the cataloging and indexing of the library's manuscripts. He doubled the size of the historic photograph collection, broadening its scope to include rare photos of African Americans at end of the nineteenth century, as well as photos from across the country and from Europe. Lombardo always felt that culture should not be the preserve of

dead white people of European origin. He arranged for the do-
nation of the Julius Lester Collection, the archives of a promi-
nent African American writer and activist with close connections
to Amherst. And he augmented the Frost and Dickinson collec-
tions with manuscripts he acquired at auction and through rare
book and manuscript dealers. With each successfully completed
project his self-confidence grew. The more he learned, the surer
he felt of the decisions he made. The more others trusted and
believed in him, the more he trusted and believed in himself.

He could not go to the auction personally—he was leaving
on a long-planned trip to Italy the next day—so he had arranged
to bid by phone. The poem was Lot 74. Sotheby's had advised
him that bidding would begin at 2:30 P.M. and had arranged to
call him two lots before. At 2:00 P.M. Lombardo installed himself
in the director's office in the basement of the Jones Library. All
calls come in there, and Lombardo wanted to be sure that he had
an open line. On the desk in front of him he had a sheet of fig-
ures that told him at each point of the bidding what Sotheby's
12.5 percent commission would add on.

Lombardo disliked telephone bidding. Things move so fast,
and there are no visual cues as to how many people are bidding
or who they are. But he had bid at auctions before, both by
phone and in person, and been successful. Working as a drum-
mer on studio sessions had also taught him about pressure. One
mistake, a mishit cymbal or a slip of the foot, can ruin a take. As
the minutes ticked toward 2:30 P.M., his heart began to beat
faster. Finally the phone rang. A woman speaking in a low voice
told him that the auction had reached Lot 69. In the background
he could hear the voice of the auctioneer on Madison Avenue.
He imagined the limousines lined up along the curb outside and
the liveried doormen ushering in the rich and powerful collec-
tors who lived on Central Park and spent more on travel than he
earned in a year.

Bidding at a Sotheby's auction was like playing in a high-
stakes poker game. There was the same adrenaline rush and the

same feeling of euphoria when your bid was accepted. Every time Lombardo had been involved in an auction and been successful, he had felt an enormous high. His bidding strategy was never to be in on the early stages so as not to heat up the auction.

There was a write-in bid for $8,000, and the bidding on the poem started there, jumping in increments of $500 in seconds. The young woman at the end of the line kept asking, "Do you want to bid? Do you want to bid?" But Lombardo held back and grew more and more anxious. If this did not stop soon, he thought, it would spiral beyond his budget of $20,000. But at $15,000 the pace of the bidding slowed. And at $17,000 Lombardo jumped in. In poker you say, "Hit me." At Sotheby's the word is "Bid." Lombardo's first bid was immediately countered by one for $18,000. Lombardo bid again. One more bid and he would have to get out. His invisible opponent bid $20,000. Lombardo bid $21,000. It was his last bid, and he felt sure that whoever he was bidding against would keep going. But at $21,000 the hammer came down. Lot 74 was coming home to Amherst.

"I went out and told everyone who was waiting outside the door," he recalled, " 'We got it!' And they all started hugging me and crowding around. People were so excited. They all felt a sense of personal involvement. It was a privilege to be part of this. I was being flooded with congratulations and warmth. It was as though the sky had opened up, a lightning bolt had come down, and God said, 'This is your moment.' "

Helped by a group of volunteers, he spent the rest of the afternoon calling members of the Emily Dickinson International Society. Twenty-four hours later he boarded a plane to Italy. The trip with his family—to Rome, the Adriatic, and the medieval hill towns of Umbria—was an important family occasion. His aging mother would probably be seeing the relatives she had grown up with for the last time. As the plane sped toward Italy, he felt, literally, on top of the world.

On his arrival back in Amherst on August 18, the first thing

Lombardo did was to go through all the articles that had been written about the poem. People in Amherst had already started to come into the library to see it, even though red tape at Sotheby's meant that it would take several more weeks to arrive. In the meantime Lombardo began to organize an exhibition for the end of July, with the theme of how to date a poem. He would draw attention to similarities in the handwriting with two other Dickinson manuscripts the library owned. So, he wrote a brief essay about the paper and the boss mark. And, again, he consulted with Ralph Franklin at the Beinecke Library.

According to Franklin the handwriting exactly matched the date given by Sotheby's, 1871. Lombardo was particularly curious to know who had written the words "Aunt Emily" on the back of the poem. They were in a different hand. Unlike the poem, which was written in ordinary black lead, the words "Aunt Emily" were in what appeared to be red pencil. Lombardo's first supposition was that they had been written either by Ned or Martha Dickinson, the poet's nephew and niece. He had samples of Martha's handwriting at the library. For Ned's handwriting he contacted Brown University, who sent him photocopies of letters that Ned Dickinson had written to his sister. Neither matched.

This did not especially worry him. Dickinson had numerous cousins, on both her father's and mother's side. Perhaps the poem had been written for one of her cousins in Boston, Fanny or Lou Norcross. Perhaps one or the other of them had written "Aunt Emily" on the back of the poem, then filed it away as a memento of her illustrious relation.

Lombardo also wanted to present to the public as much information as he could about the poem's provenance. In the historical documents world the chain of transactions known as provenance is the gold standard of authenticity. But provenance is much more than a simple list of commercial transactions. It is the story of a document or a book's journey across time, and the people whose lives it has touched.

To find out as much as he could about the poem's provenance, Lombardo called Marsha Malinowski, one of the two Sotheby's employees who had handled the sale. Malinowski was a senior expert in the Department of Books and Manuscripts, and vice president of Sotheby's. She was charming. She told Lombardo how delighted she was that the poem was going back to Amherst and that she would be happy to try and find out who had consigned it for auction. But for the moment all she could say was that it had come from a collector, who had got it from dealer in the Midwest. Who had died.

Three days later Lombardo was sitting at his desk in the Jones Library when the phone rang. It was a long-distance call from Provo, Utah. The man at the other end of the line introduced himself as Brent Ashworth. He said that he was an attorney and that, in his spare time, he was a keen collector of historical documents. Ashworth also mentioned that he was the chairman of the Utah branch of the Emily Dickinson Society.

Lombardo assumed that he was calling to congratulate him on the purchase of the poem. People had been calling or e-mailing for weeks. What Ashworth had to say was not, however, cheerful. One day, in Salt Lake City, in 1985, Ashworth told Lombardo, he had been offered an Emily Dickinson poem for $10,000 by a forger named Mark Hofmann. Ashworth was not one hundred percent sure that the poem was the same one that Lombardo had just bought at Sotheby's, but he was pretty certain it was.

Ashworth told Lombardo something else: that when he'd seen the poem in the Sotheby's catalog, he'd immediately called Selby Kiffer, the other Sotheby's employee who had handled the sale. Ashworth had done business with Kiffer, a young, upwardly mobile manuscripts expert at Sotheby's, for many years, and wanted to warn him of the Hofmann connection. Like Malinowski, Kiffer is a senior expert in the Department of Books and Manuscripts and a vice-president (in the catalog for the June 3

sale, he was also listed as being in charge of business develop-
ment). Because Kiffer had always been so zealous in reporting
stolen books to the FBI, his nickname at Sotheby's was "Special
Agent Kiffer." Kiffer insisted to Ashworth that he had had the
poem "checked out." When Ashworth asked who had checked it
out, Kiffer mentioned Ralph Franklin, at Yale University.

Lombardo put down the phone and stared out the window.
He had a hollow, empty feeling in the pit of his stomach. Mark
Hofmann, he remembered, was a Salt Lake City rare documents
dealer who had created a string of sensational forgeries of Mor-
mon historical documents in the early 1980s that undermined
some of the central tenets of the church's teaching. His most fa-
mous forgery came to be known as the Salamander Letter. It pur-
ported to have been written more than a century earlier by
Martin Harris, the scribe who had helped Joseph Smith, the
prophet and founder of the Church of Jesus Christ of Latter-Day
Saints, write the Book of Mormon from a set of golden plates
Smith claimed to have found in the ground in upstate New York.
According to the founding legend of the Mormon religion Smith
had been led to the golden plates by an angel. Hofmann's
forgery completely undermined that legend. In it he had por-
trayed Smith as a money-grubbing prospector who found the
plates while digging in the dirt for gold. Instead of divine inter-
vention Hofmann's letter had described black magic and cabal-
ism. The Mormon Church had bought the document for $40,000
in the hope that it would never be made public.

It was well known that Hofmann had also produced a string
of literary forgeries nearly always of American icons, charismatic
historical figures who touched a deep chord in the national con-
sciousness, like Abraham Lincoln, Betsy Ross, or Daniel Boone.
Had Hofmann, Lombardo wondered, also created an Emily
Dickinson poem?

As well as being a brilliant forger, Hofmann was a master of
deceit who delighted in the mayhem caused by his lies. On the
outside he was a fresh-faced, bookish man who would go unno-

ticed in most crowds. He dressed conservatively, usually with a white shirt, tie, and jacket. He was a knowledgeable and respected dealer and collector of rare books and historical documents. He was a happily married family man who had spent thousands of dollars assembling one of America's finest collections of rare children's books, including a signed first edition of *Alice in Wonderland*, as a patrimony for his four children. Underneath this guise of normalcy, however, was another person whom Hofmann hid from everyone, including his wife and children. When he found himself entangled in his own web of lies, he had mutated into a cold-blooded psychopath.

Lombardo still believed, and wanted to believe, that the Dickinson poem was genuine. Maybe the man who had called him from Salt Lake City was a kook and this whole thing a practical joke. Lombardo checked on Ashworth and found that far from being crazy, he was a widely respected member of Salt Lake City society, an attorney, and a serious collector of historical documents. Between 1981 and 1985 he had also bought nearly half a million dollars' worth of rare manuscripts from Mark Hofmann. "I was over at Hofmann's house all the time," Ashworth told Lombardo over the phone. "I usually went up on Wednesdays and he'd pull out something juicy he wanted to offer me. On one of those days he pulled out this Emily Dickinson."

The poem's agnostic sentiments had jarred with Ashworth's Mormon faith, and he had passed on it. Then, in the late eighties, several years after Hofmann had been sentenced to life imprisonment for murder, Ashworth had seen the Dickinson poem again. It was lavishly framed and selling for between $35,000 and $40,000, in an upscale historical-documents store in the Georgetown section of Washington, D.C. The store was called the Gallery of History, part of a Las Vegas–based chain owned by a man named Todd Axelrod.

The historical-manuscripts business was traditionally the curious obsession of a few hundred fanatics. There were big collectors, like Malcolm Forbes and Armand Hammer, who amassed

collections worth millions of dollars, but for most people old parchment was about as exciting as, well, old parchment. Dealers generally went into the business because they loved history and culture. Few expected to make a killing. Todd Axelrod, the son of a publisher of books on domestic pets from Neptune City, New Jersey, took this rather tweedy cultural backwater and turned it into a multimillion-dollar, mass-market business. After making a fortune as a securities broker on Wall Street, he moved to Las Vegas and, in February 1982, opened the first of a number of boutique-style stores. Crisscrossing America by plane, Axelrod then set about trying to corner the market in historical documents. In all he spent more than $3 million assembling one of the nation's largest private collections of Americana: a hundred thousand historic documents preserved, as Axelrod liked to boast, to Library of Congress standards. Among this treasure trove was Abraham Lincoln's letter to Grace Bedell, the young girl who had suggested he grow a beard to help him win the presidency. The price tag was $1.25 million. Not everyone could afford an Honest Abe. So Axelrod made sure that there was something for every taste and pocketbook. There were signed photos of Elvis. Movie buffs could buy memorabilia from *Gone With the Wind*. For sports fans there were clip signatures from Lou Gehrig or Ty Cobb. Some of Axelrod's inventory came from a young historical-documents dealer in Salt Lake City named Mark Hofmann.

In the first twenty-two months of operation Axelrod's company turned over $1.4 million and Axelrod began to open other stores in Los Angeles, Dallas, Washington, D.C., and Costa Mesa, California. All were situated in the same kind of upscale shopping malls. All featured costly metallic fronting, lavish display cases, track lighting, and state-of-the-art climate control systems. Axelrod's target customer was a new, eighties breed of collector who did not want keep their purchases tucked away in vaults or safety deposit boxes, as old-style collectors had. They wanted to see their money hanging on the wall. It was all about

"impact." A John F. Kennedy letter, matted in gray suede and framed in silver, could lend an air of probity to the boardroom of a futures trader on Wall Street. A collection of John Paul Jones memorabilia, encased in a gold frame, could make the new rich entrepreneur who owned everything feel that he even "owned" a piece of history. Competitors referred to Axelrod's company as Autographs R Us.

Had Mark Hofmann forged the poem then sold it to Todd Axelrod in Las Vegas, as Ashworth had suggested? Had Axelrod then passed it on to Sotheby's? If that were the case, thought Lombardo, why had Sotheby's made no mention of this when he had called them to ask about the poem's provenance? Why had Marsha Malinowski said that it came from a dealer in the Midwest? The more he worried over the details, the more unsettled Lombardo felt. It was not just that he might have bought a forgery. Hofmann was a convicted double-murderer who had savagely killed two innocent people. The poem would be tainted with blood. If he had, indeed, bought a Mark Hofmann forgery, it would be not just a disaster for the library. Lombardo might as well empty out his office drawer.

But perhaps Ashworth was mistaken. He could not exactly recall the words of the poem he had seen in 1985. Perhaps Hofmann had forged an Emily Dickinson poem, but not this one. Surely, he reasoned, no forger could ever acquire this level of knowledge about Emily Dickinson. It was not just the paper and the handwriting. It was those two words, "Aunt Emily." No forger would know this most private and secretive of poets well enough to know that though she kept almost everyone else in her life at arm's length, she had always felt at ease with children. It would have taken Hofmann months, if not years, of research to get to this level of intimacy with her. But Lombardo had to be sure if the poem was genuine. And if anyone could tell him whether it was or not, it was Ralph Franklin, at Yale University's legendary Beinecke Library.

CHAPTER TWO

A Riddle in a Locked Box

From the outside the Beinecke Library looks like a stage set for a George Lucas movie. Designed by one of the most celebrated architects of the twentieth century, Gordon Bunshaft, who also created the Lever House and several other of New York's most famous skyscrapers, the Beinecke is a black glass cube lined with one-and-a-half-inch-thick translucent panes of Vermont marble that change color as the sun moves around the building. Extending vertically through its center, like a spinal column, is a six-story-high glass shaft housing one of the world's most valuable collections of rare books and manuscripts. Among its treasures are a copy of the Gutenberg Bible and one of the jewels of medieval illuminated mansucripts, the Savoy Hours. Its literary works include such gems of Anglo-Saxon culture as the original manuscripts of W. B. Yeats's poem "Among School-children," Thomas Hardy's *Far From the Madding Crowd*, and James Boswell's *Life of Johnson*. It has rare sixteenth- and seventeenth-century printed works from Germany, France, and Italy; the world's largest collection of playing cards; and a priceless bequest of Tibetan Buddhist manuscripts, including the Lhasa edition of the *Kanjur* in one hundred volumes that was per-

sonally donated by His Holiness the Fourteenth Dalai Lama in 1950.

The person responsible for the safety and well-being of these cultural treasures is a dapper, intensely focused man with a compact, muscular body, cropped gray hair, gray-blue eyes the color of the Atlantic in winter, and skin as white as the parchment he spends his life handling. For the last twenty years Ralph Franklin has also tirelessly edited one of the twentieth century's great works of literary scholarship and detective work: the definitive, three-volume edition of Emily Dickinson's poems.

Though Franklin had not said so the first time Dan Lombardo had called him, he had seen the poem three years earlier, in 1994, when it was faxed to him by Tammy Kahrs, chief archivist at the Gallery of History in Las Vegas.

Like Lombardo, Franklin was not particularly impressed by the quality of the poem. It read, he thought, like a Hallmark card. That could be explained by the fact that Dickinson appeared to be writing for a juvenile reader. Masterpiece or not, the idea that a new Dickinson poem, the first in forty years, had surfaced set Franklin's blood racing. If it were to be authentic, it would be an exciting addition to the new edition of the poet's works that Franklin was preparing.

On the phone that day Tammy Kahrs had sounded more like a country singer than a bibliophile to Franklin, but she seemed to know what she was talking about. One thing that particularly impressed Franklin was that, according to Kahrs, the previous owners of the manuscript had dated it to 1871. As Franklin knew better than anyone, dating manuscripts by Dickinson was extremely complicated. That the previous owners had ascribed such a precise date suggested to Franklin that the poem had originally come from a descendant of the Dickinson family. In the back of Franklin's mind stirred the hope they might have other new poems.

The fact that the poem originated in Las Vegas, a city better known for slot machines than sonnets, did not overly trouble

him. Manuscripts, he knew, can turn up anywhere, and the Gallery of History seemed to know quite a bit about this poem. According to Kahrs the paper was lined, and the embossing had the word *Congress* over a picture of the Capitol. Franklin knew that Dickinson had used numerous different letter papers at different times in her life. They came from mills all over New England, like Bridgeman and Childs in Northampton, Massachusetts. Some were embossed with a queen's head or a flower set in an oval. Some bore the imprint of an eagle's head. In 1871 she was frequently using Congress paper. Such precise knowledge, Franklin knew, is not easy to come by, particularly when the writer in question was someone as private as Emily Dickinson.

Most writers leave behind them a paper trail of letters, diaries, and publications from which a chronology of their work can be reconstructed. We know, for instance, when William Wordsworth wrote *The Prelude*. We know where the poet was living, what events in his life precipitated the poem, where it was first published, how much he received for it, what others said about it at the time, and where it fits into the arc of his life and work.

None of this applies to Emily Dickinson. "I found (the week after her death)," wrote her sister, Lavinia Dickinson, in May 1886, "a box (locked) containing seven hundred wonderful poems, carefully copied." None of these seven hundred poems, or the other one thousand and eighty-nine that would later be located, was dated. Only twenty-four had titles. Only ten had been published in her lifetime, and those against her will. Publication, Dickinson once famously wrote, was "the Auction / Of the Mind of Man." She preferred what she called her "Barefoot Rank."

Imagine if Picasso had never exhibited during his lifetime but that, after his death, his paintings were simply found piled in his studio, without dates or titles or any other clues as to when they were painted, who for, where, or why. The riddle Emily Dickinson left behind was made even more complex because of the confused and haphazard way in which her poems were even-

tually published. The first person to bring out an edition was the wife of an astronomy professor at Amherst College named Mabel Loomis Todd. A pretty, vivacious woman with limpid brown eyes, she had been the secret mistress of Dickinson's brother, Austin Dickinson. Working with one of Dickinson's closest friends, the editor Thomas Wentworth Higginson, she produced three popular selections of Dickinson's poetry between 1890 and 1896.

Todd might have gone on to bring out a complete edition, if it had not been for a strip of land that Austin Dickinson left her at his death in 1895. Outraged by this affront to the family's name, Lavinia Dickinson, the poet's sister, sued Mabel Loomis Todd successfully for its return. Relations were even frostier between Susan Gilbert Dickinson, Austin's widow, and Mabel Loomis Todd, his former mistress, both of whom possessed substantial quantities of poems and letters. The ill feeling was passed to the next generation. Between 1914 and 1945 Martha Dickinson Bianci, Sue's daughter, and Millicent Todd Bingham, Mabel's daughter, fought a bitter battle over Dickinson's legacy, bringing out competing editions of the manuscript materials they had inherited from their warring mothers.

All these early editions were flawed. Poems were ordered according to the whim of the editors who took Dickinson's jazzy, idiosyncratic rhyme schemes and highly unusual orthography and changed them to suit late-nineteenth-century tastes. The Harvard scholar Thomas Johnson eventually restored Dickinson's unique voice and style, and established a chronology for the poems.

Johnson's edition also plucked a shy girl from Massachusetts out of her self-chosen seclusion and turned her into the It girl of modern American poetry. "I like, or at least I admire, her a great deal more now," the poet Elizabeth Bishop wrote to Robert Lowell in 1956, "probably because of that good new edition, really. I spent another stretch absorbed in that, and think . . . that she's about the best we have."

But Johnson's variorum edition was not published until almost sixty years after Dickinson's death, and it did not resolve all the tangled editorial problems she left behind her. Johnson had only been able to consult Photostats of many of the poems, and so there were errors in the transcriptions. Other versions of the poems began to surface, and in the rapidly growing academic industry that had sprung up around Dickinson, debate raged about everything from the dating of the poems to the layout of the words on the page. A new referee was needed.

Ralph Franklin, the ambitious, quick-witted director of the Beinecke Library, whose work on Dickinson's manuscripts went back to the late 1960s, was the person chosen for the job. The first thing he did was to go back to the original manuscript books in which Dickinson had stored her poems. Having scribbled down a draft of a poem, usually in pencil, Dickinson would set about the exacting work of revision and editing. This was done mostly at night, sitting at the table in her bedroom on the second floor of the Homestead. The process of editing and revising a poem might go on for months or even years. Only when she was completely satisfied did she write a finished copy of the poem. This time she wrote in ink, not pencil; and instead of the scraps of kitchen paper or backs of an envelope she used for drafts, she wrote the final versions of her poems on a sheet of notepaper already folded by the manufacturer to produce two leaves. She had a large collection of such papers from all over New England. Sometimes she chose a piece of laid, cream-colored paper; sometimes it was a wove white paper with a blue rule. When she had accumulated four—sometimes it was six—of these sheets, she would stack them on top of each other. She would then take a thick embroidery needle threaded with string and make two holes through the sheets, forcing the needle through the paper, from front to back. Then she threaded the string through the holes and tied it firmly at the front. A wonderful poem written in 1861, during a personal crisis that had af-

fected her eyesight, shows how closely, for Dickinson, making
poems and the act of sewing were connected:

> *Don't put up my Thread & Needle—*
> *I'll begin to Sow*
> *When the Birds begin to whistle—*
> *Better stitches—so—*
>
> *These were bent—my sight got crooked—*
> *When my mind—is plain*
> *I'll do seams—a Queen's endeavor*
> *Would not blush to own—*

Dickinson referred to these stitched booklets of poems in down-
home Yankee fashion as "packets." It was Mabel Loomis Todd,
her first editor, who, more grandly and pretentiously, referred to
them as "fascicles," from the French word *fascicule.* In fact, there is
nothing grand about them. Dickinson had probably learned to
make such packets of documents at Amherst Academy, where
she had gone to school. There were no ring binders in those
days, so students were taught to keep their writing assignments
in little homemade manuscript books. When she died, forty of
these packets of poems, which constitute one of the great liter-
ary treasures of the world, were found squirreled away in her
room. Hundreds more poems were found on separate, unbound
sheets.

Though none of the poems was dated, and none had titles,
their order in the fascicles would have given a reliable chronol-
ogy. Unfortunately, when Mabel Loomis Todd set about creating
her first edition—and, almost certainly, to enable her to weed
out and destroy poems that would have shocked and offended
Dickinson's contemporaries—she took a pair of scissors, cut the
threads Dickinson had sewn through the pages, and unbound
them.

For his landmark two-volume edition of the fascicles, *The*

Manuscript Books of Emily Dickinson, which was published in 1981, Franklin spent years reconstructing the order of the poems. Working like a forensic document examiner, he painstakingly reconstructed Dickinson's "workshop." He studied the paper she used, the watermarks, and any manufacturing defects, like wrinkles, that might indicate the order of the sheets. He looked at discolorations on the paper to identify the first and last page of a fascicle, knowing that the inner leaves would be much cleaner. He examined stain marks, where the poet had spilled some chamomile tea while she worked, or some water as she fed the plants in her room. Sometimes these stains formed a pattern over several sheets, and by fitting them together Franklin was able to work out which page had been bound up next to which. He looked for smudge patterns in the ink, where Dickinson had inadvertently drawn the sleeve of her dress, or her hand, across the page. He examined the puncture patterns of the needle holes she had driven through the page, and signs of stress in the paper caused by the pressure of opening a fascicle against the tension of the stabbed binding. Using a microscope, he examined the curvature along the edge of each sheet, and the damage around the binding holes, clues that might reveal which order the sheets had been stacked in. But most of all he studied the poet's handwriting.

Few people's handwriting has changed more throughout their lifetime, and revealed more, than Emily Dickinson's. If you compare the handwriting of her first poem, "Awake ye muses nine, sing me a strain divine," a forty-line valentine bubbling with girlish high spirits, written when she was nineteen, with poems written around the 1870s, when she was in her forties, it is hard to believe that they are written by the same person.

In 1871, the date of "That God Cannot Be Understood," Dickinson was at the midpoint of her life—she was born on December 10, 1830—and roughly halfway along the trajectory of her handwriting's evolution. In the course of dating Dickinson's poems Franklin had created a series of charts showing the differ-

ent letter forms and shapes the poet used at different times in her life. The first thing he did when he received the fax containing the poem from Las Vegas was to compare the letter forms with those on his charts.

Everything checked out. There were, for instance, two different forms of the letter *d* in the poem: one, in the word *God* in the first line, looked like a six turned backward. The other, in the word *should*, in the first line of the second stanza, was radically different. The two elements of the letter had split apart, making it look like a backward-sloping *c* and an *l*. Franklin knew that Dickinson had used the one form before this period (the early 1870s), and another form later. Exactly around the year 1871, though, she had used both forms. *That's Dickinson's* d! he thought as he looked at the final letter of the word *comprehend*.

There were also two forms of the letter *e*. One looked like the number three, written back-to-front. It appears, capitalized, at the beginning of the word *Everyone*, in the third line of the poem, and in the signature, "Emily." The same unusual form also appears in lowercase in the word *solace*. Other words in the poem contained a more usual form of the letter. Franklin's charts showed him that, in 1871, Dickinson was using both forms.

Even the way the sheet of paper was folded conformed to the way Dickinson had sent her poems. At this time Dickinson generally folded her letters in thirds. The fact that two thirds of the left-hand sheet of the bifolia on which the poem was written was missing suggested that there had been wear in those places, and that eventually the page had been torn away.

Despite these minute details suggestive of authenticity, Franklin had a number of questions. He asked the Gallery of History to fax him the measurements of the manuscript, in millimeters, across the fold and along the top. He also asked for detailed provenance information and how the Gallery of History had dated the poem to 1871. Out of curiosity he also asked the price.

He was out when the Gallery of History called him back,

but the information his assistant relayed to him further confirmed that the poem was genuine. They were unwilling to release any information on the poem's provenance. But Franklin knew that, in the rare-documents business, such discretion was not uncommon. Many owners do not like to release their names, for fear of publicity or for tax reasons. And the measurements were exactly right. As far as the 1871 date was concerned, the Gallery of History claimed that they had dated the poem based on research done on the boss mark on the paper by a scholar named Elizabeth Witherell. This surprised Franklin, because Witherell was a Thoreau scholar, not a Dickinson scholar. But, who knows, thought Franklin, perhaps Witherell had a large supply of nineteenth-century paper. In fact, Witherell had never seen the poem.

The price of the poem was $45,000. There had never been any discussion of Franklin doing an authentication, so when, during one of their conversations, Tammy Kahrs asked him if he would mind if they used his name when they sold the poem, he was flabbergasted. As far as he was concerned, he had supplied the Gallery of History with general information about the poem's possible historical context and his view of the handwriting. But he had not given any opinion as to its authenticity.

Despite the slight uneasiness caused by this incident, and the lack of provenance information, Franklin felt sure enough that the poem was genuine that he made tentative plans to include it in his new edition. There were some minor copyright issues—the fax from the Gallery of History came with a standard disclaimer prohibiting the distribution or copying of all communications—but he would deal with those later, closer to publication, which had tentatively been set for 1997. He thought nothing more of the matter until he saw the poem in the Sotheby's catalog in May of that year.

Franklin was on vacation in Switzerland when Brent Ashworth called him from Salt Lake City. Franklin knew Ashworth because he had conferred with him about a previous Dickinson

poem that Ashworth had bought, and he regarded Ashworth as a reliable source of information. Ashworth told Franklin what he had told Lombardo: that he had been offered the poem by Mark Hofmann in 1985, and that he believed it was a forgery. Like everyone in the historical documents trade Franklin knew Hofmann's reputation. Shattering as it was, though, the news did not definitively prove the poem was a forgery. After all, it was well known that Hofmann had also handled genuine manuscripts. But when Ashworth told him that he had subsequently seen the poem in one of the Gallery of History's boutique stores, Franklin's heart skipped a beat. If it were true, he realized that he might have unwittingly become involved in a chain of illicit transactions that stretched from a murderer in Salt Lake City to a historical documents dealer in Las Vegas, and then on to him. It was not the sort of company a distinguished scholar at Yale University was used to keeping.

Franklin also knew from bitter experience the damage a forgery can wreak on the lives of people involved in the rare manuscript world. He had seen friends and colleagues tear each other apart over one of the twentieth century's most celebrated fakes: the Vinland Map. The map, which resides at the Beinecke Library, surfaced in 1957 in clouded circumstances. It purported to be the original map used by Leif Eriksson on his voyage of discovery to the New World. Scholars took sides for or against its authenticity. Even after forensic tests revealed that, in a crude attempt to simulate age, the forger had put yellow-brown ink underneath the map's black ink outlines, controversy continued to rage, leading to bitter divisions among friends and colleagues that will never be resolved.

It seemed to Franklin that he might have become entangled in an even more sensational case of forgery: a forgery that had homicide as one of its components. Not only was Franklin's reputation as the foremost expert on Emily Dickinson's handwriting at stake, but also his position as one of Sotheby's most important customers. According to Ashworth, when he had

called Sotheby's to warn them about the poem, they had named Franklin as one of the "experts" who had vetted the poem. If that were true, it would be a grievous breach of professional trust. Franklin had not authenticated the poem for Sotheby's. Indeed, he had had no formal contact of any kind with them prior to the auction.

As Franklin puzzled over what to do, an event that had occurred at the end of May, only days before the poem was auctioned at Sotheby's, took on new significance. Franklin had traveled down from New Haven to New York to look at the poem during the public preview. These public previews take place a few days before an auction, and give dealers and collectors a chance to study the books and manuscripts they are thinking of bidding on. To study manuscripts Franklin uses a "linen tester": a powerful magnifying glass used by textile merchants to assess the quality of linen. So, having removed the poem from the glass case in which it was being displayed, Franklin set it down on a table and examined it. Up until now he had only seen a faxed copy of the poem. But with the original in front of him he was able to study the paper and handwriting with far greater accuracy. Everything tallied, as he expected it would, as far as the writing was concerned. He now turned his linen tester to the embossing in the top left-hand corner. Under magnification he could see quite clearly that this was, indeed, one of two kinds of Congress paper that Emily Dickinson had used in the 1870s.

While he was studying the boss mark, a Sotheby's employee he knew came up and engaged him in conversation. "It was mostly small talk," Franklin said, "but I suppose that they could have interpreted from that conversation that I thought the poem was genuine." Was this what they had meant when they told Ashworth that the poem had been "checked out" by Ralph Franklin? That he had seen it at the public preview and not voiced doubts about it? If so, it would be a cynical misuse of his reputation. For Sotheby's and the other auction houses know that the scholars and experts who come to their public exhibi-

tions never opine on a document or a painting (unless it is to say something affirmative) for fear that, at a later date, an irate collector may sue them.

When he had first seen the poem, he had studied it for signs of authenticity. Galvanized by Ashworth's call, Franklin now began to look at it from the opposite point of view. "I kept looking and looking for what would show a forger's hand," he said, "and I finally came up with a few anomalies. One of them is the capital *T* in the first word of the poem. Normally it slants down in Dickinson. And these *T*'s do not slant down."

Franklin's charts showed that Dickinson had sometimes written her *T* in the way it is reproduced in the poem. Examples of this form, however, were rare, and dispersed over many documents. Here, there were three in one poem. "It is as though one found a formula and repeated it," he said. "But can you prove that she did not write this because there are three of them sitting here like this? What is proof?"

Franklin was facing a question that plagues forensic document examiners. Unless a forger makes a crass and obvious mistake like using ink or paper that had not been manufactured at the purported date of the document, it is often extremely difficult to prove forgery. And there were no such signs here. The poem also passed the key test of authenticity: those minutely varied characteristics that make each person's handwriting unique. According to Franklin's charts this was Emily Dickinson's handwriting.

Or was it? Another detail that Franklin focused on was the capital *E* in *Everyone*, in the second line of the first stanza. There was an awkwardness to it that, Franklin felt, showed signs of hesitation, as though the writer had momentarily lifted the pencil. Was this the telltale sign of forgery he had been looking for? Or had Emily Dickinson just burped at that moment?

CHAPTER THREE

A Search
for Truth

*I*n the summer Dan Lombardo likes to go
kayaking. After Ashworth told him about
the possible Hofmann connection, however,
the kayak stayed in the garage. He lived on the phone. He ran-
sacked Amherst's libraries for information about Hofmann. Until
he had found out who had written "Aunt Emily" on the poem,
and could trace it back to its original owner, he would not rest. A
librarian was about to turn sleuth.

He clung to the fact that Ralph Franklin still believed in the
poem. On July 25, less than a week before the poem was due
to be exhibited publicly for the first time, he asked Franklin
to come to Amherst to have another look at it. Working in
a room Lombardo had specially set aside for him, Franklin
again studied the handwriting, letter by letter, serif by serif, us-
ing samples of Dickinson's handwriting that he had brought
with him.

One of the details he focused on was the ligatures of vow-
els and following consonants. From the Latin *ligare*, meaning to
tie or bind, a ligature is the flange linking two or more letters,
like *-an* or *-em* or *-en*. In 1871 these ligatures were fracturing and
by the end of her life Dickinson would be printing each letter in-

dividually, with no connecting strokes joining them. In "That God Cannot Be Understood" both versions were present. "You have the word *cannot* with -*an* linked," Franklin pointed out, "and you have *cannot* with the -*an* open. You even have it rendered in the same word."

How could a forger possibly get all this right? The fact that Hofmann had worked in Utah made it seem even more unlikely. For the first time Franklin and Lombardo began to wonder whether Hofmann's source for the forgery had been Franklin's own two-volume edition of Dickinson's fascicles. It had been published in 1981, three years before Ashworth said that Hofmann had offered him the poem for $10,000.

One detail made that seem unlikely. Nowhere in Franklin's two-volume edition was there a poem signed "Emily." Like her handwriting Dickinson's signature was not something constant or stable. It shifted, and changed, according to the year, occasion, or her mood. Sometimes she signed herself, formally, "Emily E. Dickinson" (the *E* stands for Elizabeth); sometimes "Emily E.D."; sometimes "E. Dickinson." When she was writing to close friends, or children, she signed herself "Emily," "Emilie," "Emily E," or on one occasion simply as "E." In a letter to her close friend Thomas Wentworth Higginson, she closed: "Your Gnome."

The signature at the bottom of "That God Cannot Be Understood" was exactly right for 1871. This, combined with the fact that Dickinson only rarely signed poems with her first name, and no examples were in his book, suggested to Franklin that his edition of Dickinson's manuscripts was, after all, not the source of the handwriting. And that therefore the poem was probably genuine. "I remember Ralph pounding on the table after he had looked at the poem," said Lombardo. "He kept saying, 'It has to be genuine! It has to be! No one could know all these minute details about Dickinson's handwriting!' At the same time, he was cautioning me. After all, Vermeer and van Gogh have been forged. Why not Emily Dickinson?"

Lombardo recalled an incident that had happened a number of years earlier. In January 1990 he had opened another Sotheby's catalog and found himself staring at what seemed to be an original Emily Dickinson poem. It was described in the catalog as an "Autograph Transcription signed, 1½ sides of an 8vo. card (c. 1859), beginning: 'Heart not so heavy as mine . . .' "

Thrilled at the prospect of acquiring a handwritten, signed poem by Dickinson, Lombardo had immediately gone to the Special Collections budget to see if he could raise the $3,000–$5,000 he thought he would need to bid on the poem. Several things bothered him, though. First, the handwriting did not look like Dickinson's. Second, the punctuation and page layout were not in the poet's usual, unique style. The poem was also signed "Emily Dickinson," a form rare for the poet outside of legal documents. There was almost no information about the poem's provenance.

Convinced that this was not an authentic Dickinson manuscript, Lombardo did a bit of research and quickly realized that what was being offered at auction was not an Emily Dickinson original at all. It was a version of the poem edited and transcribed by Mabel Loomis Todd, the poet's first editor. Realizing that the auction was only days away, Lombardo had called the head of the Books and Manuscripts Department at Sotheby's. His call was never returned. Lombardo then left a detailed message with another Sotheby's employee, alerting the auction house to the error.

Lombardo assumed that, after his warning, the poem would be pulled from the auction. He was astonished, when the results of the auction were sent to him, to discover that the so-called "Autograph Transcription" had been sold for $4,400. When he called again to find out what had happened, the story began to take on even more improbable twists. Sotheby's informed him that they had contacted Ralph Franklin prior to the auction for his opinion, and that he had agreed that it was not a Dickinson original. Despite Franklin's opinion Sotheby's decided to leave

the poem in the auction, but announce from the podium that item #2028 was not in Dickinson's hand. But the phone bidders had no way of hearing the announcement. And one of them subsequently became the proud owner of a perfect example of Mabel Loomis Todd's handwriting.

Had he become the victim of a similar deception? Perhaps he had misread things again, just as he had failed to see that under his father's happy-go-lucky exterior there was a darker side. As his doubts about the poem rose, he felt his old ghosts returning. Perhaps the competence he thought he had built up over seventeen years at the Jones Library was an illusion. Perhaps his father's Sicilian sense of fatalism had been right. No matter how good life might seem, the drought would come, the olive trees would die, and you would have to sell the farm.

To celebrate the return of the poem to Amherst, Lombardo had organized a gala reception at the Jones Library. A few days before the gala Lombardo was sitting on Amherst Common, a historic park in the center of the town. The Common was what had drawn Lombardo to Amherst in the first place. He remembered the first time he had driven here, how he had passed the Common and thought how beautiful it looked, with its rectangle of green grass framed by the historic brick buildings of Amherst College. In colonial times English Puritans had grazed their sheep here. And even today the Common was the focus of Amherst life. There were fairs and concerts, flea markets and poetry readings. The Common was where the heart of this community, which he had worked so hard to become part of, beat strongest.

Lombardo had just been to the Amherst College Library to collect a book he had ordered about Mark Hofmann: Richard Turley's *Victims*, which the Church of Latter-Day Saints had commissioned in the wake of the murder case. As he sat in the sun outside the library, Lombardo began to leaf through the book's lengthy appendixes. One of them was a list of Hofmann's non-Mormon forgeries.

In 1986, as part of a plea-bargain arrangement Hofmann made with prosecutors in Salt Lake City, he had agreed to full disclosure about his forgeries: how many there were, how they had been created, to whom they had been sold. This eventually became a six-hundred-page "confession" published by the Salt Lake County Attorney's office. As usual, Hofmann only told part of the truth. In a second agreement reached with special investigator Michael George, he had then agreed to furnish a complete list of all his Mormon and non-Mormon forgeries.

In 1989 a list was discovered in Hofmann's prison cell. The first page of this two-page document, which was handwritten in Hofmann's chicken-scratch script, is headed "Mormon and Mormon-Related Autographs." It lists a total of sixty-one names, among them most of the founding fathers of the Mormon Church, including Brigham Young and Joseph Smith. A second, alphabetical list, headed "Forged Non-Mormon Autographs," had the names of twenty-three people, among them some of America's greatest historical figures, like Abraham Lincoln, George Washington, Paul Revere, and Jack London. Emily Dickinson's was the sixth name down, between John Brown and Button Gwinnett.

Lombardo's mouth went as dry as sand. "As I looked over the Common it was entering my mind that, if this really was a forgery, I did not think I could be part of this town anymore," he recalled. "I would not be able to face people, knowing that I had caused all this."

He had no choice. Two days later, on the thirtieth of July, this eagerly awaited new work by the town's most famous daughter came home to Amherst. Several hundred people crammed into the Special Collections section of the library to witness its unveiling. Dickinson scholars who had flown in from Washington or Virginia mingled with local people who had walked across the Common. There were state representatives and local writers, as well as professors from the area's numerous colleges, like Smith and Vassar. A Dickinson family descendant, Angela Brass-

ley, the great-great-granddaughter of Samuel Fowler Dickinson, the poet's grandfather, had even flown over from England with her husband and two children. They were photographed standing proudly next to the poem. There were children and flowers everywhere.

Lombardo gave a speech in which he celebrated the numerous coincidences that had enabled the library to buy the poem (some felt that the hand of God had been at work), and thanked all those who had contributed money. He then introduced the actress Belinda West, who had been asked to read the poem. Her reading, he said, would symbolically send Dickinson's lost words into the world and make a connection with the elusive poet. After the reading a local musician, Sean Vernon, sang an arrangement of the poem that he had created for the acoustic guitar. This was followed by a classical arrangement by New York composer Leo Smit, who had once worked with Aaron Copland. Smit could not attend the event, but he had sent a copy of the score the poem had inspired him to write. "It was one of the most beautiful things we have done at the library," said Lombardo. "It was like people filing through to see the Pietà."

The analogy is apt. Since the rise of the cult of the artist-as-hero, dating back to the birth of Romanticism at the end of the eighteenth century, literary manuscripts have replaced the relics of the saints as powerful talismanic objects. When James Boswell, the biographer of Samuel Johnson, found himself standing in front of what he believed to be the original manuscript of *King Lear*, in London, on February 20, 1795—it was, in fact, a forgery by William Henry Ireland—he knelt down on the floor and kissed it. "I shall now die contented," he said, "since I have lived to see the present day."

For Dickinson aficionados the discovery of a new poem may not have been quite such an overwhelming experience. But it was nonetheless an epiphanous moment. In the last thirty years a cult has grown up around Dickinson's work and life, as powerful as the cult that surrounded Shakespeare in Samuel Johnson's

day. Her literary stock has risen so fast that, in the opinion of the celebrated critic Harold Bloom, she is, with Walt Whitman, America's greatest poet. Her idiosyncratic idiom appeals to postmodern ears. Like Sylvia Plath she is seen as an avatar of female consciousness. Her solitary life echoes with today's lifestyles. Dickinson was the girl who never grew up. She did not marry or have children. She never entered the messy world of adult sexual relations. In a postmodern, postfeminist world of frayed gender relations, this inner exile is seen as a form of heroism, her decision not to marry the only smart choice.

As a result one of the world's most private poets has spawned a sprawling, global community of devotees. There are more than 67,000 entries in a dozen languages on the Internet, including a hypertext poetry room, where you can see her poems as they appeared in the fascicles and a virtual reality tour of the Homestead. There are chat rooms where you can discuss your favorite poems. There are lesbian Web sites where you can read the steamy verses it is claimed she wrote to her sister-in-law, Sue Dickinson. You can download her recipes for black cake or gingerbread or purchase a Dor-A-Bil doll, complete with woodblock torso, for $19.95.

The thirty-nine words on this sheet of blue-lined paper brought the guests at the Jones Library as close as it is possible to get to her. This is especially true in the digital age where everything is available, and nothing is special. Whether it is Picasso or pornography, the data flooding across our screens is just that: data. You cannot touch it or feel it. It is gone in a second. An original manuscript, whether it is the piece of paper on which Paul McCartney scribbled down the words to "Hey, Jude," or a poem by Emily Dickinson, connects us in a visceral way to the past and brings us as close as it is possible to get to the men and women who have changed the world and given voice to the thoughts and emotions we ourselves cannot articulate.

For the people crowding around the poem the idea that Amherst's most famous daughter had held this piece of paper in

her hand, had shaped and formed each letter, then signed it with her name, folded it, and sent it to a child, moved them in a way that no reproduction could match. In an age obsessed with celebrity and lacking in greatness, it was also a token of how high the human spirit could rise. "She is like an eleventh-century mystic," said Lombardo. "And what she has left behind are like the parables of the saints, because they can be universally applied. You feel she is speaking to you very personally."

While people came over to congratulate him on acquiring the poem, Lombardo had a sickening feeling in his stomach. He had almost called off the gala. As it was, he asked most of his closest friends not to attend. He had told only two people in the room of his suspicions about the poem: the director of the Jones Library, Bonnie Isman, and his wife, Karen. As he listened to speaker after speaker heap praise on him, he imagined the disbelief and shock the people who were now congratulating him would feel, if they knew what he knew. The worst of it was having to put on that smiling face and pretend that this was the most exciting moment of his career, how thrilled he was to have acquired this wonderful treasure for the people of Amherst.

He knew that if it became public that Hofmann had once owned the poem, its authenticity would always be questioned. He also knew that, despite everything he had achieved at the library, this, and this alone, would be what people would remember him for. He would be remembered as the curator who took $21,000 of the library's money and spent it on a fake.

He imagined how quickly the congratulations he had been receiving would turn to sneers; how fast his efforts would be branded as egotism. People would say that he had landed himself, and them, in this mess because of his vanity and inexperience; because he liked the limelight and liked reading his name in the papers. Some people, he knew, were only waiting for an opportunity to bring him down. That was the other side of small-town life. Everyone was in everyone else's business. Emily had known that. Eventually she would not even leave her house,

so frightened and disgusted was she by the rumors and back-biting, the matrons in black tut-tutting on the street, those mean-spirited shrews, who all claimed to be good Christian women, whispering about Sapphic love and secret meetings she was supposed to have with married men.

If the poem were a Mark Hofmann forgery, it would not only mean the end of his life in Amherst, it would also annihilate his faith in his profession. He had no illusions about how institutions functioned. Whether they were governments or auction houses, institutions were always liable to corruption. But he had always clung to a belief that the individuals who worked in his profession were people of integrity who did their job because they had a genuine love of manuscripts and history. Why had Sotheby's not done their research and found out the link to Hofmann? Why had Marsha Malinowski said the poem had come from the Midwest, when it had probably come from the Gallery of History in Las Vegas?

Lombardo had never seriously considered keeping quiet. There had been moments when he had thought that perhaps he should just ignore Ashworth's call and tell Franklin that, after this latest examination they had performed, he felt satisfied that the poem was genuine. If it were a forgery, it had been so masterfully done that no one would ever know the difference. But as he watched his neighbors and colleagues file out of the library into the balmy summer air, as he shook hands with people whom he would see on the street corner in the morning, or meet at Labor Day parties, he knew that he could not do that. He owed them the truth.

The first thing he did was call the Gallery of History in Las Vegas. Gareth Williams, a senior company employee, was at first friendly and helpful. He told Lombardo that he was familiar with the poem and that the Gallery had acquired it sometime before 1994. But when Lombardo asked Williams if the Gallery of History would mind going back into their records to check who had bought the poem, Williams grew testy. He told him that the

computers were down. As to the provenance, as far as Williams could recall, the poem had come from California, as part of the estate of a collector. Who had died.

The so-called "dead man provenance"—a bogus history created to disguise a manuscript's true origins—is one of the oldest tricks in the historical documents trade. And this was now the second corpse Lombardo had stumbled upon. Marsha Malinowski had told him that the poem had originally come from a dead dealer in the Midwest. But she had made no mention of the Gallery of History in Las Vegas, even though Lombardo now knew from Franklin that the poem had been there three years ago; and that, at a later date, it had been seen by Brent Ashworth hanging on the wall with a price tag of between $35,000–$40,000 in another one of Todd Axelrod's stores. Had she just forgotten to mention it? It would seem unlikely that she had not known of the Las Vegas connection. After all, Sotheby's prides itself on its expert evaluations of the things it sells. But now he was being told that the poem had come from a dead collector in California. The corpses were multiplying. Was Malinowski lying? Was the Gallery of History lying? Were they both?

Lombardo was enmeshed in a cruel paradox. By proving the poem was a forgery, he would be proving that his finest hour had actually been his greatest blunder. There was one way to save his reputation and the reputation of the library, though: uncover the poem's true origins. For that, he would need all the expertise he had accumulated over the years. His search for the truth was an opportunity in another, more personal way. By proving that the poem was genuine, or not, he would be proving to himself and others that he could indeed distinguish between what was real and what was not. In so doing he would at last be able to lay his ghosts to rest.

Again Lombardo turned to Ralph Franklin. Franklin had by this time become increasingly fascinated with finding out the truth about the poem himself; and he told Lombardo that he would call Sotheby's. It was a generous thing to do. As director

of the Beinecke Library, Franklin was one of Sotheby's most important customers. If he got on the wrong side of this story, it could ruin their relationship.

Franklin called David Redden, a man he had known for many years. The worldwide head of books, manuscripts, and collectibles, Redden is one of the most senior and experienced members of Sotheby's staff. He is on the board of directors. He is also one of Sotheby's most experienced auctioneers. When van Goghs or Monets go under the hammer for tens of millions of dollars, the suave, debonair David Redden is likely to be the person calling the bids.

Franklin wanted to press Redden about the poem's provenance. Though there had been no mention of it in the catalog, Franklin suspected that the Emily Dickinson poem had been consigned by Todd Axelrod, of the Gallery of History in Las Vegas. Redden insisted that the poem had not come from the Gallery of History.

Franklin was not convinced. If Marsha Malinowski's account of the provenance was true—that the poem came from a collector who got it from a dealer in the Midwest who had died—it had changed hands four times between late 1994, when Franklin first saw it, and 1997, when it was auctioned. But Franklin knew that, in the rare manuscripts business, things just did not move that fast. Had the poem been consigned by somebody on behalf of the Gallery of History? Franklin asked Redden. Redden said it had not. He said that it had been consigned by "an individual" who, he told Franklin, had no connection either direct or indirect to the Gallery of History in Las Vegas.

Franklin still felt uneasy. And on August 3, some days after his conversation with Redden, he told Lombardo that he had decided to withdraw the poem from his book. It was a bitter blow. Franklin's belief in the poem had been the I-beam on which Lombardo's own hopes had rested. Now it had been removed. But Franklin did not stop helping Lombardo. He checked and rechecked his copy of the manuscript. He read up on Hofmann

and the Mormon murders. He conferred almost daily with Lombardo. Soon these two very different men—a patrician academic from Yale who dressed in Armani suits and loved the opera, and an antiestablishment liberal from Amherst who wore jeans and John Lennon signature glasses, and loved rock and roll—were becoming fast friends. They joked about being Watson and Sherlock Holmes. They shared their anxieties. Franklin had tried to call Tammy Kahrs, the archivist from the Gallery of History who had first contacted him about the poem. Apparently she was dead.

Both men had by now acquired copies of the revised 1986 edition of Todd Axelrod's book *Collecting Historical Documents*, and on page 198 they found the text of what claimed to be "an unpublished poem, handwritten by Massachusetts poetess Emily Dickinson," neatly framed and illustrated with the famous daguerreotype of the poet. The print was in a minuscule font, too small to read with the naked eye, but under magnification it became clear that this was the poem Lombardo had bought at Sotheby's.

The discovery was important because it established a detailed provenance for the poem. It showed that Axelrod had not just recently acquired it from someone else but had bought it sometime in the mid-1980s, not long before Hofmann was convicted of murder. He still had it at the end of the eighties when Brent Ashworth, who had already been offered the poem by Hofmann for $10,000, saw it for sale in one of Axelrod's galleries. And it was still in Axelrod's hands in 1994, when Tammy Kahrs contacted Franklin.

On August 4 Lombardo called the illustrious auction house on Madison to say that, given the numerous suspicions surrounding the poem, it was now their responsibility to prove its authenticity. The Marsha Malinowksi Lombardo reached by phone that day was not the breezily cheerful woman he had spoken to six weeks earlier. Her voice was shaky, and when Lombardo mentioned Hofmann, she grew defensive. There was, she said,

"absolutely no question" of the poem's authenticity. She also insisted that several experts had studied the poem, among them a well-known expert on forgery, Kenneth Rendell.

Later that day Lombardo spoke to "Special Agent Kiffer." Unlike Malinowski, Kiffer was calm and reassuring. He insisted that Sotheby's guarantees what it sells. When Lombardo raised his suspicions about Hofmann, Kiffer sought to placate him by explaining that, before he became a forger, Hofmann had been a legitimate dealer of historical documents. Kiffer did not mention Rendell, but he did say that "ten to fifteen" manuscript experts had examined the poem.

The mention of Kenneth Rendell was reassuring. A tough, ambitious man, with showrooms on New York's Madison Avenue and in Newton, Massachusetts, Rendell has built one of America's most successful historical manuscripts businesses. His flair for self-promotion and his immense experience have made him the dealer of choice for some of the richest collectors in the world. Among them is Bill Gates, for whom Rendell is building one of the world's most important collections of historical documents. When Gates bought Leonardo da Vinci's celebrated notebook, the Codex Leicester, for $30.8 million in 1994, it was Rendell who was bidding for him. Rendell is also an acknowledged expert on forgery. His book *Forging History* is a classic. He has also testified in numerous high-profile cases. Indeed, it was Rendell who exposed another celebrated forgery case, the Hitler Diaries, and his testimony at Hofmann's trial in 1987 was crucial in establishing a motive for the two murders. Rendell was away in the South Pacific when Lombardo called, but his office in Boston said they would be happy to forward him a fax. A fax came back from Tahiti saying that he had declined to authenticate the poem for Sotheby's. Later it would become clear that not only had Rendell never authenticated the poem, he had never even seen it.

Kiffer also told Lombardo that he had consulted a woman named Jennifer Larson about two questionable documents in the

catalog for the May 1997 sale, which took place one month before the Dickinson poem was auctioned. Larson is a respected rare books dealer and former chairperson of the Ethics Committee of the Antiquarian Booksellers Association of America. Since the late eighties she has also devoted herself to researching Hofmann's non-Mormon forgeries to prevent his fakes from contaminating the trade she loves. According to Kiffer, Larson had not raised any concerns about the Dickinson manuscript. Of course. He had never asked her about it.

Lombardo tried to locate Larson in San Francisco, where she ran a store called Yuerba Buena books. She had moved. He made a follow-up call to the Gallery of History, in Las Vegas. Initially, Gareth Williams had told him that the poem had come from a dealer in California who had died. Now he claimed that he was "not familiar" with a Dickinson poem at all. When Lombardo asked to speak to Tammy Kahrs, the archivist who had faxed Ralph Franklin the poem in 1994, Williams said she was dead.

A few days later, Williams called back, this time in an agitated mood. He said that *maybe* the Gallery of History had had a Dickinson poem, but he could not recall the details. He also made it clear that Lombardo's inquiries were not welcome. When Lombardo asked him to check back through the records for any information about the poem's provenance, Williams told him that he could not. The computers were down.

The next piece in the puzzle fell into place when Lombardo reached Jennifer Larson at her new home in Rochester, New York. The documentation she faxed Lombardo—documentation that she could have made available to Sotheby's, if they had asked—was enough to make any reputable dealer not want to touch the Dickinson poem. Included in it was a copy of Hofmann's travel records, which the police had put together for the trial. These placed Hofmann in Cambridge, Massachusetts, in 1983 and 1984. Perhaps Hofmann had traveled to Cambridge to visit the Houghton Library at Harvard, which holds the largest number of Dickinson manuscripts.

Larson also told Lombardo that she had spoken to a TV reporter from Salt Lake City named Con Psarris, who had made a number of programs about Hofmann's forgeries. In October 1990, while researching a possible Emily Dickinson connection, he had sent Hofmann the text of the poem that had appeared in Axelrod's book, querying whether it was a forgery. The poem began "That God cannot be understood," but Psarras had slightly misquoted the remainder of the poem. Hofmann had replied from his jail cell with the pedantry of a university professor. "The E. Dickinson item referred to is a forgery," he wrote via his lawyer, Ron Yengich. He then wrote out the authoritative version of the text, emending several points of punctuation and capitalization. It was the poem Daniel Lombardo had bought at Sotheby's.

The evidence against the poem began look compelling, if not complete, but Lombardo had to be sure. He contacted Robert Backman, a clinical graphologist with twenty years of experience with the Department of Defense (during World War II he worked on forgeries that appeared as propaganda). Backman came to Amherst to examine the poem. One of the things that made it so hard to prove either way was that the poem was written in pencil. Ink can be subjected to cyclotron tests and chemical analyses. But there are no forensic tests for pencil.

The pencil was first developed in the Renaissance, when artists began to use styluses made of silver or lead for ruling lines or drawing. The first mention of the lead pencil as we know it today came in a treatise on fossils published in England in 1565. A year earlier, in the village of Borrowdale, in Cumbria, a violent storm had uprooted a giant oak tree. Beneath it was found a vast deposit of almost pure graphite, and the pencil was born. At first, sticks of graphite were simply inserted in a wooden sheath. But by the middle of the next century these crudely made wooden pencils had been replaced by pencils made of ground graphite dust mixed with adhesives. Later, clay was added and the pencil leads were fired in kilns to increase their hardness and unifor-

mity. Apart from manufacturing improvements the only develop-
ment since then has been the introduction of the mechanical
pencil in 1822. As a result it is almost impossible to date docu-
ments written in pencil.

Backman knew this. Even the phrase "Aunt Emily," which
had been written in a different hand, on the back of the manu-
script, in red indelible pencil, appeared to be authentic. Like
Franklin and Lombardo before him he concluded that the paper
was right. The handwriting also appeared to be genuine. But
when Lombardo told him that the document had once been in
the hands of Mark Hofmann, Backman shook his head and said,
"Well, that changes everything."

If the experts could not tell a Hofmann forgery, how could
Lombardo ever determine the truth about the poem? And if he
could not definitively prove to Sotheby's that the poem was a
forgery, he would not be able to force them to return the library's
money. The circumstantial evidence strongly suggested the
poem was not authentic. But each time Lombardo looked at the
poem he found it impossible to believe that a forger could have
got inside Emily Dickinson's mind, and simulated her handwrit-
ing, so seamlessly and completely as this.

Lombardo's next call, to David Hewitt, a journalist with the
Maine Antiques Digest who had written two in-depth features about
the Hofmann case, confused him even more. Hewitt told him
that Hofmann was a compulsive liar and a braggart, and that on
several occasions, in an attempt to win favor with the parole
board, had even confessed to forgeries that he had never exe-
cuted. Was the Emily Dickinson poem one of his false claims?
Where was the truth?

Both Dan Lombardo and Ralph Franklin had read the report
of a forensic scientist named George Throckmorton, who had
done extensive examinations of Hofmann's forgeries at the time
of the 1986 trial, using an ultraviolet lamp and a high-powered
stereo microscope. The Beinecke Library had both. So, on a
hot day in the middle of August, Lombardo packed "That God

Cannot Be Understood" into his briefcase, along with about $100,000 worth of other Dickinson manuscripts from the Jones Library's collection, and set off in his car for New Haven.

Franklin and Lombardo worked in a darkroom in the basement of the Beinecke Library. As the poem had been written in pencil, there would be no telltale signs of chemical tampering with the ink. But there might be on the paper. Under ultraviolet light any attempt to age the paper artificially with chemicals would cause it to fluoresce. Would this be the proof they were looking for? It wasn't. The paper did not fluoresce. When they looked at the poem under the ultraviolet lamp, they thought that they detected a slight opalescent blue smear, like a brushstroke, around the boss mark. Franklin was not certain, but he sensed that something was not quite right with the embossed image of the Capitol stamped on the top left-hand corner of the page. There were also splotches along the edges of the document in that area, as though some sort of chemical had been spilled there. Had Hofmann applied a chemical to the paper to make it "take" the boss mark better?

Next Franklin examined the poem under a stereo microscope, with a powerful raking light shone from the side. This would show the boss mark in better relief. The roof of the Capitol building on the boss mark looked flat. In other examples of boss marks from Capitol stationery Franklin had brought for comparison, there appeared to be a cupola on the roof. On its own this might not have been enough, but in conjunction with the slight fluorescence this tiny flaw made Franklin and Lombardo suspicious. Or perhaps there was a Congress boss mark they did not know of. Perhaps it was the right boss mark, and the paper had simply not been impressed as strongly as usual. Was that why the cupola seemed faint? Every answer led to fresh questions.

Franklin also used the stereo microscope to study the capital E in the word *Everyone*, which he felt showed signs of hesitation. When we write, the pen or pencil moves fluently and unhesitat-

ingly across the page, touching and lifting from the paper rather like a plane landing and taking off. We don't pause to think about what we are doing. If we do, we usually make a mistake. Forgers are not writing naturally, however. They have to think about what they are doing, and they often give themselves away by making awkward pen-lifts or hesitating in the middle of a letter. Was the slight hesitation Franklin had detected the telltale sign that the poem was a forgery?

A few days later Lombardo reached a man named Shannon Flynn. Flynn, a jovial Irish-American from Salt Lake City, had negotiated many of Hofmann's business deals and acted as his courier. Flynn was also a crack marksman and firearms expert. When Hofmann was arrested, the police had found a cache of weapons at Flynn's apartment: a lugged rifle, a Magnum .357, and an Uzi that had been illegally converted to fully automatic status.

If anyone had told Lombardo when he became curator of Special Collections at the Jones Library that he would one day be making phone calls to a man in Salt Lake City whom the police had questioned for ten hours as a suspected accessory to a double murder, he would have laughed. When he reached Flynn at a Salt Lake City gun shop named Pro Arms and Ammunition, he also realized, for the first time, that he was frightened.

As it turned out, he had nothing to fear. All charges had eventually been dropped against Flynn, and since Hofmann had gone to jail, he had made it his policy to be completely transparent with both the media and the DA's office. To Lombardo he confirmed that, in 1985, he had flown from Salt Lake City to Las Vegas, on Mark Hofmann's behalf, to deliver what purported to be a poem by Emily Dickinson to Todd Axelrod, of the Gallery of History.

Lombardo now felt he had enough circumstantial evidence to prove the poem was a forgery. Though David Redden of Sotheby's had said there was no connection, direct or indirect, to the Gallery of History, it now seemed to Lombardo almost

certain that the poem had indeed come from Las Vegas. He knew that Axelrod had bought it from Hofmann. Ipso facto, unless Axelrod had lied about where he had originally obtained the poem, Sotheby's must have known of a Hofmann connection. Lombardo faxed David Redden, at Sotheby's, a one-page letter detailing his suspicions. Redden did not even bother to return his calls. Instead he had an underling, Kimball Higgs, respond. "It certainly looks like a forgery," Higgs said offhandedly. "It's our problem. Please send the poem back." And the $21,000? Higgs told Lombardo that there should be "no problem" about that. But when Lombardo asked for Sotheby's agreement in writing that they would return the library's money, Higgs declined.

Six days later Lombardo met with the board of trustees of the Jones Library in Amherst. It was a moment he had been dreading. He had kept his doubts, and all the research he had done, secret. Now he was about to tell his community and the world that the Emily Dickinson poem was a fake. The members of the board of trustees reacted with a mixture of shock and sympathy. One person burst into hysterical laughter at the sheer absurdity of what had been done to them. "I was heartbroken," recalled Lombardo, "just completely heartbroken that I had let so many people down." But this was no time for self-pity. Lombardo notified Sotheby's that in forty-eight hours he would be issuing a press release stating that the poem was a forgery, and that he would like by that time their assurance in writing that the Jones Library would receive a full refund. A few days later, fearing the public relations fallout from Lombardo's press release, Sotheby's complied with his demand. "There was no apology. No embarrassment," said Lombardo tartly.

"It was as if this was just a little blip in their daily business. Just routine."

Chapter Four

Auction Artifice

*T*hough Sotheby's counts among its board of directors two lords, an earl, a marquess, and Her Royal Highness the Infanta Pilar de Bourbon, duchess of Badajoz, it has, since its foundation in London in 1744, auctioned numerous works of art, and manuscripts, that have turned out to be forgeries.

The small print in their catalogs does include a guarantee of authenticity, albeit one limited to five years. But if anything proves to be "wrong," Sotheby's (and this applies to all the auction houses) can always say, as they routinely do, that they are merely the agents for the sale and, therefore, not directly responsible. The onus is on you, the purchaser, to satisfy yourself that the article you buy is genuine. The codes of secrecy by which auction houses conceal the identity of both consignor and purchaser add a further level of obfuscation. Caveat emptor.

It is a familiar ritual: a stolen painting, or a fake Chippendale chair, passes through the salesroom. Doubts are raised. The auction houses return the consignor's money, disclaim their responsibility to police the market, then six months or a year later the same happens all over again. In 1997 an exposé by the BBC actually showed a Sotheby's employee in Milan smuggling an Old

Master painting out of Italy: one instance of a cynical and widespread pattern of abuse by which unprovenanced art from Italy and India, much of it stolen by organized gangs of grave robbers, had been, with the full knowledge of Sotheby's, put under the hammer at its UK auction house.

The *Dispatches* programs and the subsequent media exposure—a headline in *The Times* read, "Sotheby's and the Art of Smuggling"—seemed to have a sobering effect on the company. In March 1997, with much fanfare, Sotheby's announced a $10 million inquiry to be run out of the New York office, under the direct supervision of its glamorous new chief executive, Diana D. Brooks.

Only later would it become clear that just as Ms. Brooks was asking the world to believe that such cases of malpractice were isolated, not systemic, Sotheby's was being shaken by allegations that its chairman, Alfred Taubman, had negotiated a commission fixing deal, with Christie's in London. Those charges led to Ms. Brooks's resignation and charges of fraud and malpractice being leveled against Taubman, for which he would face a possible term in jail.

Taubman's attempt to fix commission fees was motivated by naked greed. By the mid-nineties Sotheby's—and Christie's—had turned what in the eighteenth century was regarded as a rather grubby and dishonorable trade into a multibillion-dollar industry. Like owning a Porsche or a house in the Hamptons, raising a paddle at an auction had come to be regarded as an essential rite de passage of the very rich. And as the longest bull market in history began its vertiginous climb, prices went through the roof. In 1996 a pretty enough, but not great, John Singer Sargent painting called "Cashmere" sold in New York for $11.1 million. In the same year a sculpture by a minor French artist, titled "Petite Danseuse de Quatorze Ans," sold for $11.9 million.

The rare books and manuscripts department is the poor cousin at Sotheby's. The big money is in fine art and jewels.

Books and rare manuscripts also take a long time to catalog. As a result there is enormous pressure to turn over as much volume as possible. "Everything is hype these days," said Justin Schiller, a well-known dealer of antiquarian books. "In the old days you would collect things with true value. Today people don't know what to collect, so you have things like Diana's dresses selling for $250,000 or a Honus Wagner baseball card for $500,000. It's not what the auction houses are making on these things. The real value is in the publicity." Splashy, one-of-a-kind items like an unpublished Emily Dickinson poem are worth far more than the commission. They generate headlines. And bring in the punters.

The hunger for hype, combined with a captive clientele, has created the perfect environment for what Samuel T. Coleridge called, in a different context, the willing suspension of disbelief. This operates just as powerfully with the purchaser.

"There is an incredible desire on the part of people to believe that something they have purchased is real," Jennifer Larson said. "It is what you think you have and want to believe you have—not what you really have—that matters."

Mark Hofmann knew this too. He once said of his Mormon forgeries that they were documents he felt could have been part of Mormon history. He also said that deceiving people gave him a feeling of power. More than greed, this hunger for power—the power to shape and change history—seems to be ultimately what drove him. His forgeries found willing buyers because they told stories people wanted to hear.

The auction houses also tell stories, in the form of the narratives they publish in their catalogs. The most appealing stories of all have an element of mystery and romance: like the elderly woman who cuts the back off an old picture frame and finds a John Singer Sargent painting; or the bank clerk who stumbles on a priceless Washington letter while leafing through a dusty archive during her lunch break. The public loves these stories as they love

stories of buried treasure. They appeal to the side of us that wants to believe in Lady Luck, in coincidence, and serendipity.

Facts that might take away from the attractiveness of a painting or manuscript, or raise suspicions about its authenticity, are carefully excised from the stories that the auction houses tell. The catalog for the auction at which the Emily Dickinson poem was sold, for instance, cited august individuals and institutions like Randolph Hearst as consignees. It did not mention the Gallery of History in Las Vegas.

Something similar had already happened. When Hofmann was arrested in 1985, his possessions were seized to pay off his creditors. Hofmann was not just a forger. He was also a serious book collector. And when police raided his house in Salt Lake City, they found a magnificent collection of antiquarian children's books. The person chosen to dispose of Hofmann's children's books was a book dealer in California named Mark Hime. From him the books found their way to a well-known New York collector by the name of Richard Manney. A few years later Manney consigned his collection to Sotheby's for sale.

The books appeared in Sotheby's October 11, 1991, catalog as the Richard Manney Library. Detailed provenance was given to reinforce the importance and legitimacy of the collection. But one name was missing. Knowing that just the mention of his name would raise grave doubts about the authenticity of the items—even though he was known to be a serious and legitimate collector—Sotheby's wiped Mark Hofmann's name from the chain of provenance.

These were not the first Hofmann items that Sotheby's had sold either. In October 1985, only two weeks after he was arrested for murder, a Daniel Boone letter, supposedly written during the Indian Wars in Kentucky, was put under the hammer for $31,900. It came with a wonderful story of Boone's heroism on the American frontier. But the manuscript was consigned by a Salt Lake City businessman named Kenneth Woolley, who had in turn bought it from his cousin, Mark Hofmann. If anyone

had looked closely they might also have noticed that the letter was dated April 1.

Ken Farnsworth, one of two lead investigators for the Salt Lake City DA's office, had called Sotheby's at the time, to warn them about the Boone document. Hofmann was already behind bars. But having seen numerous lives shattered by Hofman's forgeries, Farnsworth was determined to get as many of them as he could off the market. He contacted antiquarian book dealers all over America. He contacted the New York Public Library and the Library of Congress and the American Antiquarian Society. He visited the British Library. He even went to Paris and alerted one of France's leading historical documents dealers.

All these institutions were extremely cooperative. But when he contacted Sotheby's he was met with a wall of silence. At first he was told that the auction house would provide the name and address of the consignee of the Boone letter if he (Farnsworth) provided a written account of his findings. When he forwarded a letter detailing his suspicions, he was told that Sotheby's would only comply with a subpoena from a court. Mike George, another Salt Lake City investigator who worked on the Hofmann case, remembers similar problems. "At Sotheby's we were met with 'Don't want to talk to you, don't care what you have to say.' "

One person did care, it seems. Mary Jo Kline, the Sotheby's employee who handled the sale of the Boone letter, informed the head of the Department of Books and Manuscripts that in the future she would never again catalog anything that had passed through Hofmann's hands. Her boss acquiesced and, as far as Kline was concerned, agreed to a larger policy decision: never to handle anything with Hofmann provenance. Three years after that, in a move that shocked the closely knit historical documents world, Kline's boss thanked her for her pains by terminating her. His name was David Redden. Redden was still at the helm twelve years later when, a month before Sotheby's auctioned the Dickinson poem, they advertised two other Hofmann

forgeries in their May 1997 catalog. One was a minor Daniel Boone autograph. The other was a sensational item: a Reward of Merit, "one of only three ever discovered," signed by Nathan Hale.

When he saw the Hale document in the catalog, Brent Ashworth, who would later alert them to a possible Hofmann connection with the Dickinson poem, called Selby Kiffer and told him that he had seen the Hale manuscript in one of Todd Axelrod's stores and believed it was also a Hofmann forgery. As he would a month later with the Dickinson poem, Kiffer denied that the document came from Las Vegas. He seemed to have taken Ashworth's warnings seriously, though, for on May 2 Kimball Higgs contacted Jennifer Larson by fax. "Here are two lots that Brent [Ashworth] brought to our attention as possible MH [Mark Hofmann] originals. He felt sure about the Hale and less positive about the Boone. If you have an opinion we would love to hear it."

Larson faxed back a raft of documentation. The first item read: "Appears on Mark Hofmann's holographic list, 'Forged Non-Mormon Autographs.'" This was the list found in Hofmann's prison cell in Draper, Utah, in 1988.

Both Daniel Boone and Nathan Hale were on the list. So was Emily Dickinson. Sotheby's withdrew the Boone document but kept the far more valuable Hale autograph in the auction. It was put under the hammer for $27,000. After the sale, as doubts about it began to multiply, Selby Kiffer told the *Maine Antiques Digest* that Kenneth Rendell had "authenticated" the Hale document. When Rendell learned of this, he was incensed. "I am meticulously careful about not expressing opinions on things we do not sell," insisted Rendell. "It was totally inaccurate." In a letter to the *Maine Antiques Digest*, Marsha Malinowski distanced herself from Kiffer's assertion that Rendell had "authenticated" the Hale manuscript, and Kiffer would later apologize to Rendell for misusing his name. (No such apologies were made to Daniel Lombardo, however, even though Malinowski had claimed to him

that Rendell had also authenticated the Emily Dickinson poem.)
Not only had Rendell never authenticated the Reward of Merit,
he had found it highly questionable when he had seen it at
Sotheby's public display before the auction. "There was a col-
oration I didn't like about the document, a shifting of the ink
that reminded me of some of the Mark Hofmann stuff." Rendell
said nothing to Sotheby's. But having spotted the effect on the
Hale manuscript, he decided that, however cheap it would be,
he would not bid on it.

One of the people who had nearly bought the Hale docu-
ment was the well-known New York book dealer Justin Schiller.
Schiller had almost been bankrupted by his dealings with Mark
Hofmann in the 1980s, something that was well known to every-
one in the trade. But during a phone call to Selby Kiffer at
Sotheby's a week before the May 19 auction, when Schiller had
made known his interest in acquiring the document and sought
to find out its provenance, Kiffer had made no mention of a Hof-
mann connection. "When you buy from an auction house like
Sotheby's, you assume that there is a legitimate title, and that
everything else has been validated by the auction attorneys,"
said Schiller. "So unless I had been alerted by the auction house
that there could have been a problem, I would not have sus-
pected anything. I trust the system." In this case his trust was
misplaced. For by the time he called, Sotheby's had received
enough evidence from Jennifer Larson of a Hofmann connection
to make even the rankest amateur not want to touch the Nathan
Hale Reward of Merit. Larson had told Sotheby's, for instance,
that in an interview with Mike George, Hofmann had stated that
he forged two printed documents by Hale: Rewards of Merit
with Hale's inscription on them, signed to the better students he
was teaching. Larson also alerted Sotheby's to the fact that
a similar Nathan Hale document had been sold at auction
by Charles Hamilton in August 1983, and that among the evi-
dence seized by Salt Lake City police was a record of a regis-
tered shipment from Mark Hofmann to Charles Hamilton dated

July 13, in other words three weeks before the auction. Finally, she enclosed a letter written to her by Hofmann from jail, on June 29, 1990. "Your note reminded me of the Nathan Hale 'Reward of Merit' which I failed to mention in my letter of June 25," writes Hofmann. "It is, indeed, a forgery."

As a member of the Antiquarian Booksellers' Association of America, Sotheby's was duty bound to disclose information about the provenance of any merchandise of disputed or undetermined nature. There were also personal reasons why Kiffer should have told Justin Schiller what he knew. They had worked together on numerous occasions. They knew each other socially. And Kiffer was also well aware that Schiller's life had already nearly been wrecked by his association with Mark Hofmann. Evidently none of that counted. For when Schiller called to announce his intention of bidding on the Hale Reward of Merit, Special Agent Kiffer said nothing. Luckily Schiller dropped out of the bidding before the price climbed to $27,000.

To date Sotheby's claims to be the unwitting victim of Hofmann's crime. In a three-page statement forwarded to *Harper's* magazine Selby Kiffer stated that he had taken warnings about Hofmann seriously and had subsequently read up on Hofmann in two books. Significantly he had not found *Victims*, which, as Lombardo discovered, lists Dickinson in its index and is available at the New York Public Library. What Kiffer claimed to have discovered in these books, for apparently the first time, was "Hofmann's incredible and continuing deceptiveness."

He implies that this was a new discovery. But Hofmann's duplicity is well known. And the vast majority of reputable dealers have a policy—as Sotheby's appears to have had in the eighties—of not touching anything that passed through his hands. As a result of the 1985 sale of the Boone forgery, it must also be assumed that Sotheby's had a detailed file on Hofmann.

Kiffer's account of the authentication of the Dickinson poem is equally disingenuous. He claims that prior to the auction it was studied closely at Sotheby's public exhibition by several

prominent Dickinson scholars, and that none of them questioned its authenticity. Kiffer does not identify these "scholars," but as Ralph Franklin is the only person Sotheby's mentioned to Dan Lombardo, it has to be assumed that Kiffer means, among others, him.

Kiffer's statement also makes no mention of the series of misleading and conflicting statements made by Sotheby's employees. Instead, Kiffer argues that Brent Ashworth had not told him that this poem was a forgery or that it had been offered to him by Mark Hofmann. He concludes, "Perhaps Ashworth intended to warn me; but to my mind this was simply an interesting but tangential anecdote from someone who had many dealings with Hofmann." This is cunning semantics. It is true that Ashworth could not definitively recall the words of the poem he saw in Hofmann's living room, but he insists that he told Kiffer in no uncertain terms that he believed the poem in the catalog was the one he had been offered and had later seen in Axelrod's gallery. When Ashworth heard about Kiffer's statement, this plain-talking Westerner laughed, and said, "Well, they sure changed that story."

Even more disingenuous is Kiffer's attempt to give Sotheby's credit for exposing the forgery. The "lengthy authentication process that we completed with these documents," he said, "will be of great use if we are faced with a similar situation in the future." Daniel Lombardo remembers it differently. "It makes me really angry. We were dragging them kicking and screaming toward the evidence. And only when we threatened to go public did they finally agree in writing that the poem was a forgery."

Significantly, Kiffer's statement makes no mention of provenance. Redden had given Ralph Franklin to understand that Sotheby's had had no dealings with the Gallery of History in Las Vegas. Selby Kiffer insisted to Brent Ashworth that Sotheby's had not "gotten into Axelrod's collection." Marsha Malinowski claimed that the poem came from a dealer in the Midwest, who had died. The poem had, in fact, been consigned by a dead man,

but this dead man was real. His name was James Haldan and he was a multimillionaire from Glenbrook, on the Nevada side of Lake Tahoe. His wife, Ethelmay Stuart, is a jelly and jam heiress. With 49% of the shares, Haldan was also the largest investor in Todd Axelrod's Gallery of History, Inc. After his death in 1995, the trust established to administer his estate, the Ethelmay Stuart–James Haldan Trust, decided to bail out of the company. Axelrod was strapped for cash. So he agreed to give the Trust $2 million worth of historical documents in lieu of the value of his shares.

I had always wondered why Sotheby's would risk their illustrious name on the sale of manuscripts that would bring 25% commission on a risible $51,000 (the sale price of the Hale and Dickinson manuscripts). But for Selby Kiffer, Marsha Malinowski, and David Redden the chance of securing the entire inventory of a major dealer like Axelrod was an unique opportunity. There were letters by George Washington and Benjamin Franklin; Abraham Lincoln and Daniel Boone. On a consignment worth $2 million, the commission would be $500,000. For the Sotheby's employeees who handled the sale it could mean a trip to St. Bart's; a Lexus for Christmas.

Though they had repeatedly denied that the source of the poem was the Gallery of History, Sotheby's was involved with the negotiations between Axelrod and the Trust for almost six months. Copies of the documents were faxed from Las Vegas to New York, where they were priced by Selby Kiffer and his team. These price estimates were then forwarded to the Trust, who used them to negotiate with Axelrod. When it was time to close the deal, in October 1996, a Sotheby's employee named Justin Caldwell flew to Las Vegas to inspect and take possession of the consignment. Working in an office at the Gallery of History, under the watchful eye of a legal representative for the Trust, Caldwell examined the six hundred documents. They were then packed, sealed, and initialed in Caldwell's presence. Finally, Caldwell accompanied the boxes to the Federal Express office in

the Gallery of History's van, so that the chain of custody was un-
broken. During the course of his work Caldwell made several
phone calls back to his boss in New York: Kiffer.

When it came to creating the auction catalog, Sotheby's
dropped august names and institutions like the Metropolitan
Museum of Art, the Ryerson Library at the Art Institute of
Chicago, and the Estate of William Randolph Hearst. No men-
tion was made of the Gallery of History in Las Vegas or the
Trust. Only 89 of the 571 documents in the May and June sales
came from these illustrious-sounding consignors, however. The
rest, roughly eight-five percent of the lots, were anonymously
listed as the "Property of Various Owners."

As Daniel Lombardo waited nervously for the phone to ring
from Sotheby's auction room on that day in early June, he had
no idea, of course, that the Emily Dickinson poem was a bril-
liantly constructed engine of deception, and that behind it lay a
trail of money, greed, deceit, and murder. Though Sotheby's
would eventually accept that the poem was a forgery, and return
the money a small town in New England had raised to buy it,
many questions remained unanswered. Had Sotheby's believed
the poem was genuine? Or had they thought that the poem was
so masterfully executed that no one would be able to prove it
was a forgery? Was it incompetence? Or chicanery?

Looming above all these questions was the strange, mercurial
figure of the forger himself. Who was Mark Hofmann?

CHAPTER FIVE

In the Land of Urim and Thummim

To understand Mark Hofmann, one needs to understand the Mormon religion and its spiritual home, Salt Lake City. On a clear winter day Salt Lake City seems to float above the Great Salt Basin like a fata morgana in the Sahara. It is partly the light, but most of all it is the way the city suddenly rears up out of the desert, framed by the Wasatch Mountains, which rise, jagged and sublime, like the backdrop to a Wagner opera. Looming at the end of the wide avenues that crisscross the city in a severe, Euclidean grid, the mountains foreshorten distances and distort scales. This sense of unreality is heightened by the presence, in the heart of the city, of a cathedral-like, neo-Gothic building. Towering over the downtown area, its spire topped by a golden angel, the Temple of the Church of Jesus Christ Latter-Day Saints dominates Salt Lake City as St. Peter's dominates Rome.

Most cities are established because of their accessibility to transport networks, the presence of raw materials, or the clemency of the climate. Salt Lake City was chosen as the site of the Mormon capital because of its remoteness and the hostility of the natural environment. Ringed by impenetrable mountains and canyons, and surrounded by one of the most forbidding

deserts on the planet, it was the ideal location for an outlaw religion that had thumbed its nose at the greatest shibboleth of Christian civilization, and the bedrock on which society had been built: the monogamous union between a man and a woman.

Laid out in an uncompromising grid of squares emanating from a central, ten-acre plot around the Temple, streets are numbered according to their geographic relation to what is known as the Base and Meridian, a marker placed on the northeast corner of the Temple, which serves as Salt Lake's version of the Greenwich meridian. This Euclidean geometry is the outward expression of a deep devotion to order and discipline. "No other organization is as perfect," a cleric wrote of the Mormons at the end of the nineteenth century, "except for the German army." Ways of thinking that deviate from the norm are as alien as crooked streets.

The Mormon God is a God of order. And business. Mormons, more than any other Americans, believe that it is a religious duty to make money. With assets estimated at $30 billion, and annual revenues from tithing of nearly $6 billion, more than Nike's annual turnover, the Church of Jesus Christ of Latter-Day Saints is today one of the wealthiest religions in the world. It owns vast tracts of land, including the United States' largest ranch, the 312,000 acre Deseret Cattle and Citrus Ranch, in Orlando, Florida; and oversees a multibillion-dollar portfolio of real estate, media, and securities assets. With a worldwide membership of nearly twelve million, and an annual growth rate far outstripping any other denomination, it is also one of the most dynamically expanding religions in the world. Some of America's most successful corporate titans are Mormons, like Steve Marriott, of the Marriott Hotel chain, or Jon Huntsman, the chemical billionaire. No religion has a better organized or more aggressive lobbying machine in Washington.

The founder of this religion, and its first prophet, was born on a hardscrabble farm near the town of Sharon, in eastern Vermont, in 1805. His name was Joseph Smith. The Smith household

was sustained by an eclectic jumble of beliefs and superstitions. Smith's father was interested in folk magic. His mother was what we would today call a fundamentalist Christian. The Bible was always open on the kitchen table. God was harder to find. The soil was rocky, the economy in depression. People lived in cramped wooden houses without toilets or drains. There was widespread poverty and disease. Alcoholism and suicide were common. To people at the bottom of the economic pile, like the Smiths, the American dream felt more like a nightmare. In nine years, when he was between the ages of two and eleven, Joseph Smith and his family moved seven times in Vermont and New Hampshire, working as tenant farmers, doing odd jobs like building work or tapping maple sugar. In 1816 they settled in Palmyra, New York.

Religion thrives on human suffering, and throughout Joseph Smith's childhood New England was swept by numerous spiritual revivals. An upstate New York farmer named William Miller predicted that the world would end in 1843 (he later changed the date to 1844), and within a few months a hundred thousand mostly poor, uneducated Americans had nailed their hopes of salvation and a better life to Miller's mast. Eventually, the Millerite movement, as it became known, would mutate into the Seventh-Day Adventist Church.

If God couldn't deliver, maybe the Devil would. Throughout the New England of that period there was widespread interest in magic and the occult. In Palmyra the Smiths earned a reputation for scrying, or crystal gazing. Scrying, the use of crystals or seer stones, had been widely practiced in pre-Christian times as a way of divining the future, but the medieval church had banned it. But in the nineteenth century, along with palmistry and astrology, "glass looking," as it was known, enjoyed a revival. Practitioners believed that they could gain direct access to the spirit world. Or find gold. The young Joseph Smith and his father would tramp the hills around Palmyra with their "seer stones," hoping to strike it rich. It was said that a seer stone worked best

at the northernmost declination of the sun. There were elaborate rituals for cleaning them. When that had been done, they were placed in a hat. The "glass looker" then walked across the fields, much as people troll beaches today with metal detectors looking for watches or jewelry. If the seer stone, or "peep stone," as the crystals were also known, misted up, gold was believed to be at hand.

Joseph Smith's favorite seer stone was a brown, egg-shaped piece of rock that he had found while digging a well for one of his Palmyra neighbors, Willard Chase. By all accounts the tall, lanky farmer's son, with blue eyes and a limp he had been afflicted with after a bout of typhoid, was an expert "glass looker." He was also deeply fascinated by Masonic rites (when Smith's pockets were searched after his death, a Masonic talisman known as a Jupiter stone was found). Soon, he was being hired by other families in Palmyra to look for gold and buried treasure. One of these men was Josiah Stowell. Smith seems to have conducted an exhaustive search of the Stowell property, but found no gold. Instead, he found a new religion.

In the fall of 1823, when he was seventeen, Smith claimed that an angel, whom he named Moroni, had appeared to him in one of his visions and told him that a set of golden plates were buried in a stone box on a hillside near the family farm. Smith dug up the golden plates and found, encrypted on them, in a language that came to be known as "reformed Egyptian," the gospel of the first major religion to have appeared on earth since the Prophet Muhammad rode out of the deserts of Arabia.

Smith had been home-schooled. His handwriting was messy and full of errors. He knew no foreign languages, and certainly not Greek or Latin. How could he read Egyptian hieroglyphs? To help him decipher the inscriptions on the gold plates, he would claim that the angel Moroni provided him with a pair of magic goggles. These came to be known as the Urim and Thummim. Imagine a virtual-reality headset with crystal seer stones as lenses, mounted on a breastplate that strapped around the

viewer's chest. Lucy Smith, the prophet's mother, would later describe the Urim and Thummim as "two smooth three-cornered diamonds set in glass and the glasses set in silver bows." The breastplate, she said, was "concave on one side and convex on the other, and extended from the neck downward as far as the center of the stomach of a man of extraordinary size."

By then Smith's treasure hunting had got him into trouble. Scrying was illegal in New York State. "All who pretend to have skill in physiognomy, palmistry, or like crafty science," declared an 1812 legal manual, "or pretend to tell fortunes, or to discover where lost goods may be found," were to be prosecuted for disorderly conduct. In 1826, when he was twenty-one, Smith was hauled before the courts in Bainbridge, New York, and found guilty of "glass looking." The neighbors hissed rumors of witchcraft and the occult.

Smith had fallen in love with a girl from Harmony, Pennsylvania, named Emma Hale. But her well-to-do father, Isaac, disapproved of Smith's nefarious activities with seer stones and forbade the match. The young lovers eloped. Isaac Hale relented. Smith and his young bride moved into the Hale house in Harmony, where Joseph Smith turned his attention from gold digging to the translation of the golden plates.

He started work in September 1827. Emma Smith served as her husband's scribe. The room was divided by a blanket. On one side sat Emma, pen in hand, with a sheaf of parchment in front of her. On the other side of the curtain sat Joseph Smith with the Urim and Thummim strapped to his chest. When he was about to dictate, Smith would bury his face in the battered wide-brimmed hat that he had worn to tramp about the hills looking for gold, "drawing it closely around his face to exclude the light," wrote a contemporary who witnessed Smith at work. The golden plates, Smith gave onlookers to understand, were buried somewhere in the woods. When he looked into his hat through the seer stones the images of the hieroglyphs would magically appear, like data scrolling across the screen of a com-

puter with wireless Internet access. Not surprisingly, Emma, his wife, was never allowed to see the golden plates. But eleven witnesses would later declare that they had "seen and hefted" them.

The visions Smith saw at the bottom of his hat rescued America from the outer reaches of the Christian universe and gave hope to poor, beaten-down people like him that America was, after all, the Promised Land. Mormonism was religion, Made in the USA. According to Smith the true church of Christ had been hijacked not long after Christ's death in what is called the "Great Apostasy." The building of the Vatican, Luther and the Reformation, indeed all Western history from circa 100 A.D. to 1832, when Joseph Smith was born, was one, long collective hallucination. Only with Smith's revelations was the true church restored. To prove its authenticity Smith's followers highlighted three things: Smith had direct, prophetic contact with God; he had restored the ancient priesthood, which dated back to Abraham and the Old Testament; most important of all, the Mormon church had a priceless historical document—a piece of supplementary scripture called the Book of Mormon.

Imagine a cross between Tolkien's *Lord of the Rings* and the most long-winded sermon you have ever heard—the phrase *and it came to pass* occurs more than two thousand times—and you have the Book of Mormon. Mark Twain called it "chloroform in print." But to the poor, uneducated people who flocked to Joseph Smith's banner, it offered a reassuring illusion, and a history lesson. One of the problems with traditional Christianity was that its founding myths were set in far-off places like Palestine, Egypt, and, later, Europe. The Bible offered plausible accounts of how the seed of Abraham had gotten from Jerusalem to, say, Dublin. But there was no mention of Sandusky, Ohio, or Palmyra, New York. America was a black hole on the fringes of the Christian cosmos peopled by dark-skinned "savages" for whose existence the Bible offered no explanation. If God had created America, as he created the Holy Land and Europe, why were the Apache and the Sioux not white? Why didn't they live

in houses, read the Bible, and pay taxes, as God-fearing men and women should?

Smith had always been fascinated by the Indian burial mounds surrounding the family homestead. As a child he had spun fantasies about a lost race that he believed was buried in the tumuli. "During our evening conversations Joseph would occasionally give us some of the most amusing recitals that could be imagined," his mother wrote in her *Biographical Sketches* of 1853. "He would describe the ancient inhabitants of this continent, their dress, mode of traveling, and the animals upon which they rode; their cities; their buildings, with every particular; their mode of warfare; and also their religious worship. This he would do with as much ease, seemingly, as if he had spent his whole life with them."

The Book of Mormon took this imaginary history and transformed it into a religious myth. Its most extravagant claim was that America had been settled by a proto-Mormon, Hebraic tribe around 2250 B.C. A second wave of immigrants from the Near East, the Nephites, settled here around 600 B.C. According to Mormon lore a descendant of the biblical patriarch Joseph, named Lehi, sailed to the New World via the Indian and Pacific oceans. Christ even visited America, after the resurrection. Jackson County, Missouri, is identified as the place where the Second Coming will occur.

In the pre-Columbian America imagined by Joseph Smith, good battles evil as the Nephites, who have remained true to the teachings of Christ, square off against a tribe known as the Lamanites. The Nephites are great culture builders, and Mormon scholars have expended huge amounts of time and effort trying to link Mayan civilization to the fictional heroes of Joseph Smith's narrative. Their written language was the one Smith would claim to find on the golden plates: reformed Egyptian. The Lamanites were the wicked descendants of Lehi, a craven, godless people who had turned their backs on God and been

cursed with a dark skin. These "red sons of Israel," as Smith called them, are today known as Native Americans.

According to the Book of Mormon the Lamanites fought the Nephites in an epic battle in 400 A.D. at a place called the Hill Cumorah in upstate New York. This was Smith's fantastic explanation for why there were no white Christians left in America when Columbus arrived. But as the battle raged, a valiant young man named Moroni, who was the son of the leading Nephite general, Mormon, managed to hide a set of golden plates in a hillside. Fifteen centuries later this revelation of Christ's true church would be revealed to a poor, illiterate white farm boy from Palmyra named Joseph Smith.

There is no archaeological evidence to support any of these claims. DNA evidence has proved a connection between Native Americans and Asia, but none to the Near East. But despite this, every year tens of thousands of Mormons from all over the world make the trek to the Hill Cumorah to watch a spectacular theatrical reenactment of the battle.

Not surprisingly, at the outset Smith's new religion faced something of a credibility problem. Most Americans regarded it in much the same way as they today regard the Raliens, or the Moonies. From its beginnings on the wild, lawless frontier, where guns talked louder than words, Mormonism was also steeped in violence. Schisms within the church left a trail of blood. Assassination and violence were common. Most infamous were the Danites, or "Avenging Angels," a secret society pledged to exterminating the enemies of the new religion. The most controversial aspect of Mormonism, however, was that it sanctioned polygamy.

Joseph Smith had what we would call today a sex addiction. As far back as 1830, when he was twenty-five, he had to beat a hasty retreat from Harmony, Pennsylvania, when his wife's cousin, Hiel Lewis, accused him of "improper conduct." Another woman, Mary Elizabeth Rollins Lightner, claimed that he tried to seduce her when she was twelve. Smith used a standard

chat-up line: that God had commanded him in a vision to take her as his plural wife. He was to have many more such visions, and by the time he was murdered in 1844, he had formed "celestial marriages" with an estimated forty-one women. He seems to have been particularly fond of nubile teenagers. Typically Smith would ask his close friends for their wives or daughters, using threats and religious blandishments to get his way. It was simultaneously a test of loyalty and a way of forging a primitive, tribal form of solidarity. By impregnating his friends' wives and daughters he could ensure that, even at a genetic level, they were united. By 1842–3, when he was thirty-seven, this semiliterate farm boy from Vermont had become the patriarch of a large colony in Nauvoo, Illinois. The tents and lean-tos of the earliest followers had been replaced by fifteen hundred log cabins and more than three hundred brick buildings (including shops and a Masonic lodge). In one of them Smith opened a general store. Goods were bought on credit and never paid for. And in 1842 Smith adopted the remedy of all scoundrels: he declared bankruptcy.

One teenager, Lucy Walker, whom Smith had taken into his house after her mother had died—and after he had sent her father off on a mission—left a pitiful record of what it was like to be chosen by God to be one of Smith's concubines. "No mother to council; no father to tell me what to do, in this trying hour," she wrote. "Oh, let this bitter cup pass. And thus I prayed in the agony of my soul." Nancy Rigdon, one of the few women brave enough to refuse Smith's advances, described how, in 1842, he forced her into a private room at a printing office and propositioned her. Only when she threatened to scream the house down did he unlock the door.

Among the women Smith forced into bed were four pairs of sisters and a mother-daughter pair. His youngest child-bride was fourteen. When he tried to seduce a sixteen-year-old in Kirtland, Ohio, a mob tried to castrate Smith, but the doctor refused to perform the operation. Through all this Emma Smith,

the Prophet's wife, stood by her man: and suffered. Occasionally she rebelled. When, in 1842, Smith brought a woman named Eliza Snow into the family home, Emma is reputed to have kicked her down the stairs into the snow. To keep her in line, as he did with other women, Smith used threats. "If she will not abide this commandment she shall be destroyed," he wrote bluntly.

By 1844 Smith's megalomania had reached its apex. He announced that he would run for president. He declared himself "King, Priest, and Ruler over Israel on Earth" and predicted that all the governments of the world, including that of the United States, would eventually give way to "the government of God," a New World Order with Joseph Smith as its head. By then the Mormon colony at Nauvoo had begun to feel like Waco, Texas, a hundred and fifty years later. There were charges and countercharges of immorality and wife stealing. The "Avenging Angels," whom Sir Arthur Conan Doyle would portray in his story *A Study in Scarlet*, rode through the countryside bullying and intimidating, and sometimes murdering, dissenters. The economy was collapsing.

Smith died in spectacular, Wild West fashion. In June 1844, as he and his brother, Hyram, sat in a jailhouse in Carthage, Illinois, an armed mob broke in and began firing. Smith had a sixshooter, which had been smuggled in to him the day before, and he began firing back. A bullet struck him from behind. Going to the window, Smith looked down on the angry mob. "Is there no help for the widow's son?" he cried, uttering the Masonic sign of distress, then jumped from the window. He landed on his shoulder, tried to roll away but was cornered against the edge of a well and quickly surrounded. As he lay bleeding to death, four men stepped forward and discharged their guns into him. Another drew a bowie knife to cut off his head. According to Mormon lore his hand was stilled by a pillar of light.

Mark Hofmann was fascinated by Joseph Smith, though not for the reasons that the Mormon Church would have liked. To him Smith was a con man and master manipulator who used

magic and forgery to hoodwink the gullible into believing he was a prophet. The two men had other things in common. Both had been clever, inventive children. Both were drawn to magic and the occult. Both liked money but were not good at handling it. Both would live out that most appealing of American destinies: the outlaw.

He was born Mark William Hofmann on December 7, 1954, into a devout Mormon family of Swiss-German descent. His father, William "Bill" Hofmann, was a child of the Depression, a first-generation American who had emigrated from Zurich, Switzerland, with his parents, shortly after his birth. William's own father, Karl Edward Hofmann, was a German-born architect who served in Bismarck's medical corps in World War I. When a shell exploded by him, it wounded his leg so severely that it had to be amputated. Prussian discipline, and the Mormon faith to which he and his Swiss wife, Margrethe Albisser, had converted, stanched the pain and helped him through. And in 1928 he traded the historic streets of Zurich for a life in the New World on the salt flats of Utah.

With the family's baggage came a Teutonic devotion to discipline, hard work, and obedience to authority, something that was further enforced by the strict, authoritarian codes of the Mormon faith. Karl Edward Hofmann was the family patriarch. Every morning the family knelt in a circle to pray. Dissent was not tolerated. Emotions were stifled and repressed. *Sauberkeit* and *Arbeit*, cleanliness and work, the twin carburetors of the German soul, ensured that the family prospered. Hofmann's grandmother kept a cow in the garden, grew vegetables, made clothes for the family, and amply fulfilled her biological duties as a good Mormon mother by bearing her husband twelve healthy children. Mark Hofmann's father, Bill, was number eight.

Bill Hofmann built his life on self-sacrifice and discipline. He married Lucille Sears, the youngest of ten children, two years after the end of World War II, at the age of nineteen. There was no honeymoon. Instead he left his eighteen-year-old bride, Lucille,

in Utah while he went to Europe for three years to serve on a mission. Back in the Great Salt Basin he worked as a mortician at Evans and Early Mortuary and later as a sales representative for a copying and printing manufacturer. In his spare time he served as a "temple worker," assisting church members in performing rites for the dead. These rituals, whose content is a closely guarded secret but which, like many others, owe much to Masonic ritual, were a constant reminder of the dangers of heresy. Mormons believe in collective punishment. Acts that flout church law by one family member can spoil the chances of eternal life for all.

In a photograph taken in the Utah desert during a hike with his Scout troop at the age of twelve, Mark Hofmann stands in the center of a group of boys. It is one of those photographs that parents treasure: a moment of summer innocence that will never come again. The boys are all smiling, their eyes squinting in the bright desert sunlight. Hofmann stands center-stage, in a plaid shirt, his dark hair parted from left to right, the arm of the boy behind him draped affectionately over his shoulder. Next to him stands his best friend, Jeff Salt, a tall, gangly boy with blond hair and an open, sunny expression. But it is Hofmann, with his dark, mercurial good looks and confident, quizzical expression, who draws one's attention. At any moment, it seems, he will step forward and address the camera.

I had that image in mind as I pulled up in front of the low, ranch-style house on Marie Avenue, a quiet cul-de-sac in the eastern suburbs of Salt Lake City, where Hofmann grew up and would later live with his own family. The house, a long, low ranch house with a carport and a neatly trimmed lawn, breathed solid suburban values. Farther up the street a boy ran out into the garden to toss a baseball into the air as his mother bent over the first daffodils. The Stars and Stripes flapped from a flagpole.

When Hofmann had lived here as a child, his parents hung a wooden sign from the porch. On it was written, in Germanic script, the words *Haus Hofmann*. Like all first-generation Americans they desperately wanted their son to succeed. The young

Mark seemed to be a model Mormon. He was a bright, highly imaginative child. He did well at school, attended Sunday services, and was able to recite large portions of the Book of Mormon from memory. He did not care much about his appearance. At Olympus High School he was remembered as a skinny kid with a calculator on his belt, who wore glasses, old tennis shoes, and ragged blue jeans that were too short for him. But his mother and father had high hopes for him. One day, they thought, perhaps he might even become a leader of the Church of Latter-Day Saints.

But there was another side to their precocious son. Hofmann loved magic tricks and would work hard at getting them right before performing them for his sisters, friends, and family. He was especially fascinated by card tricks. His parents disapproved of playing cards, so Hofmann would visit his cousin, Mike Wooley, and play at his house with Wooley's grandmother. On one occasion the three of them played late into the night. Hofmann won hand after hand, and though his cousin knew he was cheating, he could not work out how. Hofmann later claimed that he had won by watching the cards reflected in his own thumbnail.

He was also attracted to chemistry and spent hours in the basement of the house on Marie Avenue conducting experiments with chemicals he bought at a local pharmacy. He was particularly fascinated by gunpowder, which he had been making since elementary school from a recipe culled from the *World Book Encyclopedia*. Having bought supplies of sulfur, saltpeter, and charcoal (Hofmann's favorite brand was Perfect Chemicals), he set about making as much noise and smoke as he could. On one occasion he and a friend packed gunpowder into a Sterno can that they planned to explode in the schoolyard. They never did set it off, but on another occasion Hofmann constructed a homemade cannon out of a length of pipe, using some extension cord as an ignition system, and he and a friend roamed through the woods taking potshots at squirrels. He used dry ice to make bottles ex-

plode. He loved setting off firecrackers and cherry bombs. There was nothing particularly unusual about this in Utah. Guns and ammunition are common household items. What was unusual was the daring and intensity with which the young Mark Hofmann acted out his pyrotechnic passions. When some chemicals he was playing with ignited, setting his shirt on fire, the twelve-year-old Hofmann was rushed to hospital with a serious burn to his neck. The burn would require skin grafts, leaving him scarred for life.

During his convalescence Hofmann began avidly collecting historic Mormon coins and, at the age of fourteen, he made a discovery that would change his life. He had become interested in electroplating, which is the process that coats a thin layer of metal over a coin. Not thinking about the consequences at the time, he decided to forge a coin. Using a simple electroplating procedure, he changed the mint mark on the coin from the letter C to D. By doing so Hofmann had transformed a worthless coin into a rare coin, worth thousands of dollars. He took the coin to a coin dealer in Salt Lake City, who sent it to the U.S. Treasury Department. They pronounced it genuine.

For the fourteen-year-old Mark Hofmann it was a life-transforming event. The adult world, which had seemed so powerful and infallible, was shown to be neither of those things. The experience also showed Hofmann that most people, unless they have strong evidence to the contrary, are extremely trusting. Above all, it taught him how thin is the membrane separating the real from the fraudulent. Value, he instinctively understood, is not absolute, but relative. Ultimately it depends on an agreed set of assumptions. *Credit*, it is worth noting, derives from the Latin word *credere*, to believe. If no less an authority than the U.S. Treasury believed the coin he had altered was genuine, then surely, in a sense, it was. Soon after this Hofmann printed up a business card. Under the words *Mark's Mint Mistakes* Hofmann offered his services as an authenticator of coins.

He was, by nature, a logical person who looked at the world

around him through a lens of critical thinking. That's why he liked chemistry and mathematics. That's why he believed in Darwinism. They were rational systems of thought that he could believe in and trust. It is also why he liked chess. But as he grew older, he came to realize that the city he lived in had been built on a grand illusion and that the boundaries between fact and fiction, truth and illusion, were blurred and constantly shifting.

By his mid-teens Hofmann had ceased to be a believer. Yet in Haus Hofmann no word of criticism or doubt could be voiced. Soon relations between the young Hofmann and his father were deteriorating. Like all teenage boys Hofmann desperately needed to have a dialogue with his father. His father responded with a wall of silence. This caused Hofmann to lose respect for him. He began to see his father as the victim of a grand deception, and his devotion to the LDS church as a sign not of strength but of weakness. He took pleasure in provoking him, raising controversial subjects at the dinner table that he knew would upset his father. "I brought up evolution at the dinner table last night," he told his best friend, Jeff Salt, as they walked to school one day. It was fun to push his father's buttons and watch him lose his composure. It gave him a sense of power.

In his novel *The Counterfeiters* the French writer André Gide describes how a group of privileged Parisian youths express their contempt for society by setting up a counterfeiting cooperation. The fake coins they sell to the public are the outward expression of what Gide calls the "forced and counterfeit emotions" their upbringing has required them to feel. In a similar fashion Mark Hofmann became a distorted mirror image of Mormon culture.

Like all Mormon children Hofmann learned early on to keep secrets, which is why many of the best FBI agents are recruited from the LDS church. They have it drummed into them that only through participation in temple rituals will they earn a passage to the Celestial Kingdom. Those rituals, particularly the ones surrounding baptism and death, must remain a closely guarded

secret, however. Mormons also learn from an early age to recognize each other by means of a series of signs and symbols known only to them.

Hofmann drew on this early training in secrecy to keep his gathering agnosticism hidden. For the sake of appearances, and so as not to disappoint his parents, he was manipulated into pretending a faith that he no longer had. He had to stand up at his local ward house and swear to the truth of the Book of Mormon, when he believed it was a work of fiction. In so doing he was learning the most damaging lesson a child can learn: that it was dangerous to express what he thought and felt. If he voiced his doubts about Mormon theology, if he talked about evolution or philosophy, his parents would withdraw their love. Only when he was pretending was he worthy of their love. He learned to mask and conceal his true feelings and beliefs. He went underground and began to live a double life. This generated enormous internal confusion and a deep-seated anger at his parents and the culture they represented. That anger was only intensified when, at the age of nineteen, he was forced to go on a mission to England to convert other people to a faith he believed was a lie.

To go on a mission is one of the central rites of passage in a Mormon's life. Among some African tribes boys are separated from their mothers at the age of fourteen and sent into the bush, where they learn to become warriors. Similarly, young Mormon men are taken from their families and sent out into the world to become warriors for God. Every year some forty thousand young Mormon men between the ages of eighteen and twenty-one (Mormon girls are not encouraged to go on missions) are dispatched to places as far afield as Zimbabwe or Russia, France or Taiwan. For two years they have no contact with their families, except by letter. They live under the closest supervision. They will never be allowed to travel alone. All contact with the opposite sex is forbidden. When they are not out in the field winning converts, they are subjected to an intensive program of religious and moral education.

Boys are subjected to intense emotional and psychological pressure by their parents to go on a mission. This is as much because of its spiritual and educational value as for its social and economic benefits. Just as it is almost impossible for a Chinese student who is not a member of the Communist party to rise to the pinnacle of power in the People's Republic, promotion through the ranks of this intensely stratified and hierarchical society is made much harder for any young man who does not take up the call. To not go on a mission is regarded as a failure of commitment to the church and a poor reflection on your parents.

Mark Hofmann did not want to go on a mission, but a family legacy of self-sacrifice, discipline, and religious devotion stretching back three generations ensured that his wishes would not be heard. In a photograph taken at the airport just before Hofmann left for Bristol, a university city in the southwest of England, he looks away from the camera, an ironic smile on his face. Gone is the lightness and innocence of boyhood. The face is lean and angular, the pitch-black hair cropped. The dark eyes, under hooded lids, seem bruised and shadowed.

Before he left Salt Lake City, Hofmann took part in what is known as the Endowment ceremony. It was held in the basement of the temple. Naked, except for a white sheet covering his body, Hofmann waited in line with several hundred other young Mormons to enter a small cubiclelike room, similar to a shower stall. Inside the cubicle two elders from the church anointed him with water from a font. Then, as one of the temple workers intoned a blessing, the other reached forward and touched his head and his lips, to give him the power of thought and speech, then reached inside the sheet covering his body and touched his groin, to endow him with the power of reproduction. The ritual was repeated, using oil instead of water.

Hofmann was then handed a set of ritual underwear. Of all the sacrifices that young Mormon men are asked to make for their religion, relinquishing the chance of ever being able to

walk into the Gap and buy a pair of blue, dolphin-covered boxers or Calvin Klein briefs may not be one of the biggest. But it cannot be much fun knowing that for the rest of your life you will have to wear a shapeless white cotton undershirt and a pair of knee-length, white cotton drawers. Until recently, women had to wear a lumpy, one-piece white cotton slip. Because of the prevalence of pants, however, even among Mormon women, they now wear a thin white camisolelike top set off by a pair of white cotton bloomers.

Both the men's and the women's undergarments are decorated with symbols taken from Freemasonry. Smith was deeply involved with Freemasonry and used many of its rituals and symbols when he created his religion. The tops of Mormon undergarments have the letters *V* and *L* stitched over the breast area, signifying the compass and square of the Masons and a horizontal stitch at the right knee, which is meant to help them walk upright in the faith. The women's bloomers have the same stitch at the navel to symbolize fertility. One of the most important promises Mormons make is never to reveal the promises they have made, or any other part of temple ritual, even to their family and spouses. Another is to wear their ritual underwear at all times, except when showering or bathing, for the rest of their lives. Strict Mormons do not even take off their kit when they make love.

Wearing special underwear is just one of many ways that Mormons bond together and differentiate themselves from non-Mormons. Another is a secret handshake known as "the sure nail of the cross." The name refers to the Bible story that, to stop Christ from slipping on the cross, two nails were also hammered through his wrists. The handshake is like a claw grip. Keeping your fingers spread, you grasp the other person's hand and as you do so you touch the main artery in their wrist with your middle finger. The handshake is a Mormon's admission ticket to heaven. According to Mormon scripture, when believers arrive

at the pearly gates, God will reach out his hand and ask them to perform the secret handshake. If they cannot, they will be barred from entering.

Mark Hofmann was tested on the secret handshake at the end of the Endowment ceremony. By then he was standing on the stage in the temple's main auditorium with several hundred other young Mormons, dressed in a white outfit rather like a jumpsuit, with a pair of white moccasins on his feet. From his waist hung a green apron decorated with fig leaves, symbolizing the story of Adam and Eve. On his head he wore a floppy white cotton hat.

Hofmann regarded the whole ceremony as a joke and deeply resented being forced to take part in it. The test on the secret handshake was the most ludicrous part of the ceremony. Across the stage a curtain had been hung, with holes cut into it at waist level. When his turn came, Hofmann had to walk forward and reach his hands through the hole. On the other side a male temple worker, pretending to be God, grasped his hands. As he gave the handshake, Hofmann had to repeat a secret password: "Health in the navel, marrow in the bone, blessing on my posterity for time and all eternity." He was then ushered through the curtain. It was meant to symbolize his passage to the Celestial Kingdom. When he saw the bank managers and shopkeepers, the petty-minded, self-righteous church officials with their stern, humorless faces, some of whom he knew had beaten their children senseless, all in the name of God, standing there shaking hands through a hole in a curtain in their ridiculous outfits, Hofmann prayed that he would never ever make it to the Celestial Kingdom. It was bad enough having to live with these zealots and hypocrites in the Utah desert, let alone spend all eternity with them.

A few days later he touched down at London's Heathrow Airport. For a nineteen-year-old Mormon from Utah, England's liberal, secular values must have been both disquieting and exhilarating. The Beatles had broken up, Hendrix was dead, but

love and peace were still very much in the air. Students wore bell-bottom jeans and caftans; smoked pot and ardently discussed the writings of Gurdjieff or the latest episode of *Monty Python's Flying Circus*. Sex was on everybody's mind. In comparison with the uptight, rigidly conformist society he came from, where women have to wear special underwear to hide their sexuality, it must have felt like another planet.

Outwardly Hofmann played the role required of him in England. He read the Book of Mormon. He tramped the streets knocking on doors. Inwardly everything was beginning to slide in the opposite direction. The fractures and splits that had begun to open up in his personality were growing wider, like cracks in the desert after rain. A colleague on his mission in England remembers him weeping as he bore testimony to the truthfulness of Mormonism. The tears were almost certainly fake.

What little spare time he had he spent browsing in secondhand bookstores, above all those specializing in religion and the occult. He circulated a handwritten "Books Wanted" list to the city's secondhand bookstores, with a note promising to pay "top price" for anything they found. At the top of the list were books on Mormonism published before 1900, "pro or anti," and anything on Freemasonry and magic. Both are highly contentious subjects for the Mormon Church, which has since its beginnings been accused of being little more than a revamped version of Freemasonry. Other items included *Tertullion Opera* (Paris 1844) and *Socrates Ecclesiasticus* (Paris 1686).

While in Bristol he almost certainly acquired for the first time two of the most famous anti-Mormon tracts, William Jarman's *Hell on Earth* and Fawn Brodie's critical biography of Joseph Smith, *No Man Knows My History*. Brodie was a respected historian who went on to write books on Nixon and Jefferson. But her account of Joseph Smith, which was published shortly after the Second World War, caused her to be excommunicated from the Mormon Church. Instead of the milquetoast figure of Mormon hagiography, Joseph Smith strides out of the pages of Brodie's

book as a charismatic outlaw with the looks of Clint Eastwood and a conjuror's ability to mesmerize his public and talk his way out of the tightest corner.

Here Hofmann would have read for the first time the story of how Martin Harris and the two other scribes of the Book of Mormon, Oliver Cowdrey and David Whitmer, had signed a document claiming that they had actually seen the golden plates. The viewing is supposed to have taken place in a grove of trees near the Whitmer home, in Fayette, New York. According to Smith's account an angel appeared in the sky holding the golden plates. It was even claimed that the men were allowed to turn over and inspect individual leaves of the golden bible. However, when Harris was interviewed by a Palmyra lawyer, he said that he had only "seen" them with what he called "the eye of faith," and that the golden plates were covered with a cloth. On a later occasion Smith allowed a group of "witnesses" to peep inside a wooden box where, he claimed, the plates were secreted. When they said they could not see anything, he berated them with their lack of faith. After two hours of repetitive prayer, which had the effect of putting them in a trance, the group finally declared that they had indeed seen the plates. What actually seems to have happened on both occasions is that Joseph Smith used the power of suggestion to convince people that they had seen something they had not.

In Brodie's book he would have also found vivid examples of Smith's storytelling abilities. On a journey across Illinois in 1834 the prophet dug up a skeleton from an Indian mound. The thighbone was broken, and there were signs of an arrow wound to the ribs. Holding up the bones, Smith launched into story about the dead man. He told his followers that he was a white Lamanite named Zelf, a warrior and chieftain, who at some point in his life had had what Smith called "the curse of the red skin" taken from him. He even gave a detailed description of the battle in which Zelf had fallen. The story had clearly been well rehearsed and

was completely bogus. But Smith's followers eagerly gathered up the bones of the fictitious Zelf as holy relics.

During his stay in Bristol, Hofmann kept notes in a spiral-bound notebook. Looking at these ink jottings it is hard to believe that he would go on to become the most skilled literary forger of all time. The handwriting is a barely legible chicken-scratch. Some words hang down below the line. Others rise up at the end, as though they are about to lift off the page. Each letter is printed individually, as children write. No letter is ever written in quite the same way. One *d* slopes forward, like a drunk on the deck of a storm-tossed ship. Another stands soberly upright. One has a loop in the upward stroke. Another does not. And there are numerous misspellings: *artical* for *article; happieness* for *happiness; baptisims* for *baptisms.* "Don't teach negros," writes Hofmann in one place, revealing the entrenched racism of the Mormon Church, which until 1978 banned people of color from joining the priesthood.

The notebook provides a fascinating insight into Hofmann's daily life. Everything, from the time he has to get up to the number of Bibles he has to distribute to the lectures he has attended, is meticulously recorded. In a set of notes taken at a lecture in December 1974, he writes down the key teachings of Stephen R. Covey, a Mormon writer whose book *The Seven Habits of Highly Effective People* would become an international bestseller. At the time he was teaching organizational behavior at Brigham Young University in Provo, Utah. Later, Covey would go on to found the Covey Leadership Center. Today, he lives in an imposing white villa on the side of a mountain above Provo. His lectures command fees of up to $100,000.

Control and obedience to authority are the twin pillars of Covey's gospel of leadership, as they are of the Mormon faith. Men should lead families. Wives should obey their husbands. Children should obey their parents. Everyone should obey God. "Disobedience never was happiness," writes Hofmann at the end of a lecture he attended in the Welsh city of Swansea,

in October 1974. Elsewhere, Hofmann noted catchy Coveyisms like "You have to meet their wants before you can meet their needs" or "You can change your emotions by controlling your actions and thinking."

Hofmann was learning to be a highly effective person. In a note written toward the end of his stay in England he observed: "We have the power to control all things by controlling our behavior and actions." But what his Mormon colleagues did not know was that he was internalizing these lessons about power and control for quite other purposes. And soon he would turn them against the very people who had taught him.

One of the lectures he attended in Bristol was entitled "Integrity." Having listed its key features—obedience, incorruptibility, and completeness—Hofmann jotted down a few ideas about how to attain it. At the top of the list are the words "Don't tell small lies." A few days later, in a secondhand bookshop on Christmas Steps, a historic stairway in the center of Bristol, he came across a 1688 King James Bible. He bought the Bible and tucked it away among his belongings. Six years later, on the other side of the Atlantic, this Bible would help Mark Hofmann gain the confidence of the men who ran the church he wanted to expose.

The Forger and His Mark

*O*n his return from England, Hofmann enrolled at Utah State University in the town of Logan, which is a two-and-a-half-hour drive north of Salt Lake City. Perched on a hill above a fertile valley surrounded by snowcapped peaks, Logan lies at the bottom of one of Utah's most remote canyons, Cache Canyon. A photograph of Hofmann taken in 1976 when he was twenty-two shows him standing outside the door of the apartment he rented in Logan with his best friend Jeff Salt. Salt leans against the wall with his hands in his pockets. Hofmann, dressed in a down jacket and open-necked shirt, his hair now worn long, poses for the camera as he makes a peace sign. Compared to the prim-and-proper students at Brigham Young, these two look like wannabe beat poets.

By choosing Utah State rather than Brigham Young University, a college with close historical ties to the Mormon Church, Hofmann was not only putting physical distance between himself and his parents, but also taking another step in his disengagement from the culture into which he had been born. His faith in the Mormon religion was further eroded by his study of biology and psychology. In the theories of Charles Darwin, the

British naturalist who had first formulated the theory of evolution, Hofmann found the objective correlative of his inner world. Darwin had observed animals in the wild and come to the conclusion that the force driving life on earth is the competition between species. The creationism Hofmann had grown up believing in was replaced by a coldly determinist philosophy based on Darwin's theories of evolution. Hofmann's favorite TV programs were nature documentaries showing animals caught in the struggle for survival. Where was God when the wolf hamstrung an elk calf and bit through its jugular vein? Where was God when the lion made its kill?

It was no different on the streets of America. Under all the fun and frivolity, the amusement parks and the shopping malls, Hofmann saw that it was a cruel place. Ministers might preach ethics from the pulpit. Politicians might make florid speeches about the rights of man and the injustice of poverty. But America had never been organized around ethical principles. It was and always had been ruled by the almighty dollar. The Mormon Church might preach the essential goodness of man. They even claimed that God was himself a man, yet all around him Hofmann saw that man was not noble or good. The world was not driven by altruism and love, but by greed and selfishness. Utah, for instance, had a long tradition of scams and frauds. One of the most famous—in which a group of church members set up a phony diamond investment scheme and walked away with the life savings of hundreds of their fellow Mormons—had taken place when Hofmann was a child. Man was not made in the image of God. He was a predator and opportunist. God was an illusion; a bad cosmic joke; a hoax.

Hofmann's deepening alienation from the culture of Mormonism was intensified by his discovery of a family secret. Polygamy, or "celestial marriage," as the Mormons call it, has always been the hottest of hot-button issues for the LDS church. In the nineteenth century, newspapers and magazines referred to the Mormons as "Satanic" and "evil." When Ann Eliza Webb

Young's book, *Wife No. 19; or, The Story of a Life in Bondage*, was published in the late nineteenth century, her descriptions of an enforced plural marriage to Brigham Young, Mormonism's second Prophet, provoked visceral feelings of outrage. U.S. government marshals conducted armed antipolygamy raids into Utah.

Polygamy was finally outlawed by the LDS church in 1890 under what is known as the Second Manifesto. But polygamous marriages, unsanctioned by the church yet tolerated, continued to be celebrated. One of these clandestine marriages involved Mark Hofmann's maternal grandmother, Athelia Call. Born in Wyoming, the second daughter of nine children, she had been raised in a polygamous family, which had fled to Mexico to avoid raids by federal marshals. In 1906 she met a young Mormon named William Sears, who was visiting Mexico from the States with his wife. The marriage was childless. So he decided to take eighteen-year-old Athelia Call as his second wife. The threesome returned to Arizona, where William Sears owned a store. Athelia faithfully bore her husband eleven children. One of them was Mark Hofmann's mother, Lucille, who was born in 1929.

Athelia Call's polygamous marriage had been officially sanctioned by the church but, because of the secrecy surrounding polygamy, had never been publicly acknowledged. In the Hofmann family the subject was taboo. A friend of Hofmann's grandmother had been excommunicated for talking about her own polygamous marriage, and Hofmann's mother, Lucille, refused to discuss the subject publicly, for fear of incurring a similar fate.

Hofmann had a particularly close relationship with his mother, and it troubled him that she had been forced to conceal her past. The story of his grandmother's marriage began to fester in him like a wound. The Church asked people to believe in gold plates and angels, they demanded obedience to myths and stories that had no basis in historical fact, but they demanded the suppression of the truth about his own family history.

Hofmann became obsessed with finding out that truth. He ransacked the University of Utah library's special collections, searching through diaries and old newspapers for information about his grandmother's marriage and the history of polygamy. He read anti-Mormon books and tracts that he kept under his bed in the apartment he rented in Logan. He talked obsessively with his friends about the subject and made repeated efforts to talk to his parents.

The wall of silence he encountered turned his agnosticism to contempt. He began to despise everything the Mormon Church stood for: its hypocrisy and repressiveness, its manipulation of history. Like Winston, the hero of George Orwell's *1984*, he felt trapped in an authoritarian society where illusion was truth and truth was illusion. The internal tensions that had begun to build up in him spilled over into his outward behavior. Though he continued going to the temple and playing the good Mormon, at the same time a strong antisocial streak was becoming apparent. When he went to the supermarket, he exchanged labels on cheese and other items so that he could buy them for less. His relationship with his fiancée, Kate Reid, a fellow student at Logan, deteriorated. Twice during arguments Hofmann resorted to violence, hitting her and pushing her against a wall. At the age of twenty-four he broke off the engagement, telling her that he no longer believed in Mormonism. On the same day he wrote a seven-page, single-spaced letter to his mother.

"Dear Mom," it began, "During our Easter feast you gave it as your opinion that certain materials in the Church archives should not be made public because there exist certain faith-demoting facts that should not be known. While you may take comfort in knowing that this has been the traditional attitude of the leadership of the Church; you have expressed anxiety because I do not share this belief."

The letter is a plea for openness and honesty from a troubled young man. Using the example of his grandmother's enforced silence on her own marriage, he explained his alienation from a re-

ligion where freedom of inquiry and expression were forbidden. He told his mother that he had admitted having doubts about aspects of church doctrine to church officials, but that he had been told to forget them. He had then been interrogated about his personal life, as if his doubts and questions were symptoms of a personality disorder. "Academia teaches the student to be critical of everything including itself," he wrote. "The student is taught to accept nothing without first questioning. Mormonism, on the other hand, teaches that spiritual things are to be accepted on faith. . . . Indeed, I have talked to young church members who have the idea that thinking is a sin. I am learning at the university to think, investigate, read, and then form an opinion. The church, however, seems to be saying to me to ask the leaders and trust their answer. . . . Personal doubts and uncertainties are seen as temptations rather than as challenges to be explored and worked through. The individual's conscience and the weight of authority or public opinion are thus pitted against each other so that the individual either denies himself at the expense of personal honesty or hides from others and lives in two worlds."

These heartfelt, closely argued words could have been written by a young dissident in the Soviet Union or an American patriot struggling with his conscience in the run-up to the War of Independence. "The truth is the most important thing," wrote Hofmann at the end of the letter. "Our idea of reality should be consistent with it." He signed the letter, "With love, Mark."

Perhaps Hofmann knew that the letter would fall on deaf ears. Or perhaps he realized that it was already too late to try and change the way his mother and father thought. He never sent it. Instead, his thwarted desire to know the truth about his own family's origins, and the refusal of the church to acknowledge or discuss his doubts, led him to adopt falsehood as a way of life.

By this time Hofmann had dropped out of college. He had also begun to date the woman who would become his wife. Her

name was Doralee Olds. The middle child of five from a conventional Mormon family, she was intelligent, slightly naïve, and uncomplicated. Hofmann dazzled her with his intelligence and erudition, his quiet, almost hypnotic gaze, and his cornflower-blue eyes. In September 1979 they married in the Salt Lake temple. The bride and bridegroom wore white. As though to show his disregard for conventional gender roles, Hofmann pinned a pink rose to his lapel.

Six months later, in April 1980, Doralee Olds came home to their apartment in Logan to find Hofmann examining the pages of the 1688 King James Bible he had brought back from England. Several pages were stuck together, and Doralee watched with fascination as Hofmann pried them apart. Only much later would Doralee Olds come to understand that the man whose child she was already carrying was in the process of setting her up as a witness and alibi to the sensational discovery he was about to make. Between the pages of the Bible was what looked like a sheet of yellowing paper, repeatedly folded, and sealed at one edge by black adhesive. Hofmann removed it from the Bible. The glue prevented him from opening the letter, but by peering inside it Doralee Olds could just make out a signature. Apparently her husband had just found a document signed by Joseph Smith Jr., the Mormon prophet.

The next day Hofmann took the Bible to Jeff Simmonds, curator of Special Collections at Utah State University. When Simmonds pried the pages apart and opened the folded piece of paper stuck between them, he could hardly believe his eyes. Drawn in a spindly black hand was a series of strange hieroglyphiclike symbols. They were laid out in five vertical columns. At the bottom of the page, on the right-hand side, was an elaborate double circle filled with more symbols.

The Anthon Transcript, as it was known, was one of the key documents of the early Mormon Church. According to church history, in 1828, while Joseph Smith was dictating his translation of the Book of Mormon, he had given a sample of the "reformed

Egyptian" symbols he claimed to have found on the golden plates to his scribe, Martin Harris. Harris was a wealthy farmer from Palmyra, New York, who would go on to become a key early member of the Church. But like many people, at the outset he had doubts about Smith's veracity. Smith wrote some of the hieroglyphlike symbols on a piece of paper and gave them to Harris to take an eminent professor of Greek and Latin at Columbia University in New York, for authentication.

Exactly what Professor Charles Anthon said to him is not known. But when Harris returned from New York he was convinced that the hieroglyphics were genuine. Soon Dr. Anthon's expert "authentication" was being touted as "proof" of Mormonism's legitimacy. Anthon issued a scathing denial. In a sworn affidavit he stated that the piece of paper he had seen "consisted of all kinds of crooked characters disposed in columns. . . . Greek and Hebrew letters, crosses and flourishes, Roman letters inverted or placed sideways, were arranged in perpendicular columns, and the whole ended in a rude delineation of a circle divided into various compartments." Anthon's denial was forgotten, though, and the Transcript subsequently vanished.

New religions have always been especially susceptible to fraud and forgery. The rivalry between different branches of a faith, the need for proof to support the claims of a new religion, combined with a passionate desire to believe, produce an insatiable hunger for manuscripts and documents. The centuries after the death of Christ witnessed a surge of forgeries—notably, the "writings" of Dionysius the Areopagite, which, purporting to be the work of a contemporary of Saint Paul, were later exposed as the creations of a Greek philosopher, Proclus. It is still almost impossible to separate fact from fiction in studying the literature of this era.

Some of the first words a Mormon child learns to repeat are "I swear that the Book of Mormon is true." Yet the evidence to support that claim is thin. The gold plates have never been found, nor has Smith's original version of the Book of Mormon.

John the Baptist's cloak has obviously turned to dust. Isn't it odd, though, that a religion that is little more than a century old should have so few artifacts to support its claims?

Even while Joseph Smith was still alive, a newspaper reported that six bell-shaped brass plates had been unearthed near the town of Kinderhook, Illinois. The so-called Kinderhook Plates appeared to be embellished with ancient hieroglyphs, like the ones Smith claimed to have found on the golden plates. The Kinderhook Plates turned out to be a frontier-style hoax.

Hofmann would also have known the story of James Strang. After Joseph Smith's death in 1844 most Mormons chose to follow Brigham Young as their rightful leader. But others challenged his legitimacy, and none more defiantly than a man named James J. Strang. A handsome, charismatic convert, Strang had managed to convince most of Smith's inner circle of his leadership claim, including Smith's brother, William, his widowed mother, Lucy Mack Smith, and Martin Harris, the man who had acted as Smith's scribe during the translation of the golden plates. Strang claimed that he, too, had found some buried plates (in Burlington, Wisconsin). Like Hofmann, Strang was leading a double life. On the outside he was an ardent convert. Privately he had become a skeptic. In a coded diary entry in his journal he confessed that he had long since ceased to believe in the doctrines of the Church.

To support his claims Strang produced a letter that he claimed Smith had sent him before his death appointing him as his successor. It was a forgery. But the postmark was the wrong size and color, and Strang had inadvertently used two kinds of paper. He was exposed as a fraud. Later, he went on to found his own polygamous community on Beaver Island, Michigan—a Web site today asserts that their descendants are "the Original" Church of Jesus Christ of Latter-Day Saints—where he was murdered in 1856. Strang's death shows the depth of animosity felt toward the early Mormons by the rest of America. Prefiguring today's state-sanctioned assassinations, Strang was lured aboard

the U.S. steamer *Michigan*. As he was stepping onto the bridge, two assassins approached him from behind and shot him.

One of the most famous Mormon hoaxes of the twentieth century began in 1909 when a Utah geologist named James E. Talmage discovered what appeared to be an ancient clay tablet in a university in the Midwest. The tablet proved similar to others found near the Great Lakes, and the depictions on them appeared to confirm key aspects of the Book of Mormon. They were in fact fakes. So, too, were a dozen tiny gold plates that were supposedly unearthed in a tomb in Mexico in the 1960s. The inscriptions on what became known as the Padilla Plates resembled the hieroglyphs that Joseph Smith claimed to have found on the gold plates in Palmyra. Was this the longed-for proof of Hebraic settlements in the Americas? Some similar inscriptions that turned up in 1976 suggested it might be. On closer examination the mysterious squiggles and circles turned out to be the branding patterns used by Utah cattle ranchers.

By chance, while Hofmann was in England serving on his mission, he had come across two other Mormon hoaxes. One involved an Englishman named William Saunders Parrot. In the nineteenth century Parrot had sought to dissuade people from joining the church. Posing as a Mormon, he had fashioned six brass plates and a pair of spectacles set in brass: the Urim and Thummim of Mormon lore. He had then taken these artifacts to Salt Lake City to expose Joseph Smith as a fraud. In 1975 his daughter, Phyllis Parrott, had donated the fake brass plates, and two anti-Mormon pamphlets written by her father, to the Bath library, where Hofmann secretly photographed them, using a miniature camera.

Just before Hofmann left England to return to Salt Lake City, another set of brass plates and magical spectacles turned up in London. They belonged to an unemployed man named Bert Fuchs. Fuchs told a group of visiting Mormon missionaries that his grandfather had brought the plates from South America,

where many Mormons still believe there were Hebraic settle-
ments long before Christ. The plates weighed about 150 pounds
and were bound by rings, just as Joseph Smith had described the
gold plates in the Book of Mormon. There was even an orna-
mental jeweled sword hilt to go with them. The artifacts were
shipped to Utah for inspection, and Bert Fuchs began a new life
in Zion, where he was received with open arms by some of the
highest-ranking officials in the Church. But when it was discov-
ered that the jewels in the hilt of the sword were glass, and the
plates were forgeries, Burt Fuchs's sojourn in the Promised Land
came to an abrupt end: he was excommunicated.

Despite these hoaxes and frauds, the lack of any solid his-
torical evidence to support many of Joseph Smith's claims con-
tinued to make the LDS church eager to acquire what were
known as "faith-promoting" documents. The Anthon Transcript,
if it were genuine, would be a faith-promoting document of the
highest order. It was like the Vatican discovering a piece of Jesus'
shroud. For the first time Mormons could actually see what their
prophet, Joseph Smith, had seen when he looked at the gold
plates. Within days Hofmann found himself being ushered into
the august presence of Gordon B. Hinckley, who is today presi-
dent of the Mormon Church.

The Mormon Church is organized in a series of hierarchical
pyramids leading to what is known as the First Presidency. This
consists of three men: the president, and two councilors chosen
for their loyalty and devotion. The term *president* is mislead-
ing. Not even the pope enjoys the absolute power and authority
invested in the head of the Mormon Church. As "Prophet,
Seer, and Revelator" he is regarded as the direct representative
of God on earth. Below the First Presidency is the Quorum of
the Twelve Apostles. Combined, these fifteen men exercise al-
most absolute control over an organization that, with more than
twelve million members, is today the fastest-growing religion in
the world.

Below the fifteen men of the First Presidency and the Quorum

come tier after tier of officials, arranged in an ever-descending pyramid of influence. At the bottom of the pyramid are the "stakes" and "wards" (according to the Book of Mormon, Christ coined the term *stake*, which refers to the poles that held up the sacred tabernacle in biblical Israel, during his visit to America). These local community organizations are the eyes and ears of the Church, funneling reports of disobedience and dissent up through the system in much the same way that local party officials in Communist China keep tabs on local neighborhoods. Acts of dissent, or failure to pay the ten-percent tithe that is the foundation of the Church's wealth, are recorded on a database housed in the First Presidency (the practice goes back to a decree by Joseph Smith that "abuses" and "libelous publications" should be documented). A well-oiled public relations machine aggressively controls the flow of information.

At the time that the Anthon Transcript was discovered, Gordon B. Hinckley was the second counselor to the President and the godfather of Mormon publicity. He began his career as the head of the Church Radio, Publicity, and Mission Literature Committee. Eventually, he was overseeing all relations with the media. Born on June 23, 1910, he was also an ambitious, hardworking member of the Council of Twelve Apostles, the body of officials immediately below the First Presidency. Indeed, since 1979, when a blood clot on the brain had nearly killed President Spencer W. Kimball, he had effectively been running the Church.

Hinckley was the quintessential Mormon, with a picture-book family of five children, twenty-five grandchildren, and eighteen great-grandchildren. He arrived at his office every day at 7:00 A.M. and rarely left before 6:00 P.M., his briefcase stuffed full of papers to work on at home. He exercised nightly on a treadmill, optimizing his time by simultaneously watching the *News Hour with Jim Lehrer*. Like all Mormons he refrained from smoking and drinking coffee and alcohol.

But he had one weakness: his driving ambition. At the time

that he became entangled with Hofmann, Hinckley was oversee-
ing the greatest expansion of the Mormon Church in its history.
In the 1970s just four new temples had been dedicated. In the
next decade there were twenty-six. The moving force behind
this dramatic expansion was Hinckley. When he was not in Salt
Lake City—negotiations with Hofmann were interrupted at one
point because he had to fly to the former East Germany—
Hinckley was traveling tirelessly around the world, opening
temples in places as far afield as Samoa and Chile. If the Anthon
Transcript were genuine, it would be the most powerful proof of
the truth of the Mormon religion the world had ever seen. It
would generate headlines. It would bring in thousands of new
converts.

Hofmann's hardest task in creating the forgery was to make
it appear as though this was the original, ur-version of the An-
thon Transcript. He had recently been reading about how analy-
sis of the internal consistency of the language of Shakespeare's
plays could be used to determine which version of a text was the
one that Shakespeare had actually written, and which had been
corrupted during the transcription process. He now applied
what he had learned to the Anthon Transcript.

Though the original of the Anthon Transcript had disap-
peared, a copy had been made by a friend of Martin Harris and
Joseph Smith's. His name was David Whitmer, and this version
became known as the Whitmer Transcript. The hieroglyphs in
the Whitmer version were arranged horizontally, from left to
right. Hofmann arranged them vertically. He also embellished
the hieroglyphs, adding details that did not appear in the other
versions. He realized that if the Whitmer Transcript and the
other known versions of the document were copies of an origi-
nal, there would have been a gradual degeneration in detail and
accuracy. So, where the Whitmer Transcript showed a small
flourish on the letter *V*, Hofmann created a much bigger one. He
also included symbols described by Dr. Anthon but not present
in the other versions. One resembled the circle surrounding the

signs of the zodiac. When experts from the LDS examined the document, they cited this double circle as proof that the document must be genuine. Hofmann used the bottom of a beer bottle to draw it.

For the note attached to the Transcript, in Joseph Smith's hand, he studied photocopies of his handwriting obtained from the LDS library. It was the first of many forgeries Hofmann would do of the writing of the Prophet of the Mormon Church, and he prepared for the task with the attention to detail that would characterize all his subsequent forgeries. Smith was semiliterate, having left school at age thirteen to work on his father's farm. He spelled phonetically, as the words sounded. As a result his writings were full of childish mistakes and grammatical errors. He spelled *city,* "citti." *Character* came out as "karaktor"; *copied* as "coppied." Before the invention of the fountain pen, turkey feathers were the standard writing instrument. But a quill would only work well if it was kept sharpened, hence the term *pen knife.* Smith seems to have been unusually inept at sharpening his quills. His writing is sloppy and uneven and full of crossings-out or words that are inserted above the line. On average he made four to five orthographic errors every hundred words. Another peculiarity of Smith's was to break off in the middle of a word if he reached the end of a line, like a typewriter, even if this meant breaking a syllable in half. Smith would then put a dash on the paper, move the pen across to the left-hand margin, draw two lines, like an equal sign, then carry on writing.

The LDS Church had always been embarrassed by Smith's lack of education, and printed versions of his writings tended to clean up his grammar and spelling. By incorporating elementary spelling mistakes and other orthographic errors Hofmann was not just simulating Smith's handwriting. He was poking fun at the Mormon religion's claims that a man who could barely write had somehow become fluent in a language as abstruse as reformed Egyptian.

To obtain the paper for the Anthon Transcript, Hofmann

had cut an end page from an 1830s volume on biblical history from Utah State University. He made the iron gall ink from a recipe he had found in a German book, stolen from the Utah State Library. That was the easy part. Simulating the complex chemical reactions that occur as ink seeps into paper over a long period of time was much more complicated.

Under extreme magnification the ink tracks left by the nib of a pen on a piece of paper look like the fissures and craters on Mars. It has been calculated that the ions from the ink spread outward from the grooves and gashes cut in the paper by a nib at the rate of one two-thousandths of an inch per thousand years. As it does so, the paper is being subtly altered by time and climate. Documents get damp, have coffee or water spilled on them. They are affected by heat or cold, and by how and where they are stored. Their chemistry can even be altered if they are in direct contact with other documents or books.

Creating the illusion of time has always been the forger's hardest task. The great art forger Hans van Meegeren, a Dutch painter who created masterful clones of Vermeer's paintings in the 1920s and '30s, used badger hair from antique shaving brushes to make paintbrushes like Vermeer's, and conducted exhaustive experiments to create paints that resembled Vermeer's. By mixing Bakelite into his oils he discovered that he could bake his canvases in an oven to give them that authentic cracked look.

To create the Anthon Transcript, Hofmann developed a technique that would become one of the hallmarks of his art: the use of ammonium peroxide and other chemicals to age ink. This turned it brown, giving the appearance of age. He was also extremely careful about preparing the paper. Over time paper becomes cracked and porous. If fresh ink is applied to it, it will soak into the fibers like blotting paper, create a "feathering" effect, which can easily be spotted during forensic analysis. To avoid this Hofmann dipped the paper he used for the Anthon Transcript in a hot gelatin solution, which prevented the ink from running while he drew the hieroglyphs. After he had drawn

THE FORGER AND HIS MARK 101

them, he then washed the gelatin off and treated the ink with hydrogen peroxide. To create the mottled, rustlike damp patches that frequently appear on old documents, known as foxing, he sprayed the finished manuscript with milk and gelatin, then heated it with an iron. He also used a household iron to make the acid in the paper on which the transcript was written bleed into the pages of the Bible, turning them brown, as they would over time.

Some of Hofmann's other techniques were less sophisticated. To make the glue to stick the transcript into the Bible, he ground up the burnt end of a match with a mortar and pestle, poured it onto a piece of paper, then, using a toothpick, mixed it with salt, water, and wholemeal flour. Hofmann knew that white glue had not been used in the nineteenth century, and he had at one time thought of getting an old book and soaking it to retrieve glue from the spine; but Hofmann was in a hurry to finish the forgery, and that would have taken too long. So, when he realized his mixture was not sticky enough, he simply added a few drops of Elmer's.

Hofmann knew that to do a complete forensic examination, part of the document would have to be destroyed. And he rightly assumed that the Church would not take such a drastic course of action, in case the Transcript was genuine. He also knew that forensic tests can never be conclusive. They can detect signs of forgery. They can never conclusively prove authenticity. He also rightly assumed that the Church's desire to believe in this faith-promoting document would be so great that they would not subject it to a rigorous examination. He was right. After examining it for four months the LDS's manuscript experts declared that the Anthon Transcript was genuine.

The document's provenance posed a greater problem. Where had the document come from? How had he got the Bible? To whom had it belonged before? Like Joseph Smith, Hofmann was a consummate storyteller. He claimed he had bought the King James Bible in which he had found the Anthon

Transcript from a man in Salt Lake City who had, in turn, got it from Carthage, Illinois, in the 1950s from a granddaughter of Katharine Smith, the Prophet's sister. When Hofmann was pressed to reveal the name of the man he had bought the Bible from, he exploited his insider's knowledge of how the rare documents trade works. He said that the man he bought it from did not want his identity revealed. There was nothing strange about this. In the collectibles business it was normal for sellers to conceal their identities, usually for tax or security reasons. Hofmann said he felt ethically obliged to respect the man's privacy.

The Carthage story checked out. Katharine Smith had indeed been the Prophet's sister. There had also been an important Mormon colony in Carthage, Illinois, the place where Smith would eventually be murdered. LDS church officials also discovered that a great-granddaughter of Katharine Smith, an antiques dealer named Dorothy Dean, was still living in Carthage.

By chance Hofmann's parents were traveling to the midwest in the summer of 1980. His mother, Lucille, was due to attend a special ceremony at Nauvoo, the site of an important early Mormon colony, near Carthage. So Mark Hofmann went with them. Though they rode in the same car, they were on very different journeys. His mother was going to Illinois to drink from the wellspring of her faith. Hofmann was on his way to convince a woman he had never met that her mother had once owned a Bible containing one of the most exciting Mormon documents ever discovered.

He found Dorothy Dean's house on North Madison Street in Carthage, and knocked on the back door. He showed her the Bible and asked her if she recognized it. Dorothy Dean had heard about the Bible through church newsletters and had assumed it must have belonged to her great-grandmother, Katharine, but she could not recall ever having seen it herself. But the well-dressed young Mormon at her door seemed so sure that the Bible had come from her family, he was so polite and pleasant, and seemed so keen to help the Church authenticate

this important discovery, that she agreed to check her mother's sales records.

Like Iago in Shakespeare's *Othello*, Hofmann knew how to be one thing on the outside and another on the inside. If asked something that threatened to compromise one of his fabrications, he invented another. When Dorothy Dean asked him the name of the person who had bought the Bible from her mother, Hofmann blurted out the name White. That evening, when Dorothy Dean examined the store's record books, she found an entry by her mother recording the six-dollar sale of an unspecified item on August 13, 1954. Next to it her mother had written the name of the purchaser: "Relative to Ansel White from California."

Hofmann returned the next day, this time with his father, Bill. The devout Mormon father could only enhance the sense of legitimacy and pious endeavor that Hofmann wanted to create. The fact that Bill Hofmann had just been diagnosed with Hodgkin's disease did not trouble his son. Just as he would repeatedly use his wife, Doralee, as an alibi, he was not above using his ailing father as cover. To further enhance the appearance of legitimacy Hofmann kept a diary throughout the trip to Illinois. Mormons are encouraged to keep journal records of important events. By writing a fake diary Hofmann would become both the creator and chronicler of what a Church historian would call "one of the most important and significant documents of Church history to be discovered in this century." By the time Hofmann left Carthage, he had convinced Dorothy Dean that she, too, had played a crucial role in that history. Handing Hofmann a copy of the relevant page in her mother's sales register, she agreed to sign an affidavit confirming that her mother had sold the Bible containing the Anthon Transcript to a Mr. White in California.

On the long drive home to Utah, Hofmann sat in the backseat of the family car, staring out of the window. He felt bad about deceiving his mother. For his father he had no such

feelings of remorse. As they waited at a railroad crossing in Nebraska, Hofmann stared at the back of his father's neck, and his severely cut hair. He realized how he had always hated his strict piety, his blind obedience to Mormon doctrine. When Hofmann was a child, he had tried to forbid him from reading books about dinosaurs, because they supported the idea of evolution. As Hofmann thought about it, he realized how much he hated all religious fanatics, whether they were Mormon or Christian, Jewish or Moslem.

As his eye caught sight of the old King James Bible lying next to him on the seat of the car, he started to laugh inside himself. He had done it! He had fooled the most powerful men in the Mormon Church. Joseph Smith had claimed that God gave leaders of the Church the power to detect deception and fraud. They were seers, endowed with the power of discernment, who, according to the Book of Mormon, could "translate all records that are of ancient date." Yet when Gordon B. Hinckley and the president of the Church, Spencer W. Kimball, had looked at the Anthon Transcript, they had been no more able to translate Hofmann's forged hieroglyphics than if they had been in Swahili. As Hofmann remembered how tears had come to their eyes, he felt a surge of sadistic pleasure. If they could not tell illusion from truth, if they could not see that the Transcript was a forgery, how could they claim to be God's representatives? He had proved that God did not exist; that He is a hoax and an illusion, and that the prophets and seers of the Mormon Church are fakes. He had also proved that he had nothing to fear from divine inspiration. Each subsequent forgery would repeat this initial triumph and increase his sense of invulnerability. He had proved that his voodoo was more powerful than theirs.

Back in Salt Lake City, Hofmann traded the Anthon Transcript with the Church for $25,000 worth of genuine Mormon artifacts: a rare five-dollar gold coin, some historic Mormon banknotes, and a first edition of the Book of Mormon. It was not so much as he had hoped to get. But it was still good business.

More important, Hofmann had won the trust of the most power-ful men in the Mormon Church. He had had his picture taken standing next to Gordon B. Hinckley and other leaders of the Church. Believers all over the world had read about the Anthon Transcript in Church newsletters. Magazines and newspapers had written about him, not just local ones like *The Salt Lake Tribune* and the *Deseret News*, but prestigious national publications like *Time* magazine and the *Los Angeles Times*. It was, Hofmann thought, how Joseph Smith must have felt as he watched thousands of gullible converts flock to join the religion he had claimed to have discovered in the bottom of his hat.

The Magic Man

*T*he discovery of the Anthon Transcript not only made Hofmann a hero in the Mormon community. It also gave him unfettered access to the church's research archives. Dressed in his green letterman's jacket, Hofmann became a frequent visitor at the Historical Department in downtown Salt Lake City. The officials who signed out books to him, or helped him locate rare manuscripts, believed that he was conducting research that would help him discover more rare treasures for the Church. To them he was "Brother Hofmann," the pious son of an upstanding member of the community whose expertise and contacts in the world of historical documents were being put to the service of the Church.

The Anthon Transcript also established Hofmann as Salt Lake City's premier dealer in Mormon memorabilia. "Welcome to my first list of Mormon Manuscripts," his retail catalog began, before going on to list thirty-five manuscripts, each exhaustively described. All items were guaranteed; there was a two-week return privilege and a free sixty-day layaway for items over $300.

It was the perfect front. And soon Hofmann was feeding the Mormon Church a string of bogus documents. Many of them

were funneled through Brent Ashworth, the man who would spot the Emily Dickinson forgery. Hofmann had gotten to know Ashworth as a result of the Anthon Transcript. Ashworth had seen Hofmann on television, and heard so many stories about him, that in the late spring of 1982 he had telephoned Hofmann and introduced himself. With his business suits and family values, deeply held religious beliefs and financial acumen, Ashworth was a model Mormon. He was vice president of a company called Nature Sunshine Products, which manufactured vitamins and supplements. He was an attorney for the LDS church and a Mormon bishop. He was happily married with seven children. Ever since his college days he had also been a passionate collector of historical documents.

Soon Ashworth was a regular visitor at Hofmann's house in the town of Sandy, Utah, where Hofmann was living with his wife, Doralee, and their two small children. Generally, Ashworth dropped in on a Wednesday en route to a meeting with his company's securities attorney. One morning, as Ashworth sat at the kitchen table with Hofmann and Doralee, eating home-baked pie, Hofmann told him about another exciting find. Among a collection of stampless cover letters from a collection on the East Coast, Hofmann had located a letter signed "Lucy Smith," the prophet's mother. Hofmann had not forged the letter yet, but when he saw how excited Ashworth was at the prospect of acquiring it, he set to work creating it. "Dear Sister," it began, "It is my pleasure to inform you of a great work which the Lord has wrought in our family, for he has made his paths known to Joseph in dreams and it pleased God to show him where he could dig to obtain an ancient record engraven upon plates made of pure gold and this he is able to translate."

Everything was right. Using an early history of the United States postal service, Hofmann had even worked out the exact postal rate, 18¾ cents, for a letter sent from Palmyra to Wilmington, Vermont. To make the letter even more attractive to Ashworth, Hofmann salted it with enticing new details about the

translation of the golden plates, some of which deviated from received versions. Most important, it mentioned the lost 116 pages of the Book of Mormon: an original draft of the Book of Mormon that had disappeared while Joseph Smith was translating the golden plates. Ashworth immediately traded away $33,000 worth of genuine documents, including letters of Andrew Jackson and a rare copy of the Thirteenth Amendment signed by the members of Congress who voted for it.

A few weeks later Ashworth and his wife attended a press conference where it was announced that he had donated the letter to the Church. Soon, Ashworth was using the Lucy Mack Smith letter in his talks to Mormon groups as proof of the authenticity of Joseph Smith's claims, and of the Mormon religion in general.

Hofmann's real intention, however, was to destroy the Church he hated. Like a virus planted in a computer, he began to feed the Church of Latter-Day Saints not faith-promoting documents, but ones that turned their version of history upside down. His main target was the man he believed to be one of history's greatest illusionists and confidence men: Joseph Smith. And he began by striking at the most sensitive area of the Smith legend: sex.

The LDS church had always been discomfited by Smith's well-documented polygamous liaisons. And in recent years there had been an attempt to whitewash the record by suggesting that, at the end of his life, Smith had been in the process of abandoning polygamy. The letter Hofmann now forged, dated June 23, 1844, only four days before Smith was murdered, suggested that right up until his death Smith had been engaged in polygamy. "Keep all things treasured up in your breasts," writes Smith, in Hofmann's forged letter, to sisters Maria and Sarah Lawrence, with whom Smith was known to have had a "celestial marriage." "Burn this letter as you read it. I close in hast [sic]. Do not despair. Pray for me as I bleed my heart for you."

Hofmann also began to skillfully exploit schisms in the Mor-

mon Church. After Smith's death a succession struggle had broken out as two factions tried to seize control. One was headed by Joseph Smith III, the prophet's eleven-year-old son, and other members of his family. The other was led by Brigham Young, a hard-nosed, fiercely disciplinarian New Englander, who had been one of Smith's earliest converts. Young eventually prevailed and initiated the exodus west to Salt Lake City. The Smith faction went on to create its own, much smaller, branch of the Mormon faith, the Reorganized Latter-Day Saints (RLDS), which is based in Missouri.

Questions remained about the legitimacy of Brigham Young's succession. So Hofmann threw down a bone for the two churches to scrap over. The Joseph III Blessing, as the forgery became known, purported to be a blessing conferred by Joseph Smith on his son, in which he designated him as the legitimate heir to the church. If true, it would undermine Brigham Young's claim and, in effect, the foundation on which Salt Lake City had been built.

Hofmann knew that a controversial document like this would fetch a high price, and he went to great lengths to forge it. The handwriting presented the first obstacle. Thomas Bullock, one of the Mormon Church's early historians and the supposed author of the Blessing, had learned to write in England, prior to his emigration to Utah. The formation of the letters was different from American orthography, as was the way Bullock lifted his pen while forming words and letters. He also had a distinctive way of indenting paragraphs.

By now Hofmann had acquired a deep scientific understanding of paper and ink. Paper manufacture had remained almost the same until around 1860, when wood pulp was added. So anything prior to that could not be accurately dated. His main source for paper was the library of Brigham Young University, where he would cut end papers out of historic books. He would then size or glaze the paper. Old paper is porous, and without sizing the ink is likely to blur or feather. This feathering is one of

the most obvious signs of forgery. To prevent this happening Hofmann mastered complex sizing techniques to prepare his paper for a forgery, using hot gelatin obtained by boiling animal parts. Some of his methods were even more ingenious. When he discovered that insects had eaten their way through a paper bag used to store wheat in his basement, he took the insects and placed them between two sheets of antique paper, to simulate the holes caused by bookworms in nineteenth century paper.

He was equally skillful in manufacturing his own ink. The ancient Egyptians were the first people to produce ink. Using soot collected from burnt wood and a solution of gum, they created simple carbon ink for use on papyrus. It had a drawback, though. Instead of sinking into the papyrus it lay on the surface, like charcoal, and could be easily smudged or erased. This problem was eliminated by the Greeks, who added copperas, a compound of copper and ferrous sulfate, and tannin. The tannin was obtained from nutgalls, small, ball-shaped accretions, the size of acorns, found on oak trees. The addition of these chemicals caused the ink to bite into the paper, and so-called iron-gallotannate inks became the standard medium for writing until the middle of the nineteenth century, when aniline dye, the base of today's easy-wash inks, was introduced. Historic recipes are widely available. In England, for instance, almost every literate family kept a household recipe book, containing tips on everything from cooking a goose to making ink. Other ingredients included gum Arabic, logwood, and even gunpowder.

A forger is like an actor. Assembling the research materials, getting hold of the right paper and pens, and the preparation of the ink, are equivalent to an actor immersing himself in a part. Hofmann had the paper. He had composed a text. He had cooked up the ink in the family kitchen, using distilled water and one of his wife Doralee's cooking pots. Now he had to walk out onto the stage and give his performance. He had to put pen to paper. And just as an actor cannot pause to consider a phrase or a

word in the speech he is delivering, a forger has to write quickly and, above all, without hesitation.

The day Hofmann forged the Joseph Smith III Blessing he must have been nervous, because as the pen reached the bottom loop of the letter *S* in the word *Blessing*, his hand began to shake. He slowed the pen, now almost drawing the letter, then continued writing. But as he reached the word *Joseph*, he hesitated again, so that the letters *S* and *E* appeared shaky. Hofmann knew that such a sign of hesitation was dangerous. But he was by now so confident that he did not bother to go back and start the forgery again. He simply used a toothpick and some pumice stone to erase the words and then retraced them in ink. A trained forensic documents examiner should have been able to spot the error. But his experience with the Anthon Transcript had shown Hofmann that the LDS Church did not have anyone with those skills.

The basement of Hofmann's house in Sandy, Utah, was by now better equipped than most high-school science labs. He had photo-etching equipment to make copper plates. He had bottles containing chemicals, and jars of quill pens, mostly made from turkey feathers, which he cut and sharpened himself.

Making ink was easy; the hard part was artificially aging it. Like an inventor Hofmann proceeded by trial and error, using whatever equipment came to hand. For the Joseph III Blessing he developed an ingenious new technique for drawing the ink deep into the paper to simulate the action of time. Having written the letter, he laid it out on a fine-meshed window screen. He then sprayed it with hydrogen peroxide, causing the ink to oxidize, turning it brown, as it would naturally over time. Using an old vacuum cleaner, he then drew the ink through the paper by suction.

He added one last virtuoso flourish. He had dated the document January 17, 1844, and marked it with the title "Joseph Smith Blessing," in Thomas Bullock's hand, to make it seem as though the historian had at some point docketed and filed the

manuscript for future reference. There were no hanging files in 1844, so when the document had dried, Hofmann carefully folded it in thirds. "This was a fairly common way to fold documents and docket them," he explained to investigators later. "If someone had wanted to obtain the Blessing out of a file they wouldn't have to unfold all the pieces of paper and look at them to see what they were."

Both the LDS church and the rival RLDS church wanted the document: though for very different reasons. For the LDS church the Blessing was an embarrassment, undermining as it did Brigham Young's succession. For the RLDS church it was a validation of their claims to be the true heirs of Joseph Smith. Hofmann, in typically Machiavellian style, began a series of protracted negotiations in which he played one church off against the other. At the request of the RLDS officials the document was also subjected to an intensive forensic examination by one of the world's leading documents experts, Chicago-based Walter McCrone. A decade later McCrone would unmask what is arguably the most famous religious hoax of the twentieth century, the Shroud of Turin, which believers claim was the shroud wrapped around Jesus when he was laid to rest in the sepulchre.

McCrone used microscopy and chemical tests to analyze the document but found no sign of forgery. The paper was made of cotton, hemp, and straw, which suggested it had been made between 1800 and 1890. It also contained crushed mica, an additive that had come into use around 1807. The sizing was starch. Questions remained about the provenance of the document, but Hofmann had a solution there too. He forged an affidavit from a man named Alan Bullock, in which Bullock claimed to have sold Hofmann the blessing. Using letters and other documents to create a false identity, Hofmann then had the affidavit notarized. He had made up the name Alan Bullock. When church officials looked into the name, they discovered that there was indeed an elderly man by the name of Alan Bullock living in Salt Lake City. More extraordinary, the date of birth Hofmann had invented for

THE MAGIC MAN 113

his fictitious persona matched the real Alan Bullock's. Once again, luck seemed to be on Hofmann's side.

He clearly had great fun creating his forgeries. He had an instinctive feeling for dialogue and character and was able to get inside the heads of the people he was forging, and their language, with astonishing skill. He was steeped in the language and history of the Mormon Church, and mellifluous phrases like "His days shall be lengthened upon the earth and he will be received in an instant unto himself," which appear in another forgery (a letter from Thomas Bullock to Brigham Young), have the ring of authenticity about them. There are moments of humor as well. "My conscience is clear 'as Rocky Mountain water,' " writes Hofmann at the end of the letter. "I do not want a stink, and trust that you do not want one either." Having signed off, Bullock adds a P.S. "I would love to write more, but my hand smarts. Can we talk privately?"

Like the Joseph Smith III Blessing this letter was extremely embarrassing to the Church. "I have never said that you are not the right man to head the Church," writes Bullock, alias Mark Hofmann, "and if any man says otherwise, he is a liar; I believe you have never pretended to anything that did not belong to you. Mr. Smith [young Joseph] has forfeited any claim which he ever had to successorship, but I do not believe that this gives you license to destroy every remnant of the blessing which he received from his father. . . ." The implication is clear: to ensure his claims to leadership of the Mormon Church, Brigham Young had resorted to document shredding, that favorite device of frauds.

Hofmann knew that the Mormon Church would want to suppress the letter's contents. He also wanted to bind the Church hierarchy to him even more closely so that he could infiltrate the Church with other, even more damaging forgeries. He now did something of Machiavellian cunning. Instead of selling the letter to the Church, he personally donated it to Gordon B. Hinckley. "Are you telling me that you wish to give this document to the Church without cost?" Hinckley is reported to have asked in

amazement. Brother Hofmann told him he did, in order to prevent the document from falling into the hands of the Church's enemies. Hinckley shook him by the hand and blessed him.

It will never be known precisely what the relationship between Hinckley and Hofmann was. The Mormon Church has drawn a tight veil of secrecy over the whole affair. But Hinckley clearly liked Hofmann. They both shared a passion for history; specifically, for the history of the Mormon Church. Hofmann was well read. He could quote large chunks of the Book of Mormon extempore. He was also extremely knowledgeable about historical documents (in an act of supreme irony Hofmann gave the Church advice about how to detect forgeries) and seemed to have excellent contacts "back East," as Mormons still referred to the East Coast. Soon Hofmann was acting as Hinckley's semiofficial purveyor of historical documents. Hofmann even had the audacity to propose that he and the Church formalize their commercial relationship. Under the terms of a letter he sent to Hinckley he promised to "actively (although not on a full-time basis) search out Folded Letters and Covered Letters of historical interest on behalf of the church." After carefully considering the proposal the First Presidency turned him down. The Church did, however, agree to consider any individual items that Hofmann might find.

Over a five-year period, starting in 1980, Hofmann would "find" nearly four hundred and fifty Mormon documents, which he would sell to the Church for hundreds of thousands of dollars. Nearly all of them were sensational documents that shed important new light on Mormon history. To other dealers working in the field it appeared that Hofmann had almost magical powers. "I called him the Magic Man," confided Rick Grunder, a rare documents dealer who specializes in Mormon manuscripts and knew Hofmann in Salt Lake City. "He was like a nondescript Richard Cory, fluttering pulses when he said, 'Good Morning,' glittering when he walked. Not by his appearance or by his manner. He didn't stand out. I never heard him raise his voice or

exhibit any kind of bravado. The charisma he enjoyed was be-
cause of what we thought he had. He convinced us that he knew
something we did not, that he had access to things we could
otherwise never hope to find. There I was, grubbing around in
piles of old paper, and not getting very far. Mark seemed to just
wave his wand and this amazing stuff turned up. He was the
Mormon Indiana Jones who could lead us to impossible treasures
of information and wealth."

The fact that Hofmann was so elusive only increased the
mystique. "My old card file lists his name with three or four tele-
phone numbers. None of which were easy to reach. When he
granted an audience, you felt privileged to see him. It was excit-
ing to feel you were part of an inside group: to be on a first-name
basis with a person who was constantly in the news."

As he would with everyone he came into contact with, Hof-
mann exploited his friendship with Grunder for nefarious ends.
"We would have lunch or dinner and talk about books," he re-
called. "He was planting seeds in those conversations. Or he
tested me to see how things would work. He asked me on two
different occasions, for instance, what a piece of papyrus would
be worth. He was always sounding people out like that. And he
rarely gave out copies of what he sold. This made it even more
exciting. It was like being given a glimpse of the philosopher's
stone."

Forgery enabled Hofmann to make money doing some-
thing that fascinated him. He could live the free life of an artist.
Forgery also brought intrigue, excitement, and celebrity into his
life and satisfied a narcissistic conviction that he was smarter
than everyone else. Above all it enabled Hofmann to simultane-
ously win the respect and admiration of the LDS hierarchy while
sticking a knife between their ribs. Power and money, social ac-
claim and revenge, art and celebrity, were rolled into one seduc-
tive bundle. Ultimately forgery was his way of bridging the gap
between who he was on the inside and the person he had had
to pretend to be on the outside. As a child he had been forced to

conceal the truth about himself and live a lie. Forgery enabled him to say what he really believed and win the argument he had never been allowed to have with his parents. He could prove that the religion that they so adamantly insisted was true was, in fact, an illusion. All without losing their love. By "discovering" such rare artifacts he had gained the love and respect he had always dreamed of. He was the man with the magic touch, the king of the Mormon documents trade.

He was not the first person to use forgery to alter history or vent his anger and frustration on society. Indeed, since man first learned to write more than two thousand years ago numerous literary forgers have stepped forward to dazzle and dismay the world with their creations.

The Art of Forgery

The word *forge* comes from the Old French, *forgier*, meaning "to fabricate or fashion." In the Middle Ages it referred primarily to the making of images or art objects. Iron, or metal coins, could also be forged. But as early as the fourteenth century the word had begun to accrue other meanings. The Oxford English dictionary defines one of these meanings like this: "to fabricate, frame, invent (a false or imaginary story, lie, etc.); to devise (evil); also, to pretend (something) to have happened, to fable."

In other words, forging was something you did with your mouth. But with the growth in literacy and the increasing use of written documents to regulate civil society, forgery's associations shifted to another part of the anatomy. You forged not with your mouth but with your hand. The pen, not the tongue, became the forger's instrument of choice. "Thinke not . . . that I have forg'd or am not able Verbatim to rehearse the Methode of my Penne," wrote William Shakespeare in 1591.

Literary forgery is far older than the English language. Two millennia ago the ancient Egyptians were already establishing laws to deal with fake papyri or forged seals and signatures. The story of one of the world's first forgeries, a cruciform block of

stone dating from the first half of the second millennium B.C. found in southern Mesopotamia, begins with a tax hike. A new temple had been built at Sippar, which is today part of Iraq, and to pay for it the priests had increased the tithes they collected from the surrounding population. By what authority, the people demanded of the priests, do you ask us for more money? The forged text the priests inscribed in Babylonian hieroglyphs on the twelve sides of the block of stone gave the answer: the expansion of the temple and the increase in tithes had been commanded by a previous king, the mighty Manishtushu, king of Akkad. The priests were not acting arbitrarily. They were following historical precedent. In case anyone disputed the text's authenticity, the priests added both a guarantee and a warning. "This is not a lie, it is indeed the truth," ends the inscription. "He who will damage this document let Enki fill up his canals with slime."

Another ancient forgery, the Shabaka Stone, which dates from eighth century B.C. Egypt, sought to validate the conquest of the city of Memphis by the Nubian pharaoh Shabaka. The forged text inscribed on this slab of black basalt, which Shabaka erected in Memphis's main temple, was intended to win over the hearts of his new subjects by flattery. According to traditional Egyptian mythology it was the god Atum, from rival Heliopolis, who had created the world. Shabaka's forgery put a new spin on the past by giving that honor to Memphis's local god, Ptah. Like all forgers Shabaka concocted a phony provenance—the inscriptions on the basalt slab purported to be a copy of an ancient document—and employed techniques, like simulating the layout of earlier documents and using archaic forms of grammar and language, to give the illusion of antiquity.

The creation of the great libraries of the ancient world stimulated demand for forgeries. In the third century B.C. the Hellenistic dynasty of the Ptolemies established the great library at Alexandria, in Egypt, and set about aggressively acquiring hundreds of thousands of manuscripts. Star items on their acquisi-

tions list, like the original Greek versions of plays by Aeschylus, Sophocles, and Euripides, were sometimes stolen. Having borrowed the originals against a huge deposit, the library would keep the manuscript and forfeit the deposit. At the same time there was a burgeoning trade in forgeries of works by other giants of the antique literary world, like Plato and Aristotle. The Alexandrine librarians distinguished between genuine and spurious works in the same way as they distinguished between their children. Genuine works were classified as *gnesioi* (legitimate), forgeries as *nothoi* (bastards).

The first forger, in a modern sense, was born in the year Columbus sailed to America. Giovanni Nanni was born in 1492 in the town of Viterbo, Etruria, not far from Genoa, but he soon Latinized his name to Annius to suggest a Roman lineage. He then became a Dominican monk and a theologian of some repute, publishing and lecturing in the Genoa area. He was a passionate local patriot. To boost the status of his beloved Etruria he began to create a series of sophisticated, forged historical documents and inscriptions aimed at glorifying his native city as the birthplace of civilization. Greek statesmen had done much the same in the sixth century B.C. when they interpolated lines into the works of Homer to magnify the importance of Athens.

Just as Mark Hofmann's forgeries told stories people, be they Mormons or Emily Dickinson scholars, wanted to hear, Annius de Viterbo's Etruscan fakes struck a deep chord in Renaissance Italy, recalling as they did a previous golden age in Italian history. Annius went to extraordinary lengths to establish their authenticity. Having written his pre-Roman, Etruscan inscriptions on pottery objects, he buried them in the ground for himself to dig up and "discover." He even broke the pottery inscriptions into pieces before he buried them so he could produce them as "fragments" that he would then ingeniously put back together. Having faked the "discovery" of his forgeries, he then wrote commentaries on them, analyzing their content and language to prove their authenticity. Annius's critique of his own forgeries

was one of the first examples of what we would today call textual analysis.

Since then numerous forgers have used fabricated documents to alter history. Their falsities have come to be accepted as fact, cross-pollinating authentic history with new and often compelling inventions. Without forgery we would probably never have heard of the Knights of the Round Table. They first made their appearance in the twelfth century, when the medieval British historian Geoffrey of Monmouth published his *Historia Regum Britanniae*. Supposedly derived from ancient sources (as usual none was produced), this weighty tome traced British history back to the time of Merlin and King Arthur. Though it subsequently disappeared, and was almost certainly a fiction, it effectively became the founding myth of the British Isles. The Grail legends were derived from it. Malory used it as the basis for *Morte d'Arthur*. Shakespeare plundered it for dramatic material. Generations of British schoolchildren were raised on its inspiring legends.

Money is a comparatively recent motive for forgery. Misplaced patriotism; hatred of authority; a longing for social prestige or a need to reinvent oneself have been others. Forgery has been used for religious, financial, and political purposes; to gain, influence or discredit an enemy. In the sixth century B.C. Athenian statesmen interpolated lines into the works of Homer to magnify the importance of Athens. Queen Elizabeth I used forged documents to discredit Mary Queen of Scots. In the Second World War, the Allies produced counterfeit postage stamps showing Hitler's death's head in order to undermine German morale. A forged manuscript in the British Museum appeared to fulfill the alchemist's dream of transmuting base metal into gold.

Forgers are attracted by the sheer fun, and creativity, of their craft—the scholarship and research; the inventiveness involved in rearranging the jigsaw puzzle of history in new, and surprising ways. A prolific nineteenth-century French forger named Denis Vrain-Lucas created numerous epistolary conversations between

historical figures that never actually took place. He forged letters from Alexander the Great to Aristotle, Francis Bacon to Galileo, Richard the Lionhearted to his troubadour, Blondel.

Like Hofmann, Lucas was a meticulous historical researcher. His fictional letters from the French philosopher, Blaise Pascal, to the English mathematician, Isaac Newton, for instance, teem with technical discussions of the equilibrium of fluids. If suspicions were aroused about his documents, Lucas resorted to a trick Hofmann would repeatedly use: he created a new forgery to authenticate the old one. A Scottish scientist named Sir David Brewser noticed that according to Vrain-Lucas's forged letters Newton would only have been twelve years old when Pascal wrote to him. So Vrain-Lucas produced a letter from Newton's tutor, confirming that the precocious genius had, indeed, corresponded with the author of the *Pensées*. Just as Hofmann's Mormon forgeries confirmed the Church's version of its own history, Vrain-Lucas's fictions were successful because they flattered French egos. According to his forged correspondence, it was Pascal, not Sir Isaac Newton, who first mapped out the laws of gravity.

Forgery is not unique to Europe. In ancient Japan both the imperial court and the country's most powerful families used forged genealogies and histories to enhance their prestige and authority. During the seventeenth-century Tokugawa dynasty, shogun warlords fabricated genealogies to bolster their claims of kinship with the royal family. Fake maps and geographical writings known as *fudoki* (topographies) were "discovered" to give spurious land claims by ambitious nobles the illusion of legitimacy. For the first time in Japanese history forgers also began to create documents for profit. Many of these new forgers were unemployed samurai or poor monks living on the margins of society. Forgery provided both a means of making a living and, as it would for Mark Hofmann, a context in which to vent their alienation.

Some of these forgers gained the status of folk heroes, like

the peasant Sawada Gennai, who invented a false identity for himself by forging documents linking him with one of Japan's most powerful warrior clans, the Sasakis. Using the nom de plume Sasaki Ujisato, he forged numerous historical fictions. His most ambitious work was a series of forged diaries, the *Kogen bukan*, executed between 1537 and 1621, which purported to have been written by his illustrious ancestors. The diaries were published and became a popular text in Japan.

Forgery has an even longer pedigree in China. During the Ch'ing dynasty numerous fake manuscripts, including Taoist treatises, Confucian commentaries, official documents, as well as poems, prose writings, and calligraphic works, were produced, often to extremely high standards. Some of these forgeries, like the *Shan-hai ching* (Book of Mountains and Sea) or the sayings of Lao-tzu, went on to become revered classics.

Punishments for forgery have varied greatly over the centuries, and between cultures. Forgers in ancient Egypt were punished by having both their hands cut off. A law passed in Japan in A.D. 718 made the forging of historical documents by public officials punishable by exile. In ancient China it was punishable by death. A law passed in England in 1572 made forgers liable to have their ears cut off or their nostrils slit. With the creation of the Bank of England in 1694, when gold was replaced by promissory notes, the forging of counterfeit currency became a capital crime. But it was not until 1769 that "the false making, or making *malo animo*, of any written instrument for the purpose of fraud or deceit" was codified under common law by the jurist William Blackstone.

By then the cult of the writer as hero had caused literary forgery to blossom. Forged autographs and manuscripts enabled the public to see and touch the works of genius. William Henry Ireland, a prolific British forger, shared a first name with William Shakespeare, though this William was born more than two hundred years later, in 1777. His father, Samuel Ireland, was a London dealer in rare books and prints. A job in a law firm in the

Inns of Court brought the young Ireland in contact with ancient manuscripts and trained him to write in a fluent calligraphic hand.

Ireland was drawn to forgery because of his fascination with one of the It boys of the Romantic age, the teenage poet Thomas Chatterton. Ireland was only seven years old when the seventeen-year-old Chatterton committed suicide by drinking arsenic, but London's gossiping classes still buzzed with tales of his brilliant career. Using the pen name Thomas Rowley, a fifteenth-century monk whose work Chatterton claimed to have discovered at St. Mary Redcliffe Church in Bristol, he forged a series of seductive medieval poems that in their day were as popular as Beatles songs were in the 1960s. Wordsworth called Chatterton a "marvelous Boy." Coleridge immortalized him in "Monody on the Death of Chatterton." Keats dedicated one of his greatest poems, *Endymion,* to his memory.

Ireland saw forgery as his own avenue to celebrity. He also wanted to help his father, who, like all rare book and manuscripts dealers, dreamed of discovering the ultimate historical document: a manuscript by Shakespeare. Though Shakespeare wrote many millions of words, all that has survived of his own handwriting are a few signatures. Whether Ireland senior knew that the mortgage contract between Shakespeare and one Michael Fraser and his wife, Elizabeth, which his son presented to him shortly before Christmas in 1794, was a fake, we do not know. What we do know is that Samuel Ireland almost collapsed with gratitude and happiness.

For paper Ireland used the blank end of an old rent-roll from the reign of King James the First, who ascended the throne as Shakespeare was beginning to write his greatest plays. Using his right hand to create Shakespeare's signature, he used his left for the inscription by Michael Fraser. Emboldened by his success, he went on to create a magnum opus of Shakespeare fakes, including the complete manuscript of *King Lear,* to which Samuel Johnson would show such reverence, fragments of *Hamlet,*

and hundreds of documents and letters by Shakespeare and his contemporaries.

Ireland's forgeries were amateur works that should have fooled no one. The handwriting was poor, the content well below even Shakespeare's worst work. However, just as Hofmann's Mormon forgeries excited a powerful desire to believe in them, so captivated were the British public by the idea of having found original examples of the Bard's writings that they were swept along on a wave of euphoria. Riding the wave, Ireland set about creating the ultimate Shakespeare forgery: a complete, new play. It was called *Vortigern and Rowena.* Like *King Lear* and *Cymbeline* it was set in ancient Britain. The script looked vaguely like Shakespeare's handwriting. There was lots of stirring action and theatrical language. Then, as now, it was not hard to find an expert who, for a small consideration, would testify to its authenticity. Soon it was playing in Drury Lane, in an expensive production by the Tom Stoppard of the day, Richard Brinsley Sheridan, with the celebrated actor John Philip Kemble in the title role.

Unfortunately, the plot was as lively as cold gravy, the poetry doggerel. In the fifth act, as Kemble delivered the line "And when this solemn mockery is o'er . . ." the audience began to hoot and jeer. "No sooner was the above line uttered in the most sepulchral tone of voice possible," Ireland wrote in his *Confessions,* "than the most discordant howl echoed from the pit that ever assailed the organs of hearing."

The printed forgeries of T. J. Wise and Harry Buxton Forman, which appeared in England at the end of the nineteenth century, were works of a far higher caliber. Forman was the son of a Royal Navy surgeon from Devon. He was born in 1842 and, as a young man, had dreamed of becoming a poet. Instead he became an editor of other people's poetry. His four-volume edition of the works of Shelley, which appeared in 1876, followed by a similar one of the works of John Keats, established him as one of the leading editors of the day.

T. J. Wise had also dreamed of being a poet. Born in 1859,

the son of a London craftsman who described himself variously as a pencil-case maker, manufacturing jeweler, tobacconist, and independent, he had a Dickensian childhood in Holloway, a bleak district in north London. A job at Herman Rubeck and Company, a commodities brokerage in the City of London, propelled him upward. Entering the firm as an office boy, he quickly rose through the ranks to become a wealthy businessman and one of London's most successful book collectors.

The two men met in 1886. Both shared a passion for poetry and rare books. Both were extremely knowledgeable about the techniques of printing and bookmaking. Both seem to have lacked the moral backbone typical of the Victorians. Starting in 1888, these two well-connected bibliophiles began to forge a string of first editions. Among them were such treasures as *Grace Darling*, by Swinburne; *Morte d'Arthur*, by Alfred Lord Tennyson; and *Ticonderoga*, by Robert Louis Stevenson. There were also first editions of works by Ruskin, George Eliot, and Matthew Arnold.

Beautifully printed, on the finest paper, much of it handmade, with an extraordinary attention to typographic detail, these first editions were mostly sold across the Atlantic, to American collectors eager to own a piece of the motherland's literary heritage. Many of them were sold at Sotheby's. Auction sale records for the years 1888–1920 show amounts varying from a few pounds to the £135 paid at Sotheby's in 1919 for a collection of Robert Louis Stevenson works.

In all Wise and Forman produced at least one hundred forgeries, most of them in multiple copies. They were exposed when two London booksellers, John Carter and Graham Pollard, grew suspicious of the sudden proliferation of rare editions and subjected Wise's reprint of an 1847 edition of Elizabeth Barrett Browning's *Sonnets* to exhaustive tests. In one of the world's great pieces of literary detective work, Carter and Pollard uncovered a number of minute anomalies. One was that the paper contained esparto grass and chemical wood, both of which had not been introduced until after the supposed date of publication. They

also discovered a tiny typographical flaw. The letters f and j both lacked what is known as the "kern," or curled head, at the top and tail, respectively. Such "buttonhook" letters did not exist in 1847 when, it was claimed, the text had been printed. They had first been introduced in the early 1880s.

To track down the source of the spurious first editions, Pollard and Carter spent months visiting nearly every type foundry in London. Their hunt eventually led to a printer named Richard Clay and Sons who, sometime between 1880 and 1883, had developed a typeface known as Long Primer No. 3. One of the innovative features of Long Primer No. 3 was its use of the sort of "kernless" letters found in the *Sonnets*. One of Richard Clay and Sons' most faithful customers was a wealthy businessman and bibliophile named Thomas J. Wise.

While Wise and Forman were driven by a complex mixture of motives—the desire to make money, a genuine love of books and manuscripts that had become twisted by greed, a need to impress the fashionable London literary circles in which they moved—Sir Edmund Backhouse, aka the Hermit of Peking, was, like Mark Hofmann, animated by a desire for revenge on the society into which he had been born. He attended the same school as Winston Churchill but despised what he regarded as the vulgarity and hypocrisy of late Victorian Britain. Arriving in China in 1898, Backhouse began working for a shipping company, and as a spy. He spoke and wrote fluent Japanese and Chinese, and under the patronage of the famous China hand and *Times* correspondent Dr. G. E. Morrison, he was soon providing backgrounders on everything from the latest political intrigue in the Forbidden City to the movement of armaments by Chinese warlords. What his handlers did not know was that most of what Backhouse told them was invented.

Fiction also informed the books he wrote. The most famous of these, *China Under the Empress Dowager*, was hailed as a classic. What no one knew was that one of the key sources for the book, the diary of a Chinese nobleman named Ching-Shan, which

Backhouse claimed to have found in Ching-Shan's house as it was looted during the Boxer Rebellion, was a forgery. Numerous other forged Chinese manuscripts followed, including the diary of the grand eunuch of the imperial court, Li Lien-ying. Backhouse also claimed to have had a clandestine love affair with the empress.

Backhouse's forgery of Chinese literary texts went hand in hand with a Walter Mitty–like reinvention of his life story. Backhouse claimed descent from the British prime minister Charles James Fox and from a Russian aristocratic family. He claimed to have traveled all over Europe, Russia, and America as a young man, encountering on the way some of the great names of the day, including Oscar Wilde, Sarah Bernhardt, Leo Tolstoy, and Aubrey Beardsley.

The truth was shabbier. Backhouse was a homosexual in an age before gay rights, and in 1898, after suffering a nervous breakdown, and bankruptcy, at Oxford University, he was dispatched to the Far East to prevent him from further sullying the family name. With physical distance came a pathological flight from reality. By the end of his life Backhouse's once lucid mind had become a haunted house of fantasy, sexual obsession, and resentment. He adopted the original German form of his name, cheered the Luftwaffe as it pounded London during the Blitz. He railed against Jews and eschewed contact with Westerners. Shuffling about in his Peking house with a long white beard and floor-length silk robes, he would eventually resemble a cross between a mad Confucian scholar and Ezra Pound. His two-volume memoir, most of it fictional, teemed with explicit descriptions of his sexual adventures in imperial China.

The marquis of Pa k'o-ssu, as this son of a middle-class British Quaker family liked to call himself by the end of his life, died in the French Hospital in Peking on January 8, 1944. By then he had been exposed as a fraud and a charlatan. But it was too late to expunge his name from the roll call of history. Thanks to a gift of seventeen thousand volumes of Chinese printed

books and manuscripts that he made in 1913 to the Bodleian Library in Oxford, the latinized version of his name, "Edmundus Backhouse, baronettus," can still be found inscribed on a marble tablet at the Bodleian, next to the names of the duke of Gloucester, Oliver Cromwell, Paul Mellon, and the other major benefactors of Britain's most famous library.

Literary forgery appeared in the New World at the same time as a new epithet entered the English language. In 1855 a journalist in New York described a notorious criminal named William Thompson, who had used numerous aliases to swindle hundreds of people of their savings, as a "confidence-man." A theater on Chambers Street was soon producing a farce celebrating this new American folk hero. A few years later the phrase was inscribed on the world's consciousness by Herman Melville, with the publication of his novella *The Confidence Man*.

The first Confidence Man of letters was a Philadelphia bookseller named Robert Spring. Born in England in 1813, Spring emigrated to America as a young man. In the 1850s, using his rare-book business in Philadelphia as a front, he began to produce numerous George Washington documents. His favorite fakes were personal checks drawn on Washington's bank, the Office of Discount and Deposit in Baltimore. Like the original Confidence Man, Spring also adopted a series of aliases to disguise his true identity.

One of the most gifted of American forgers was an Irish-American from New York named Joseph Cosey. Cosey was born in Syracuse in 1887, the son of an Irish cabinetmaker. A restless, angry teenager, he left school, and home, at the age of seventeen and began working for a printer at a salary of three and a half dollars a week. But he soon quit and began a life of crime. By the age of forty he had served ten years in jail, including spells in San Quentin and Riker's Island.

"I owe my real start in life to the Library of Congress," he would later recall with irony. "I wandered in one day in 1929 and asked to examine a file of historical manuscripts. I was intrigued

by them. When I left I took along with me as a souvenir a pay warrant dated 1786, signed by Benjamin Franklin when he was president of Pennsylvania. It wasn't stealing, really, because the Library of Congress belongs to the people and I'm one of the people."

Cosey offered the document to a dealer on Fourth Avenue's Book Row in New York. The dealer pronounced it a fake. His self-assurance infuriated Cosey, so he decided to teach him a lesson. Having bought a bottle of Waterman's brown ink from a dime store, he started practicing the handwriting of famous Americans, above all Abraham Lincoln. A few months later he went back to the document dealer and sold him the forgery for ten dollars.

Cosey possessed a dazzling mimetic talent. He wrote quickly, never retouching a manuscript, and was able to capture what graphologists refer to as the psychodynamics of his subjects' handwriting: the bold, masculine hand of Washington, Mark Twain's volatile scrawl, the neat, elegant penmanship of Rudyard Kipling. Like Hofmann, Cosey was also a master technician. He cut his own quill pens and mixed his own ink, using rusted iron filings and Waterman's brown ink, a compound that perfectly simulated the brown iron-gall ink of the Revolutionary period.

His chef d'oeuvre was a manuscript of Edgar Allan Poe's "The Raven." Poe lived in New York at the time he wrote his legendary poem, and by chance Cosey had acquired an antique account book from that era. On a sheet of paper cut from this account book, Cosey inscribed several stanzas of "The Raven," complete with Poe's corrections. It was the working draft of America's most famous poem.

Holed up in a squalid apartment on lower Broadway, the pockets of his threadbare jacket bulging with penholders, nibs, and scraps of old paper, Cosey went on to produce hundreds of forged manuscripts by historical figures as diverse as Lincoln, Washington, Franklin, and Samuel Adams, many of which are

still being bought and sold. To stop the condition known as forger's tremor, a trembling of the hand that gives many forgers away, Cosey eventually began mainlining heroin.

Since then numerous other forgers have stepped forward to dazzle and deceive the world. In the 1930s Charles Weisberg, an alumnus of an Ivy League college, who became known as "the Baron" due to his aristocratic manner and appearance, followed Cosey in forging numerous Lincoln and Washington documents, as well as works by Whitman and Heinrich Heine. In the 1970s Thomas McNamara used the knowledge he had acquired as curator of the George H. Brown collection of Robert Frost, at Plymouth State College in New Hampshire, to create numerous Frost poems, as well as works by William Carlos Williams. When he was arrested, police found in his possession an armory of inks and pens. Even he occasionally made elementary blunders. The ink McNamara used in his William Carlos Williams forgeries was not manufactured until the year after the poet died.

Large amounts of expendable income, a hype-driven auction market, and a gullible public, with more money than sense, have made our own era a golden age of literary forgery. The market in collectibles is today worth an estimated $30 billion annually. And where there were once a handful of auction houses, like Sotheby's and Christie's, there are now dozens. The biggest growth is on the Internet. With the success of eBay, America's first and biggest on-line auction house, there has been a proliferation of virtual sales rooms. Both Sotheby's and Christie's now have on-line operations. In all there are 150,000 on-line auction sites where, for as little as one dollar, punters can bid on anything from original artwork to a baseball signed by Babe Ruth.

Owning a Babe Ruth autograph—or a piece of wedding cake from the Windsors' wedding, which was auctioned at Sotheby's, New York, in 1999 for $27,000—offers today's celebrity-driven collectors a tangible link to the world of glamour and fame. And as the auction of Marilyn Monroe's personal effects at Christie's, New York, showed, there is almost no limit to what people are

prepared to pay to own a piece of a star. Monroe's makeup case, estimated at $1,000, sold for nearly a quarter of a million. The same year, the New York–based auction house Gurnsey's auctioned the baseball hit by Mark McGwire for his seventieth home run for $3.2 million. McGwire's record would stand for only two years, though, as Barry Bonds hit seventy-three home runs in 2001. It will be very difficult to find that kind of money again for McGwire's baseball.

Prices for historical documents have been similarly inflated. "A George Washington letter that used to sell for $500 can now fetch $500,000," says Charles Sachs, owner of the Scriptorium, a well-established dealer in Beverly Hills, California. "What has happened is that people have drifted in from the art world, where they were used to paying that kind of money. Hollywood people have started to buy extensively for gifts: Lincoln letters for their lawyers, Freud for their psychiatrists."

With the escalation of prices the competition for material— and the temptation for abuse—have increased exponentially. "I probably came across one forgery per week," recalled Roy Davids, from 1970 to 1994 the head of the Books and Manuscript Department at Sotheby's in London (ironically, one of the people Davids trained was Marsha Malinowksi, the employee who handled the Hofmann sale). "But we had very few things returned. In fact, I can remember only one case: a letter by the painter Raphael. It's one's first duty: to make sure that something is right. And when I was at Sotheby's, it was a fairly rare occurrence that forgeries went undetected. My impression is that it is not so rare: that the system is not as watertight as it used to be."

It gets worse the farther down the auction-house food-chain one travels. In 1999 eighty-seven percent of the complaints to the National Fraud Information Center, a consumer organization in Washington, D.C., involved on-line auctions. The illegitimate trade is particularly brisk in forged sports, celebrity, and World War II memorabilia: everything from signed photos of the Spice Girls to letters by Rommel. Estimates suggest that as much as

seventy percent of sports and celebrity memorabilia traded on the Internet are forgeries.

Our obsession with celebrity has been behind most of the sensational literary forgeries that have appeared in the last quarter century. Whether it is Clifford Irving's fake autobiography of reclusive billionaire Howard Hughes; the forged correspondence between JFK and Marilyn Monroe, which surfaced in New York in the early nineties; or the diary of Jack the Ripper, which appeared in England in 1993, it is the explosive new "revelations" these documents saddle upon the heroes and villains of the past that make them so valuable.

Most of these forgeries have been technically inferior. But twenty-four-hour news cycles, the ravenous appetite of the media for sensational stories, combined with a lowering of its ethical standards, has ensured that disbelief is not just willingly suspended but swept aside in a whirlwind of wishful thinking and hype. The Hitler diaries caused a sensation when they first appeared in Germany's *Stern* magazine in 1983. They were so amateurishly produced that it is hard to believe that they deceived anyone, let alone one of the greatest British historians, Hugh Trevor-Roper, author of *The Last Days of Hitler*. Having looked over the diaries, Trevor-Roper declared that they represented "the most important event of contemporary history."

They were in fact the work of a forger and dealer in Nazi memorabilia and documents named Konrad Kujau. Admittedly they came with a great story. It was well known that, in the last days of the war, Hitler had sent ten metal trunks full of personal papers out of Berlin by plane, destination Berchtesgaden, as the Nazi capital was about to fall to the Russians. The plane crashed and has never been found. Kujau claimed that a relative of his in the former East Germany—a general, no less—had located the plane and with it the diaries. They were bought for two million German marks by an ambitious investigative reporter at *Stern* magazine with known Nazi sympathies—he already owned Hermann Goering's yacht, *Carin II*—named Gerd Heidemann.

The German Federal Archives failed to spot the forgeries (partly because the control samples of supposedly genuine documents provided by Heidemann came from Kujau's forged diaries). So did the noted American expert Ordway Hilton, despite the fact that he had previously exposed Clifford Irving's fake Howard Hughes memoir. Within hours of publication in *Stern* magazine, a worldwide media feeding frenzy had begun. Rupert Murdoch's flagship British publication, the London *Sunday Times Magazine*, raced against *Newsweek* to bring them out in the English-speaking world. Television and radio stations beamed news of the sensational discovery into millions of homes. Only when, at *Newsweek*'s request, the diaries were examined in New York by Kenneth Rendell, the man Sotheby's would claim had authenticated the Emily Dickinson poem, did it become clear that what historian Trevor-Roper called "a journalistic coup without parallel" was in fact a journalistic hoax without parallel. The handwriting was wrong. The imitation leather notebooks with their crude wax seals were quite unlike the beautifully bound leather desk dairies Hitler is known to have used. The typeface, Engraver's Old English, used for the metal initials on the cover of one diary, had been outlawed by the Nazis in the early 1940s as being "too Jewish."

Thousands of miles away, in Salt Lake City, Mark Hofmann watched with fascination as the Kujau saga unraveled. It proved to him once again how flimsy was the wall between truth and illusion; and how, if the desire to believe is strong enough, even a mediocre forgery can pass undetected. And Hofmann was not a mediocre forger. Indeed, in the long annals of literary forgery there has never been a forger so meticulous in his research, so skillful in his techniques, so malevolent in his intentions or grandiose in his designs. And less than a year after Konrad Kujau was exposed, he set about doing what no forger had ever done before. He created a document that, if it were true, could shake the foundations of a major world religion. It would become known as the Salamander Letter.

CHAPTER NINE

The Salamander Letter

It was a bitterly cold day in early January 1984 when Lyn Jacobs, a friend of Hofmann's who had just flown in from Boston, made his way toward the twenty-eight-story Church Office Building. Snow had fallen over the holidays, and the wind, sweeping down from the Wasatch Mountains, cut through him like a knife. Jacobs, a quick-witted extrovert with frizzy black hair, a goatee, and dark, saturnine eyes, had known Hofmann since 1979, when the two of them had talked in a bookstore and discovered that they shared a common passion for Mormon historical documents.

Jacobs didn't spend a lot of time in Salt Lake City anymore. He had moved "back East." The phrase always made Jacobs laugh, as though the Mormons had only just arrived in a covered wagon. As a gay man who liked books, art, the theater, and ethnic food, putting three thousand miles between him and Mormon Central was the smartest thing he had ever done. In Boston, where he was studying theology at Harvard University, he was free of the scrutiny of the self-proclaimed guardians of public morality. He could dress how he wanted, think how he wanted, and, equally important, sleep with anyone he wanted.

In fact, if his old friend hadn't called up and asked him to come out and help him sell this manuscript to the Church, he would have stayed in Boston for Christmas. When Hofmann told him about the document he had found, however, he knew this was something he had to see. The letter turned Mormon theology on its head, and Hofmann had offered him a fifty-percent cut of the profits.

Dated October 23, 1830, the letter Hofmann claimed to have discovered was written by Martin Harris, one of the first scribes of the Book of Mormon, to a certain W. W. Phelps. Phelps, who would go on to become a prominent member of the Mormon Church, had apparently written to Harris asking him for details of the new faith that was sweeping through New England. "Dear Sir," Harris began his reply, "Your letter of yesterday is received & I hasten to answer as fully as I can—Joseph Smith Jr. first came to my attention in the year 1824 in the summer of that year I contracted with his father to build a fence on my property. . . ."

The letter's most extraordinary revelation was Harris's description of Joseph Smith's discovery of the golden plates. In the picture books Jacobs had read as a child, this epochal moment was depicted like a scene from a Disney film. In the foreground Joseph Smith knelt on the ground in a glade of backlit, golden-leafed trees, dressed in a flowing green cape. Towering over him was the angel Moroni: a tall, muscular, Aryan-looking young man with Hollywood good looks, long blond hair, and an ankle-length white robe tied with a golden belt, standing in a shaft of white light, like an actor in a spotlight, his right hand raised, palm up, in a gesture of giving. Smith looked gratefully up at him, balancing on his right knee what looked like a gold ringbinder. These were the mythical plates on which Smith claimed to have found inscribed the Book of Mormon.

Joseph Smith's discovery of the golden plates is the central event of Mormonism's founding legend; its virgin birth; the pivot around which everything else revolves. Hofmann's letter turned

the legend on its head. "In the fall of the year 1827," writes Martin Harris, "I hear Joseph found a gold bible I take Joseph aside & he says it is true I found it 4 years ago with my stone but only just got it because of the enchantment the old spirit come to me 3 times in the same dream & says dig up the gold but when I take it up the next morning the spirit transfigured himself from a white salamander in the bottom of the hole & struck me 3 times & held the treasure & would not let me have it because I lay it down to cover over the hole."

Most of the first six hundred converts to Mormonism were "scryers" like Joseph Smith: poor farmers who used magic and the occult to try and find gold. As Fawn M. Brodie writes in her biography of Joseph Smith, *No Man Knows My History*, "New England was full of treasure hunters—poor, desperate farmers who, having unwittingly purchased acres of rocks, looked to those same rocks to yield up golden recompense for their back-breaking toil." But when Joseph Smith came to write an autobiographical sketch at the height of his fame, all reference to such occult activities were excised from the record. Since then LDS church historians have continued a vigorous campaign to suppress all discussion of the subject.

Yet this forbidden history has continued to percolate beneath the surface of the official versions of the Mormon legend. Hofmann's forgery tapped into these deep fears and anxieties. Instead of divine intervention there was black magic. Instead of an angel there was a talking lizard. Instead of a prophet there was a gold digger, and an impostor. One of the main sources for Hofmann's story of the salamander was an affidavit written by a Palmyra neighbor of Joseph Smith's named Willard Chase. Chase had employed Smith to dig him a well, and during the excavations Smith had discovered the seer stone that he would use to translate the golden plates. This "singularly appearing stone," as Chase called it, was almost black, with light-colored stripes. "I brought it to the top of the well," wrote Chase, "and as we were examining it, Joseph put it into his hat, and then his face into the

top of his hat. . . . After obtaining the stone he began to publish abroad what wonders he could discover by looking in it."

Later in the letter Chase describes the discovery of the golden plates. "In the month of June 1827, Joseph Smith Sr., related to me the following story: That some years ago, a certain spirit had appeared to Joseph, his son, in a vision, and informed him that in a certain spot there was a record on plates of gold, and that he was the person that must obtain them, and this he must do in the following manner: On the 22^nd Of September, he must repair to the place where was deposited this manuscript, dressed in black clothes, and riding a black horse with a switch tail, and demand the book in a certain name, and after obtaining it, he must go directly away, and neither lay it down nor look behind him. They accordingly fitted out Joseph with a suit of black clothes and borrowed a black horse. He repaired to the place of deposit and demanded the book, which was in a stone box, unsealed, and so near to the top of the ground that he could see one end of it, and raising it up, took out the book of gold; but fearing someone might discover where he got it, he laid it down to place back the top stone, as he found it; and turning round, to his surprise there was no book in sight. He again opened the box, and in it saw the book, and attempted to take it out, but was hindered. He saw in the box something like a toad, which soon assumed the appearance of a man, and struck him on the side of the head."

The idea for the letter was "stewing" in Hofmann's mind for several months before he forged it. He studied many contemporary accounts of the discovery of the golden plates, including Chase's account, and drew heavily upon three books in particular: E. D. Howe's 1834 anti-Mormon tract, *Mormonism Unveiled*, and Fawn M. Brodie's biography of Joseph Smith, *No Man Knows My History*. From these he got the outline of the story he would put into Martin Harris's mouth.

The choice of Martin Harris was an inspired one. Only a few examples of his handwriting exist. Harris was also a man with a

problematic life story. A balding, permanently worried-looking man with long, pointed ears, he was a well-to-do farmer from Palmyra, New York, who, before he joined Smith's new religion, was known to have been interested in folk magic and the occult. In his search for God he had already bounced between various sects. He had been a Universalist, a Quaker, and a Restorationist. When he heard of the golden plates, he declared that "a great flood of light was about to burst upon the world." More practically, he offered to pay off Joseph Smith's debts and underwrite the translation of the plates.

His wife, Lucy Harris, thought her husband had lost his mind, and when Harris left his prosperous farm in Palmyra to follow Joseph Smith to Harmony, Pennsylvania, in April 1828, to begin working as Smith's scribe, Lucy had a conniption. A practical-minded Yankee farmer's wife, she was not about to see years of hard work squandered on what she believed was a scam. She demanded to see the golden plates. When her husband did not produce them, she ransacked the cupboards, interrogated the neighbors, and even searched the garden of the house her husband was sharing with the impoverished Smith and his pregnant wife, Emma. To prevent her causing any more trouble, Harris packed her off back home to Palmyra while he began work on "translating" the Book of Mormon.

Mormon scholars claim that the Book of Mormon was written in seventy-five days, at an average of 3,700 words per day. But like any other literary work—Graham Greene only managed 400 words a day—it probably took longer. Most days Martin Harris and Joseph Smith managed just two pages. As neither man was a writer, the finished manuscript looked rather like the first draft of Jack Kerouac's *On the Road*. There was no punctuation, no paragraphing, just a single, 275,000-word sentence.

Harris was never allowed to see the golden plates, even though he was one of eleven witnesses who would later declare that they had "seen and hefted" them. In the hope of convincing

his wife, Lucy, he also took home to Palmyra the manuscript of the first 116 pages of the Book of Mormon. The redoubtable Mrs. Harris promptly destroyed it. Dire warnings of perdition were issued, pillows were cut open, chicken coops overturned, but the manuscript was never seen again.

Despite the loss, publication of the Book of Mormon went ahead as planned. At the last minute, however, Harris did not want to pay the costs. And only after Smith had attacked him with one of his characteristically threatening letters—"Repent, lest I smite you by the rod of my mouth," he wrote, "and by my wrath, and by mine anger, and your sufferings be sore"—did he finally agree to mortgage his farm for $3,000 to pay for the printing and binding of five thousand copies of the Book of Mormon.

Soon afterward Lucy Harris left her husband to start a new life on her own eighty-acre farm. In an affidavit written toward the end of her life, she described her ex-husband's reaction when she questioned the veracity of the book that had cost her her home and her marriage. "In one of his fits of rage," she wrote, "he struck me with the butt end of a whip. . . . Whether the Mormon religion be true or false, I leave the world to judge, for its effects upon Martin Harris have been to make him more cross, turbulent, and abusive to me."

Toward the end of his life Harris became mentally unhinged. While living at one of the first Mormon colonies in Kirtland, Ohio, he fell under the spell of a young prophetess. Like Smith she also used seer stones to have visions. Swaying about in a self-induced trance, she would perform ecstatic dances in front of her followers, then fall on the floor and talk in tongues. Harris himself began claiming he was Christ. He was excommunicated. In old age, after repenting of his follies, he joined the thousands of other pioneers crossing America to settle in Utah.

His damaging revelations about Joseph Smith could not so easily be put back in the bottle (among other things he claimed that Smith had consumed large amounts of liquor to stoke the

creative fires while "translating" the golden plates). It was his revelations about Smith's money-digging activities that caused the Church the greatest unease. In an article that appeared in *Tiffany's Monthly* in 1859, he named Smith as one of a group of people in Palmyra "who were digging for money supposed to have been hidden by the ancients."

Hofmann had a novelist's ability to take research material and synthesize it into an authentic-seeming, imaginative construct. Written mostly in reported speech, in a single, unpunctuated sentence nearly six hundred words long, the Salamander Letter retells the founding myth of the Mormon religion, in a colloquial vernacular that perfectly captures the speech patterns of a Yankee farmer in mid-nineteenth-century America. There is a brief reference to Joseph Smith Jr.'s elder brother, Alvin, which appears in the letter. Hofmann had unearthed rumors that Alvin Smith was also involved with magic and scrying. His death at the age of eighteen was shrouded in mystery. His mother stated that he died from an overdose of calomel prescribed by an inept doctor. But rumors circulated that the body had even been exhumed for an autopsy. To quell the gossip Joseph Smith's father placed an advertisement in a local paper. A year later the Smith family exhumed Alvin's body themselves. Hofmann compresses all these disparate elements into a single cryptic reference: ". . . the spirit says bring your brother Alvin Joseph says he is dead shall I bring what remains."

Since samples of Harris's handwriting have never been found except for a few signatures from the end of his life, Hofmann's first task was to create a script. He had only eight letters—*a, b, i, m, n, r, s,* and *t*—to go on, but by studying other examples of handwriting from the period, he was able to build up a complete alphabet. To create a "voice" for Harris he read contemporary newspaper interviews Harris had given and studied letters by his contemporaries, jotting down phrases and patterns of speech in his notebook. He then created a draft of the letter that, in turn, went through many revisions.

The most powerful image—the white salamander—sprang from Hofmann's imagination. "I chose it [the salamander] only because it was commonly used in folk magic," he would tell investigators. "I didn't realize until later all the implications other people would associate with it as far as being able to dwell in fire. I wasn't smart enough at the time to understand all that. But it just happened to be important, or at least some people thought it was important, the way some people thought various things with the Anthon Transcript or other forgeries were important. . . . People read into it what they want or get out of it what they want."

Hofmann consciously built into the Salamander Letter cross-references to previous forgeries, like the Anthon Transcript. He also embedded in the letter numerous clues suggestive of authenticity. The date of its composition, October 23, 1830, exactly fits the time frame when rumors first began to circulate about Smith's discovery of the golden plates. Another clue was the phrase *short hand Egyptian*, which Harris uses to describe the hieroglyphics contained in the Anthon Transcript. "Joseph says when you visit me I will give you a sign," writes Harris, "he gives me some hieroglyphics I take them to Utica Albany & New York in the last place Dr. Mitchel gives me a introduction to Professor Anthon says he they are short hand Egyptian the same what was used in ancient times."

The term that later came to be used by the Mormon Church to describe the hieroglyphics in the Anthon Transcript was *reformed Egyptian*. But in his researches Hofmann had come across a letter from Phelps in which he uses the phrase *short hand Egyptian*. Phelps's letter was written three months after the date Hofmann ascribed to the Salamander Letter, thus suggesting that Phelps's source for the phrase *short hand Egyptian* was this letter from Martin Harris.

Hofmann applied the same extraordinary attention to detail in constructing a false provenance for the letter. He claimed that

he had bought the letter from a New England dealer in postmarks named Elwyn Doubleday, who had in turn acquired it from a dealer in the Syracuse, New York, area. When Doubleday was interviewed by an official from the church, he said that he did not remember the 1830 letter per se, but that he was "ninety-five-percent certain that it was in his possession" and that he had sold it for $25.

Before the invention of the postage stamp letters were written on double sheets of paper. The second, outer sheet was then folded in such a way as to become the envelope. The envelope was then postmarked and delivered. Dealers like Doubleday generally collect these so-called stampless covers less for their content than for the historic postmarks. Hofmann had taken the stampless cover he had bought from Doubleday, removed the inner sheet of paper, and then written the Salamander Letter on the back of the sheet containing the address panel. He then fabricated a postmark, using a copper plate technique he had learned in high school.

To ensure that the date on the postmark was accurate, he researched Phelps's life, making sure that he was at home around the time of his purported exchange of letters with Harris. He found a letter Phelps had written from Canandaigua to a local newspaper around the twenty-third of October. He even researched the postal history of New York state to make sure that there was a mail delivery to Palmyra on the twenty-second of October, the day that Harris gives ("your letter of yesterday is received") for his receipt of Phelps's letter.

Because the letter was so controversial, Hofmann had his friend Lyn Jacobs negotiate the sale of the forgery to the Mormon Church. Like a politician sending a spokesperson out to face the cameras over a contentious issue, Hofmann wanted to put someone else between him and an explosive document that might blow up in his face. He had also begun to worry that he was simply turning up too many documents. Someone might grow suspicious.

Jacobs told Church officials that he wanted a ten-dollar Mormon gold piece in return for the manuscript, a rare coin with a market value of roughly $40,000. Schmidt balked. So did Hinckley. Not just because the price seemed excessive. The Church was deeply worried about getting involved with the purchase of such a controversial document. They obviously did not want its contents to become public. But they doubted that Hofmann's flamboyant friend, Lyn Jacobs, could keep the transaction confidential. So it was arranged that the letter should be bought by a middleman: a dynamic young businessman and Mormon bishop named Steve Christensen.

Christensen worked for an investment advice company, Coordinated Financial Services. In his spare time he had also assembled a collection of Mormon historical documents, which filled thirty large bookcases and forty-four filing cabinets. After researching and authenticating the manuscript, the plan called for Christensen to buy it and donate it to the Church. The person he approached to help him authenticate the document was Mark Hofmann, who in turn arranged for it to be examined by Kenneth Rendell, the manuscript dealer and expert on forgery, who Sotheby's would claim had authenticated the Emily Dickinson poem.

Hofmann had had several dealings with Rendell, and for an undisclosed fee Rendell declared that, based on his examination of the handwriting, paper, ink, and postmark, "there is no indication that this letter is a forgery." Christensen agreed to pay $40,000, then donated the manuscript to the Church.

As usual, Hofmann was not just interested in making money. He wanted to embarrass and humiliate the Mormon Church by proving that they were actively involved in covering up Mormon history. Long before the spin doctors of today Hofmann knew how to control and shape the flow of information so as to generate publicity and take the initiative away from his adversaries. Strike hard and strike first was his rule, and always keep ahead of the opposition. While he confidentially negotiated the sale

of the letter, he orchestrated a series of news leaks to ensure its contents became public. Soon reporters were calling the LDS church for clarification. Backed into a corner, Hinckley issued a statement acknowledging that he had seen the letter but could not disclose its contents.

The Salamander Letter was not the only fire the Church was trying to put out. A short time before he offered them the Salamander Letter, Hofmann had secretly sold the Church another forgery linking Joseph Smith to gold digging and magic. It was a letter purportedly written by Smith to a landowner in Pennsylvania named Josiah Stowell. In the most damaging section of the letter Smith offers Stowell advice on how to locate the mine. "You know the treasure must be guarded by some clever Spirit," writes Smith. "And if such is discovered So also is the treasure. So do this take a hasel Stick one yard long being new but and cleave it Just in the middle and lay it asunder on the mine so that both inner parts of the stick may look one right against the other one inch distant and if there is treasure after a while you shall See them draw and Join together."

Hofmann had dealt directly with Gordon B. Hinckley about the sale of the letter, and after a series of clandestine negotiations, and a thorough examination of the document, the Church had agreed to buy it for $15,000. To prevent the transaction becoming public, it is believed that Hinckley may even have written Hofmann a personal check. Using his friend Brent Metcalfe, a dissident young historian who had a particular interest in material relating to Joseph Smith's connection with magic and gold-digging, Hofmann now began to leak information about the Josiah Stowell letter to the press. "With Hofmann's permission I showed a copy to a friend of mine," recalled Metcalfe. "And this friend of mine in turn shared it with a reporter from the *Los Angeles Times*. The reporter then called the LDS church and said he was going to write an article about the letter in their Saturday edition."

By making the Josiah Stowell letter public Hofmann was ac-

complishing several things to help further his own cause. He had provided corroborative evidence of Smith's gold-digging activities, which enhanced the Salamander Letter's credibility. More important, he had proved that the LDS church was in the business of suppressing the truth. Fearing the PR fallout, the LDS at first denied that they owned the Stowell letter. In an embarrassing about-face they were forced to admit that they did.

These attacks on the Church's credibility were followed by a burst of disinformation. Hofmann began to leak fictitious stories about other documents, which, he claimed, also contained references to gold digging and magic; and, which, he claimed, were also being suppressed by the Church. One of these fictions concerned a manuscript purportedly written by a man named Oliver Cowdrey. Like Harris, Cowdrey had been one of the first scribes of the Book of Mormon, but later in life he had fallen out with Smith. It was believed that he had written a controversial history of the early Mormon Church, but the manuscript had disappeared.

As a dissident Mormon with a passionate interest in this kind of document, Metcalfe could be relied on to believe in the Oliver Cowdrey History, Hofmann knew. Over lunch at Crown Burger in downtown Salt Lake City, he told Metcalfe that he had seen the Oliver Cowdrey document with his own eyes, in the Church's top secret vaults. He even claimed that Gordon B. Hinckley had been with him when he had done so; and that the manuscript corroborated many of the details about gold digging and magic contained in the Joseph Stowell and Salamander Letters. He then gave Metcalfe a detailed description of the Oliver Cowdrey History, as it became known. It was written on lined paper in a volume approximately 8¼ inches wide, 10 inches long, and ¾ inch thick. It was bound in brown leather and had marbled ends.

This description of a book that did not exist eventually found its way into the *Los Angeles Times*, which cited "a highly reliable source" as evidence that the story was authentic. The highly

reliable source was Mark Hofmann. Other newspapers and magazines, both local and national, ran stories about the forgeries. Radio and television stations, theologians, experts of every kind, discussed the explosive revelations contained in them. The story even went global, when the *International Herald Tribune* published a reprint of one of the articles that had appeared in the *Los Angeles Times*. *Time* published an article under the title "Challenging Mormonism's Roots."

To see America's most influential news magazine use his forgeries to question the foundations of the Mormon religion gave Hofmann immense satisfaction. Even more satisfying was the confusion he had sown in the Mormon Church as it scrambled to contain the damage from two forged documents and locate two others that did not even exist. Swept along by an avalanche of negative publicity the LDS church appeared deceitful and inept. Hofmann had comprehensively outmaneuvered them. When the Salamander Letter was sent to the FBI for authentication, the LDS church sent with it seventeen examples of Martin Harris's signature from their archives. Fourteen of them were forgeries from documents that Hofmann had already sold to the Church. Based on a comparison of the signatures the FBI concluded that the document was genuine.

The Salamander Letter was part of an even grander scheme. By creating an extended document in Harris's hand Hofmann was establishing the orthographic standard for Harris's handwriting. Like an engineer creating a software code, he built into the text minute idiosyncratic details that he knew would be later used to authenticate any other Harris documents he produced. Whenever a *y* begins a word, for instance, as in *you*, the first stroke of the letter is always higher than the second. But if *y* appears within a word, as in *everyone*, this does not occur. This detail was consistent throughout the document.

Hofmann knew that such minute details of a person's handwriting are used by forensic documents examiners to detect forgeries. The last two letters in Abraham Lincoln's signature, for

instance, float above the line. That detail is one of the clues experts use to distinguish between a genuine Lincoln signature and a forged one. By building these details into the Salamander Letter, Hofmann was creating a template for Martin Harris's handwriting. He was also establishing Martin Harris's style. By choosing particular words and phrases, by introducing imagery related to magic and gold digging, he was embedding in the text a series of tropes that he knew would one day be used to authenticate an even more audacious forgery: the Lost 116 Pages of the Book of Mormon.

It is every writer's nightmare to lose a manuscript—or, today, have a hard drive crash—but for Joseph Smith it was a particular disaster. What if he could not remember what he had written? What if his new version of the Book of Mormon changed some key details of the founding legend of his new religion? After all, he was meant to be translating a sacred text revealed to him directly from God. The idea that one day the 116 pages would turn up and tell a different version of the events he described deeply alarmed the Church of Latter-Day Saints. It would prove, among other things, that Joseph Smith was not a prophet but a gifted fiction writer. As a result the Lost 116 Pages of the Book of Mormon became the Holy Grail of Mormon artifacts, the manuscript that the Church hoped to find more than any other in the world. Also known as the Book of Lehi, it was described by Joseph Smith as "the cornerstone of our religion."

Hofmann had started to float rumors about the Lost 116 Pages soon after he sold the Anthon Transcript. He knew that, if he could create them, the Church would probably be willing to pay him as much as $10 million (today they would probably fetch $30 million). To prepare for their creation he embarked on a systematic deconstruction of the language, syntax, and imagery of the Book of Mormon. There were no computers to help him with the task. Instead, having obtained a facsimile copy of the printer's manuscript of the Book of Mormon, the original version from which all subsequent facsimiles were produced, he

hired his friend Jeff Salt to list every word in the manuscript on index cards. (Whether he told Jeff the purpose of this exercise is unknown.) These index cards were then cross-referenced, using a system of color-coding he had developed himself.

Throughout his career Hofmann was also forging and selling counterfeit historic Mormon currency. This time he was literally paying back the Church in its own coin. Charges of counterfeiting had swirled around the early Mormon Church ever since the ill-fated banking scheme that Joseph Smith established in Kirtland, Illinois, in 1837. The Kirtland Safety Society, as it became known, operated like an offshore bank. It was established illegally, without a charter (Smith claimed to have had a divine revelation instead), and was soon printing its own money. For a while everyone in Kirtland was rich. But like the S & L banks of the eighties, there was nothing to back up the currency. Merchants began to refuse to accept it as legal tender. A collapse in land values and several failed land speculation deals further aggravated the situation. When a warrant was issued for his arrest on a charge of banking fraud, Smith fled Ohio on horseback in the dead of night. "Notice is hereby given, that Joseph Smith, of Hancock County, has filed his petition in this court to be declared a Bankrupt," reported a local Illinois paper in May 1842.

Not long before Joseph Smith's death another newspaper, *The Warsaw Signal*, published a number of articles asserting that the Mormons were still printing their own money. "There is a species of counterfeit, extensively circulated in this community, called Nauvoo Bogus," declared the *Signal* in April 1844. "They are a pretty good imitation of the genuine coin . . . some of our businessmen have been imposed upon by them. It is said they are manufactured in the City of the Saints."

Eight months later the Mormons appear to have spoiled quite a number of people's Christmas. "No less than a dozen farmers who have taken their pork to Nauvoo, have been paid in spurious coin, or counterfeit bills," grumbled *The Warsaw Signal*

on December 25, 1844. A month later *The Warsaw Signal* informed its readers that twelve bills of indictment, for counterfeiting "Mexican dollars, and American half dollars and dimes" had been presented to the United States Circuit Court. More damaging still was the assertion that the scam went to the very top of the Mormon Church, to the "Holy Twelve." Were God's Apostles making funny money?

The government certainly thought so. The indictment specifically mentioned Brigham Young and four of the other apostles, William Richards, John Taylor, Parley P. Pratt, and Orson Hyde. Five days later a U.S. marshal was dispatched from Springfield, Illinois, to arrest them. Young was in the temple when the marshal arrived and many years later he would gleefully recall how he evaded arrest by getting a man named William Miller to impersonate him. "William Miller put on my cap and Brother Kimball's cloak," writes Brigham Young, "and went downstairs meeting the marshal and his assistants at the door, as he was about getting into my carriage the marshal arrested him, on a writ from the United States court, charging him with counterfeiting the coin of the United States." He then punctiliously notes the exact time of his escape. "Eight-twenty. I left the Temple disguised." He later referred to the incident as "one of the best jokes ever perpetrated."

The government of the United States of America was not amused. And in the spring of 1846, fearing arrest, Young set off for the Rockies with 70 wagons carrying 143 men, 3 women, 2 children, a boat, a cannon, 93 horses, 55 mules, 17 dogs, and some chickens. In the lead wagon, strapped down so it could not get damaged, was the bell from the Nauvoo temple, which is today proudly displayed in Salt Lake City.

For Mormons the trek west to Utah has a transcendent meaning comparable to the exodus of the Israelites from Egypt to the Promised Land in Palestine. It is an American epic of endurance and courage imbued with the divine. Hungry and

weakened by Colorado tick fever, the pioneers headed toward Zion. As they waited to cross the freezing Mississippi, an "ice bridge" formed, allowing them to walk across the river, replicating Moses leading the Isrealites across the Red Sea. They ate quail's eggs and a mannalike substance they called honeydew. They burned buffalo dung to cook food and provide warmth.

In addition to being an exit to Eden, the trek to Utah was an outlaw's flight from justice. Indeed, in one of the wagons rolling West was one of the best forgers of the day, a man named Peter Haws, who had already been indicted for counterfeiting U.S. coins. After Brigham Young and his followers arrived in Salt Lake City, counterfeiting continued unabated. In the summer of 1858 a young Mormon engraver named David McKenzie was arrested and charged with engraving plates for counterfeit money. McKenzie was one of Brigham Young's protégés. At the time of his arrest he was living in the Beehive House, Brigham Young's private mansion (the beehive is today on Utah's official seal). This privileged position was accorded to McKenzie because he was, literally, the man who made money for Brigham Young. He was in charge of engraving the plates for Utah's first banknotes, the so-called Deseret Currency.

The word *deseret* has nothing to do with *desert*. It is a Book of Mormon neologism meaning "honeybee." Outside Utah, though, Deseret Currency was not worth the paper it was printed on. To access the economy of the rest of the United States, McKenzie, with the full knowledge of Brigham Young, began counterfeiting government drafts on the U.S. Treasury in St. Louis. In a speech to the House of Representatives in 1863, Judge John Cradlebaugh described how the forging had been done in an upstairs room of a store inside Brigham Young's heavily fortified compound. Having used a copper plate to print Deseret Currency, McKenzie would slice off a chunk of the plate and engrave the reverse side to produce the counterfeit notes. It was an early example of recycling.

One of the first forgeries Hofmann sold to the Mormon Church was a small red leather diary, measuring 3¼ by 5¼ inches, belonging to David McKenzie. Forensic tests later suggested that the notebook was authentic, but it had been interpolated with entries in McKenzie's hand forged by Mark Hofmann. One of these forged entries—"Burned all $10 & $20 Deseret Currency"— opened the way for a string of superbly executed counterfeit $10 and $20 Deseret notes. Hofmann was, again, altering history. This time, numismatic history.

Starting in the early 1980s Hofmann also began to produce a string of superbly executed literary forgeries. They were nearly always of American icons: charismatic historical figures that he knew would touch a deep chord in the national consciousness. As in his Mormon forgeries Hofmann deftly exploited lacunae in the historical record—a favorite strategy was to forge a document that was known to have existed but had disappeared—to create a document that fit perfectly into the historical context. When he forged an inscription by Mark Twain to his Connecticut neighbor, Edward Twitchell, in a first edition of *Tom Sawyer,* he did more than simply copy handwriting. Twain never actually corresponded with Twitchell, but he did live next door to him for several years. Hofmann's forgery invented a new and intriguing relationship.

On another occasion he forged an inscription in the front of a first edition of Jack London's *Call of the Wild.* The inscription read: "To Buck and his human friend Austin Lewis." Lewis was the real-life hero of London's book. Just as the words "Aunt Emily" provided Dickinson fans with a warm, familial connection to their heroine, this inscription to the canine hero of one of the greatest American novels added an enticing new dimension to a legend.

In all, Hofmann simulated the handwriting of 129 historical characters, including Joseph Smith, Martin Harris, Lucy Mack Smith, Nathan Hale, Button Gwinnett, Butch Cassidy, Billy the Kid, Betsy Ross, Abraham Lincoln, John Hancock, Paul Revere, George Washington, Martha Washington, Myles Standish,

Francis Scott Key, Mark Twain, Walt Whitman, Daniel Boone, and Emily Dickinson.

To understand how difficult that is, it is necessary to appreciate the complexity of an activity that most of us perform without even thinking about it.

CHAPTER TEN

Isochrony

*U*nder a microscope a segment of cursive script, the form of writing most of us learn at school, looks like swirls of paint on a Jackson Pollock canvas or the brushstrokes of a Chinese calligraphy. Each letter is connected to the next in a continuous, pulsing line that loops and meanders across the paper like a river. Writing is, with speech, what makes us human. Each time we set that river of symbols flowing across the page we are performing a miracle of imagination, reason, and coordination.

Writing involves the coordination of roughly fifty muscles in the hand, upper arm, and forearm. These muscular synergies are extremely complex, but eventually they become automatic. Writing is what is known as an overlearn activity. The picture of our handwriting is stored in the brain, like a software program on a hard drive. When we write, that picture is released by the brain to the hand. On the way thousands of complex instructions pass from the brain to the nerves and the muscles of the arm and hand.

Our handwriting is a marker of our individuality. Though they may have learned to write using the same methods, no two people will write in the same way, not even twins. In a study

conducted by the United States Postal Laboratory, the same organization that led the hunt for the perpetrators of the anthrax-filled letters that brought terror to America in 2001, six forensic document examiners compared the writing of five hundred sets of fraternal and identical twins over several years. What they found surprised them. Despite their numerous other physical and psychological similarities, the twins' handwriting showed as much variation as between any other two, nonrelated individuals.

Graphologists claim to be able to read a person's character and psychology in his or her handwriting. Hitler's manic, violent script suggests the ferocity and inhumanity he would reveal as a political leader. Lincoln's upright-downright handwriting suggests the honest, incorruptible person he was. We can lose limbs or suffer severe handicaps, but we will not lose the picture of our handwriting engraved in our brains.

Numerous factors shape our handwriting: where we were born, our level of intelligence, and age; which writing system we were taught; the instrument we learned to write with; even the size of our wrists and fingers. Watch a class at any elementary school. No two children sit at their desks alike or hold the pen in the same way. Some grasp it like a mallet. Others hold it as though it were a bird's neck. Some write with the pen almost vertical. Some write from the side. Most have their hands below the line on which they are writing. Some have their arms bent around the top of the paper like a contortionist's. The way the pen strokes rise and fall; the pressure we put on the paper; the amount of space between the letters and words; the size of the script and its regularity; how we dot an *i* or cross a *t*—each of us does nearly all those things differently. Our handwriting can be affected by whether we are sitting or standing, whether we have drunk alcohol or caffeine, whether we are suffering from stress or illness, even whether we have just had sex. One of the few things that does not affect our handwriting is our gender. Men and women rarely display discernible differences in their handwriting.

The basic building blocks of writing in the western world are

the twenty-six letters of the Latin alphabet that was developed by the Phoenicians in about 1000 B.C. from an earlier, Semitic alphabet, then refined by the Romans. When we learn to write as children, we construct the letters of the alphabet by drawing a series of strokes. The letter *e*, for instance, is composed of two strokes. Starting in the middle of the letter, we move the pen upward, in a line that curves to the right. At the apex of its trajectory the pen then bends back on itself and drops back to its starting point, forming a loop. Without pausing it then continues to descend, before turning to the right and slightly upward. By repeatedly practicing these strokes we learn to make letters. We then learn to join those letters to form words. By the time we reach what is called graphic maturity, around the age of eighteen, our writing has become automatic. All we have to do is pick up a pen or a pencil, and it flows out of us like water from a tap. If we think about what we are doing, we will probably make a mistake.

Scientists have isolated nine different processing stages in the act of writing, from the initial idea to write, the so-called activation of intentions, to the selection of individual letters, their size and slant and position, to the bursts of neurophysiological activity required to coordinate the muscles in our arms, forearms, and hands. "Writing begins with an intention to want to write," said Ted Wright, a cognitive psychologist at the University of California, Irvine, who uses handwriting to study how the brain works. "And this is fairly abstract. The brain then has to convert that intention into action. This all happens below the level of consciousness."

The intention to write originates in the upper cortex, where other mental activities, like thinking or problem solving, or decision making, take place. The next step is called semantic retrieval. This can be compared to the way binary code pulls information off a hard drive. "It's like a memory trace, a place in part of the brain that says *q* is made up of these particular

strokes. There is a sequencing process to order these strokes, like the brain making a list."

As the complex process of coordinating more than fifty muscles begins, control switches from the upper brain to the brain stem, the place where our most basic drives and reflexes are stored. We begin to form the individual strokes of a letter and our hand moves up and down as the muscles push and pull against each other. Scientists call this push-pull action of the muscles the agonist and antagonist.

All of these processes are being performed below the level of consciousness at a speed that makes the nimblest of supercomputers look sluggish. Like a bullet fired from a gun, letters and words flow from our hands onto the page in a continuous ballistic line. It takes us only 150 milliseconds to form a stroke, and on average we produce four to seven strokes, or two letters, per second. As we do so, the pen is moving across the paper at speeds of up to 200 millimeters per second. By the time we notice that we have made a mistake, the pen is usually three or four letters farther across the page.

Not that the pen or pencil is always moving at the same speed. It speeds up and slows down according to the complexity of the strokes required for each letter. The letter q, for instance, consists of seven strokes. At the end of each of these strokes is what is known as a stroke boundary. Studies have shown that it is at these stroke boundaries that the pen slows down the most, above all at moments of high curvature, like at the top of the letter e.

In 1983 an Italian psychologist, Paolo Viviani, discovered that the speed of the pen as it moves along a curved trajectory is always in direct proportion to the local radius of the curve. Imagine a car slowing down as it comes into a curve, then speeding up as it leaves the curve. Viviani proved that the speed of the pen or pencil, as it follows the curves of a letter, is in proportion to the tightness of the curve. The equation he formulated, known as the Two-thirds Power Law, is, in the world of handwriting research, the equivalent of Einstein's laws of relativity.

"The speed the pen moves varies a lot in the course of writing a word," explained Professor Ar Thomassen, a Dutch professor widely regarded as one of the world's experts on handwriting. "A velocity peak is the maximum speed the pen is moving. These usually occur in the middle of a stroke, and they are very specific to each of us, which is why security systems usually focus on them."

These internal rhythms can be thought of as the bone structure of our handwriting. "Each of us creates strokes at a particular speed, with regular time intervals between each stroke," says Ted Wright. "This is what is known as isochrony. But it is the deviations from these regular patterns that most readily identify a person's handwriting. These are idiosyncratic between people, but very stable within one person's handwriting."

In an experiment performed at the Nijmegen Institute for Cognition and Information in Holland, two psychologists, Arend van Gemmert and Gerard van Galen, examined what happened when people tried to forge someone else's handwriting. Using a Calcomp 9000 digitizer tablet, an electronic writing pad hooked up to a stylus, which can measure the exact position of the pen and its velocity one hundred times per second, they asked ten volunteers to write the Dutch sentence *"Is het mormel in het hok,"* "The monster is in the den," first in their own hands, and then in someone else's.

Most of the subjects did a passable job of imitating the general look of the handwriting they were simulating. However, the internal dynamics of that handwriting, the way that it was produced, was markedly different. They took longer to initiate the act of writing; they wrote slower; they moved the pen with far less fluency; and they were more prone to hesitation. "Even though they could imitate someone else's writing fairly well," said van Gemmert, "if you looked carefully it was quite different. Basically, everything slowed down. And there were far more dysfluencies, moments of hesitation where they paused for a split second to consider what they were doing. It was more like drawing."

When we write in our own hand, we are using visual control or "global monitoring." This can be compared to driving on a highway where we take in our surroundings in a general way but do not consciously note each landmark. Forging is more like making your way along a potholed back road, at night, where you have to concentrate in order not to crash into a tree or fall into a ditch. That conscious attention throws a forger out of open-loop mode into a closed-loop mode. The conscious mind takes over, the handwriting slows down and becomes less fluent. "You have to look at the handwriting you are imitating, and compare and change what you are doing as you go along," continued van Gemmert. "And this usually causes disfluency."

The study revealed something else: that when we attempt to imitate someone else's writing we instinctively stiffen up. "There is stiffening of what is called the pen-limb system," he explained. "The fingers, the wrist, the arm muscles. We tend to grip the pen harder and press on the paper with more force."

Forgers have to counteract all these tendencies. Above all they have to simulate the fluid, uninterrupted flow of natural writing. Authentic writing begins and ends with what are called flying starts and endings. A stroke begins as a faint, narrow line that thickens as the pen moves forward. As it approaches the end of a word, the pen begins to slow down again, and the river of ink contracts, growing thinner and fainter until the pen lifts from the paper. Forgers usually don't make these flying starts and endings. They leave telltale accumulations of ink at the beginnings and ends of strokes; make sudden changes of direction, or hesitate in midstroke. Often, in a desire not to be detected, they unconsciously shrink the scale of the handwriting. Richard Nixon's signature was a self-important squirt of ink up to four inches long. Most forgers render it half that size.

By far the greatest challenge for a forger is to simulate the complex internal rhythms of another person's handwriting. "Studies of a person forging show that high-frequency spectrums are much more present in forgery," Professor Thomassen ex-

plained, "because the forger is putting more energy into copying the shapes, which requires extra muscular tension. And this will usually be visible when a person is forging. Probably the hardest thing to imitate is the dynamics of a person's handwriting: the velocity and velocity changes which make up the distribution of strokes in a word."

Is it possible for someone to simulate another person's handwriting perfectly, to so completely absorb its internal properties that they could replicate it as fluently and automatically as their own? "If you could achieve a state of mind in which you are in perfect control of your sensory and motor faculties, without any obvious effort," Professor Thomassen answered, after a long pause, "perhaps it would be possible...." Then his voice trailed off, as though baffled by the implications of the idea.

It is said that at the age of ten the eighteenth century Scottish philosopher David Hume could write Latin with his right hand, while simultaneously writing Greek with his left hand. Hofmann's ability to forge numerous other people's handwriting showed a similar virtuosity. He seems to have been able to access a state of mind that enabled him, in the moment of executing a forgery, to be both intensely focused and fully relaxed. Just as elite athletes talk of being "in the zone," he was able to achieve such a level of immersion in what he was doing that he could set aside his own deeply ingrained writing patterns and effectively become the people he was forging. At a Chinese restaurant in Boston in 1984, where Hofmann was having dinner with his wife and several of his closest friends, he took a crayon and began to reel off signatures on the white paper tablecloth: the solid, columnar construction of Abraham Lincoln's signature; the florid, wrought-iron curves of George Washington's hand, with its ornate loops and arabesques; the low, rightward-rushing scrawl of Samuel Langhorne Clemens.

How did he do it? An incident from his childhood suggests that Hofmann had early on developed extraordinary mental powers. One day, when he was still a teenager, he sat contem-

plating an apple on his desk. He studied its shape and the marbled red-and-yellow patterning on its sides. He inspected the woody texture of the stalk and the way it rose, like a miniature flagpole, from the cavity at the top of the apple. He noticed how little circles of light shone on the waxy surface of the fruit, as it does in the paintings of Caravaggio. Like a camera tracking across the moon his eyes roamed over the surface of the apple, noting each mark and blemish, each curve and speckle. Then he blinked. And the apple was gone.

Self-hypnosis would become Mark Hofmann's religion and the most powerful weapon in the armory of skills he used to manipulate and deceive the world around him. He first became interested in self-hypnosis when his father took him to see the legendary stage hypnotist Reveen the Impossibilist. In the fifties and sixties Peter Reveen, a Canadian-born performer, widely regarded as one of the masters of the art, had a huge following across North America. His shows were always sold out, and people returned again and again to watch him perform his extraordinary feats of magicianship.

The highlight of Reveen's shows involved hypnotizing members of the audience. With the stage bathed in blue light he would put volunteers from the audience into a deep hypnotic trance before leading them through a series of performance routines. A housewife who had never had music lessons would play an instrument. A lumberjack would dance like Nureyev. A shy, self-conscious bank manager would lose all his inhibitions as he enacted the part of a sheriff in the Wild West. This seemingly magical transformation of ordinary people into confident performers never failed to bring the house down.

Reveen's success was based on a keen understanding of the power of suggestion and a conviction that we all have untapped potential that we do not use. He would later develop these ideas in a book called *The Superconscious World*. For several years, starting in 1973, Reveen lived in Salt Lake City. As well as giving frequent performances of his stage show, he worked with local

doctors on the use of hypnosis to cure smoking or reduce the pangs of childbirth. Articles about him appeared in local newspapers. He was interviewed on regional television networks. And it was during this time that, unbeknown to him, the teenage Mark Hofmann attended one of his shows.

Reveen's ability, through the power of suggestion, to make his audience do things they never would normally have done, his photographic memory, and his belief in the almost infinite potential of the human mind had a profound effect on Hofmann. He had already begun to forge coins. He had begun to believe that Joseph Smith was first and foremost a charismatic fraud who, through sheer force of mind, had convinced people that he was a prophet. Watching the Impossibilist hypnotize people only confirmed his gathering sense that reality and illusion are much closer than we imagine: that beneath the surface of our lives lies another, mysterious dimension. He began to read everything he could about hypnosis and self-hypnosis, including Peter Reveen's book, *The Superconscious World*. He practiced on himself and his friends. Before long he was able to put himself in a trance almost at will. He used self-hypnosis to have a root-canal filling without anesthetic. He also used it to train his memory. On one occasion he put himself in a trance and walked from his home on Marie Avenue to a coin shop about a mile away. When he came out of the trance, he was able to recall the journey in photographic detail, right down to the license plates of cars that had passed him while he walked and the numbers on stores. He also built his own biofeedback machine and enjoyed showing off to the other kids on the block how he could control his brain waves and galvanic skin-responses. He even built himself a crude lie detector and amazed his friends by demonstrating how he could beat it.

Like a Zen master, Hofmann would eventually gain almost total control over his own mind and emotions. It was these extraordinary psychic powers that enabled him to control and manipulate others. Before going into a business meeting where

he knew he would have to lie, he would put himself into trance to convince his subconscious mind that what he was telling the truth. Self-hypnosis stopped his hand from shaking as he forged a document and gave him his almost shamanistic ability to enter the spirits of the people he was forging. Was he, as the New Age mystics would have us believe is possible, "channeling" Emily Dickinson? At some level, it seems that he was, for his forgery went far beyond the mere copying of her handwriting. It was as though Hofmann had temporarily taken possession of her spirit.

It was then, in the moment of forgery, that he felt more at peace, more free, than at any other time. By pretending to be someone else he could escape the inner demons that haunted him. He could forget himself. He was no longer the mixed-up son of repressive Mormon parents; the geeky schoolboy with the calculator on his belt who could not tell anyone what he really felt; the small town documents dealer who would spend the rest of his life scratching a living from the literary remains of the dead. He was a poet and a magician; a conjuror of ink and paper; a ventriloquist and shape-shifter. He was Joseph Smith and Walt Whitman; Abraham Lincoln and Daniel Boone.

And in "bad, sad Emilie," as she once jokingly referred to herself, he found a life almost as shrouded in secrecy as his own.

CHAPTER ELEVEN

The Myth of Amherst

"Almost nothing to do with Emily Dickinson is simple and clear cut," Richard Sewell wrote in the introduction to his landmark biography, *The Life of Emily Dickinson*. "She told the truth, or an approximation of it, so metaphorically that nearly a hundred years after her death and after much painstaking research, scholars still grope for certainties."

Certain it is that, in 1871, the year the forged poem was dated, Emily Dickinson was forty years old, unmarried, and living at home with her parents and younger sister, Lavinia, at "the Homestead." Set back from the road, with a grove of oaks screening it to the rear and a large concealed garden, it was a suitably discreet and private place for this most private of artists. Locals called the house the Mansion.

It was as well that passers-by could not see into the interior of the house, for few families have been as complicated, and as dysfunctional, as the Dickinson clan. As is true of many artists, the very qualities that made Emily Dickinson capable of hammering a string of words into a passionate work of art—extreme sensitivity, a tendency to live inside her own head, intellectual rigor—had undermined her potential for happiness. By now, her

already strong tendencies toward introspection and reclusiveness had become chronic. She spent most of her time in the second-floor bedroom where she wrote her poetry. Except for the occasional visitor, she had no contact with anyone except her parents, her sister, Lavinia, and her beloved Maggie Maher, the Irish serving girl who helped in the house. Usually, when visitors arrived, she would refuse to come down, insisting on speaking to them from behind the banisters at the top of the stairs, or through a crack in her bedroom door. Much has been made of the fact that, by this point in her life, as though to emphasize her spiritual purity, Dickinson dressed only in white cotton house dresses. Some believe the real reason may be that, as a result of the kidney complaint that would eventually kill her, she may have been incontinent. Like hospital smocks, these plain, white dresses were easy to change, and wash. She was also aging fast. Her diminutive frame was beginning to stoop. Her eyesight was failing. She had now become hypersensitive to sunlight. Her closest companion, her beloved Newfoundland dog, Carlo, had died five years earlier.

Her father, Edward Dickinson, who was sixty-eight years old in 1871, was an authoritarian, humorless man ("thin, dry, and speechless" was how one contemporary described him). A successful lawyer, former congressman, and leader of Amherst society, he had spent most of his life doing everything but be with his family ("too busy with his Briefs—to notice what we do" was how Emily described him). At the same time as neglecting them emotionally, he never let go of his children and feared the competition of other men in his family. Emily Norcross Dickinson, the poet's mother, was a cold, Puritanical woman who could neither give nor receive love ("I never had a mother," the poet wrote in 1870). She was an obsessively tidy housekeeper and a lifelong hypochondriac. In 1871 she was sixty-seven years old and suffering from depression.

Emily's isolation was accentuated by the conditions of life at that time. There was no electricity, of course: just candles and

kerosene, and these were kept to a minimum. In the winter she would have spent much of her day in semidarkness. Only the living room was properly lit. The rest of the house remained shrouded in darkness and shadow.

Next door, at the Evergreens, lived the other half of the clan: Emily's beloved brother Austin; his wife, Sue Gilbert Dickinson, and their children, Martha, Gilbert, and Ned Dickinson. Austin was forty-two in 1871. He had dreamed of leaving Amherst and starting a new life in the Midwest, but he had never slipped the tangled knots binding him to his family. Instead, he had followed in his father's footsteps and become successful in Amherst. He was president of the Village Improvement Society and sat on the board of numerous local organizations, including Amherst Academy and the Amherst Gas Light Company. When walking about town he liked to wear lavender-colored trousers and a wide-brimmed yellow planter's hat over his bushy red hair.

His marriage to Sue, a heavyset, darkly attractive woman with powerful appetites, gastronomical and sexual, had started in rapture and ended in misery. A photograph taken of her toward the end of her life, in 1897, shows Sue seated on a bench wrapped in mourning clothes, like an Arab matriarch in purdah. Like many women for whom social advancement becomes an all-consuming passion, she had started life on the wrong side of the tracks. The daughter of an alcoholic ne'er-do-well from Baltimore, she had been orphaned in early childhood. In the Dickinsons she hoped to find the sort of stable family she had never had. It wasn't to be. The brilliant young poet got hopelessly entangled in her brother's courtship of Sue, both as go-between and suitor. In his psychoanalytic study, *After Great Pain*, John Cody suggests that Emily Dickinson was drawn to Sue because she hoped to get from her what she had never got from her mother. There is also a suggestion that she was transferring sexual desire for her brother, Austin, for whom she had developed incestuous feelings as a child. "Susie, will you indeed come home next Saturday?" she wrote to Sue in Baltimore, in 1852, one

of hundreds of letters and poems—more than to anyone else—that Dickinson addressed to her brother's future wife. "And be my own again, and kiss me as you used to? . . . I hope for you so much, and feel so eager for you, feel that I cannot wait, feel that now I must have you—that the expectation once more to see your face again, makes me feel hot and feverish, and my heart beats so fast." At the same time, Sue was being bombarded with long, agonized letters from Austin. "I love you Sue up to the very highest strain my nature can bear. . . ." he wrote her from Amherst before their engagement. "Love me, Sue—Love me—for it's my life."

Having insinuated herself, cuckoolike, into the Dickinson nest, Sue proceeded to establish herself as Amherst's social queen. Soon the Evergreens was the social hub of the town. When Ralph Waldo Emerson came to Amherst on a lecture tour in 1857, he stayed at the Evergreens.

Yet, beneath Sue's social veneer was a deeply angry person. She is believed to have aborted four children. Her only surviving son, Ned, suffered from epilepsy, probably as a result of her attempts to abort him (at night he would sometimes bite through his tongue). Like many children of alcoholics Sue drank heavily herself. Eventually life at the Evergreens would resemble a nineteenth-century version of *Who's Afraid of Virginia Woolf?* Sue threw wild parties, ate oyster stew at midnight, and had affairs (her husband called the Evergreens "my wife's tavern"). Austin, whose idea of a pleasant evening was reading a book, hated the socializing but had to foot the wine and food bills. "Austin is overcharged with care," commented sister Emily, with characteristic prescience, "and Sue with scintillation."

When drunk, Sue would fly into fits of rage. On one occasion she threw a carving knife at Austin that missed killing him by inches. Austin responded with stony silence. Ned Dickinson, who later said he had grown up in "an atmosphere of Hell," recalled finding his mother kneeling on the floor begging his fa-

ther to speak to her. "Abnormally self-centered; an egotist; arrogant; haughty; pretentious; and, to give the Devil her due, she could be gracious, clever, entertaining on the surface, and black as the blackest ink inside, where truth is generated, and where it lives, lives at all" was the verdict of a contemporary. Emily's sister, Lavinia, called her "the Old Scratch."

Like many Americans, before and since, Austin Dickinson found consolation in God. And in the arms of another woman: Mabel Loomis Todd, the woman who would become Dickinson's first editor after the poet's death. Dickinson, and most of Amherst, knew of the liaison. But propriety demanded the pretense of secrecy. Emily corresponded with his brother's mistress and sent her poems, but to preserve decorum the two women never met face to face. By that time Dickinson had also broken off all contact with her brother's wife, Sue. Though Emily Dickinson and Sue lived only a hedge away, fifty yards from each other; though their lives were intimately linked by marriage and the poet was aunt to Sue's three children, Martha, Gilbert, and Ned, for fifteen years, from 1868 until 1883, Emily Dickinson did not once set foot in the house of the woman she had once worshiped as "an Avalanche of Sun." The last time she had left the grounds of the Homestead was six years earlier, in 1865, when she went to Boston for eye treatment. "I do not cross my father's ground to any House or Town," she wrote to one of her closest friends, Thomas Wentworth Higginson, in 1869.

She felt equally out of step with the times. The religious revivals that swept through Amherst unnerved her with their hysteria and fundamentalism. The carnage and divisiveness of the Civil War distressed her. She loathed the windy rhetoric of politicians. Despite all this she went on keeping up appearances. She helped her father run the household; she gardened and baked; organized the household's three servants; wrote letters of condolence to local widows; and kept up a lively correspondence with her many friends, both male and female. But only when she was upstairs in her bedroom writing at the table by the

window could she be truly herself. Then she could say who she really was and give voice to the thoughts and feelings she kept hidden at all other times.

Her poems were her private torch-songs, by turns violent and loving, sadistic and self-hating. "I felt a Cleaving in my Mind—" she wrote, in 1864, after she had suffered what we would today call a nervous breakdown, "As if my Brain had split—/I tried to match it—Seam by Seam—/But could not make them fit./The thought behind, I strove to join/Unto the thought before—/But Sequence ravelled out of Sound/Like Balls—upon a Floor—"

It took almost one hundred years for the world to be able to handle art as raw and confessional as that. These short, sharp, shocking cries from the heart, with their jazzy rhythms, needle-sharp wit, and white-hot emotions, would have shocked her family and friends, and outraged the smug guardians of public morality in nineteenth-century Amherst. As a result Emily Dickinson was careful to ensure that the connective tissue linking her life and her art was almost entirely missing. As Richard Sewell has noted "she hid herself to write her poems—and (for whatever reason) hid her poems, except for a few."

None of the seven hundred poems her sister found in a locked box in her room after her death, and the other one thousand and eighty-nine which would later be located, was dated. Only twenty-four had titles. Among them are some of the most intense and intimate love poems in the English language. Dickinson intentionally left no hint, however, as to the events in her life that precipitated them or the people who inspired them. In fulfillment of a stipulation in her will all her correspondence was burned after her death. Many of the letters she wrote to others vanished. The rest of her papers were, often crudely, bowdlerized by her relatives. Almost certainly one of the reasons that Mabel Loomis Todd unbound Dickinson's fascicles was to weed out and destroy poems that, in their frank assessment of the world or explicit sexuality, could have damaged the reputation of Amherst's leading family. A note from her sister-in-law had

chunks cut from it with a pair of scissors. Other letters had words crudely blacked out or disfigured.

We do not even know with any certainty what the poet looked like in later life. Dickinson was extremely wary of being portrayed or photographed, and she made sure that the only image that has come down to us is the famous daguerreotype which is believed to have been made by Otis H. Cooley, a photographer who ran a studio in Springfield, Massachussets, in 1847, when the poet was a seventeen-year-old schoolgirl. A photograph that many believe to be of Dickinson that turned up on eBay's auction site in the year 2000, is almost certainly a forgery. It shows a dark-haired woman, with full, sensual lips, large, dark eyes, and sallow skin pockmarked with pimples. A forensic anthropologist who examined it claimed that the physiological structure of the face and shoulders do not preclude it actually being Emily Dickinson—and the kidney complaint she suffered from could well have made her skin as unhealthy as it looks in the photograph—but no provenance or other documentary evidence has yet been found.

Dickinson was especially careful about concealing everything to do with her love life. We do not even know if she ever lost her virginity. She is known to have been extremely self-conscious about her body (on one occasion she refused to allow a doctor to examine her), and though she could write sensual, erotic poems like "Wild Nights," it seems unlikely that she was ever alone with a man long enough to consummate a relationship. Her repressive Protestant upbringing had also imbued her with ambivalent feelings about sex. Nothing seemed to frighten her more than the possibility of happiness. As a result she nearly always fell in love with people who were either married or unavailable in other ways.

In the last years of her life she did fall in love with a prominent Massachusetts judge: a friend of her father's, twenty years her senior, named Otis Philips Lord, of Salem. In her letters Dickinson called him "My lovely Salem," "My Sweet One," even

"My Church." How intimate they were remains unknown. One story has it that they were discovered entwined in each other's arms on a sofa. It is also believed that Lord proposed to her. A relative of the septuagenarian judge, who deeply disapproved of the relationship, called Emily Dickinson a "little hussy" and claimed that, as well as having "loose morals," the poet was "crazy about men."

The verdict owes more to vindictiveness than truth, though as a young woman Dickinson is known to have had numerous crushes, some of them intense, on various young men (and women). There is a persistent rumor in the biographies that one of these crushes developed into a full-blown passion, but that her father stepped in to crush it before it could lead to marriage, cutting the young poet's life in two and causing her withdrawal from the world. Various candidates have been put forward, among them a young student from her father's law office named Benjamin Franklin Newton, whom the poet first met when she was seventeen. Dickinson is also known to have had feelings for one George Gould, a brilliant young student from Amherst College admired for his artistic nature and oratorical skills. Dickinson's overpossessive father is believed to have forbidden his daughter from seeing or corresponding with Gould. Was this the person who broke her heart and blighted her life? Or was it the rancorous collapse of a passionate lesbian relationship with her sister-in-law, Sue, as feminist scholars have argued, that cast a pall over her? The postmortem mutilation of Dickinson's letters to her sister-in-law suggests it might have been. There is also evidence to suggest it was not. One scholar has raised the possibility of incest with her brother, Austin; another, of a secret pregnancy. The fashionable verdict today is that she was bisexual.

At the height of her powers, between 1860 and 1864, Dickinson was completing a poem, on average, every two days. In four short years, from 1861 to 1865, she would produce nearly half of all her work. In one year, 1862, it is estimated that she

wrote, revised, copied, and bound nearly three hundred poems. But by 1871, the year that Hofmann chose to situate his forgery, her creative powers were cooling. The quality of her work was also declining. Instead of a poem every two days she was now producing, on average, three to four poems per month. Many of them were just the sort of playfully agnostic "wisdom pieces," as Richard Sewell, her biographer, called her occasional verse, as "That God cannot be understood."

The way she stored her poems had also changed. By 1871 Dickinson had all but abandoned her dream of being published, and she no longer put herself through the rigorous work of composition, revision, and binding that she had in the previous decade. She no longer painstakingly worked on her first drafts. She had almost given up making fascicle sheets. Most of her poems were now composed on scraps of household paper. If she was sending a poem to someone, she wrote it on a sheet of writing paper. In 1871 she was using mostly blue-lined Congress paper from Boston, the same paper Hofmann forged for his poem, "That God Cannot Be Understood."

Very few people had tried to forge Emily Dickinson poems, and since her autograph material is among the most valuable of American poets, she was a perfect target for Hofmann. Much of Dickinson's life is filled with myth, conjecture, and is unsupported by the historical record. Hofmann knew he could help fill in the blanks. Before he would attempt to write the poem, however, he would dazzle the American literary establishment with another sensational forgery.

CHAPTER TWELVE

The Oath of a Freeman

While looking through an auction cata-
log, Hofmann had noticed that First
Folios, the original printed editions of
Shakespeare's works, were selling for several hundred thousand
dollars. Today they would be worth four to five million. Surely,
he reasoned, a rare piece of early printed Americana, something
that touched a chord with Americans, as Shakespeare resonated
with the British, would sell for a similar amount. What could
possibly touch a deeper chord than the first document ever
printed in North America?

The Oath of a Freeman came with a wonderful story that in-
cluded a smuggled printing press, death at sea, sedition, and the
first flowering of freedom in historic New England. "A printing
house was begun at Cambridge by one Daye," Governor John
Winthrop, of Massachusetts, recorded in his journal in March,
1639, "at the charge of Mr. Glover, who died on sea hitherward.
The first thing which was printed was the freeman's oath."

The printing house Winthrop was referring to was set up by
a locksmith named Stephen Daye. Little is known of Daye, ex-
cept that he was from Cambridge, England, and in 1638 set sail
on a ship called the *John of London* to begin a new life in the Bay

Colony, in what is today Boston. With him went his wife, Re-
becca, and his two sons, Matthew and Stephen. Their passage—
"the summe of fforty and fower pounds," as a contemporary
document records—was paid by Joss Glover, a wealthy Puritan
cleric from the village of Sutton, in Surrey.

Glover had fallen out with the Church of England over
something that, three hundred years later, would come to domi-
nate the American way of life. A royal order of 1634 required all
clerics to read from the pulpit what was known as "the Book of
Sports." The ostensible purpose of this edict was to legalize
recreational activities like hunting or shooting on Sundays, so
long as these recreations did not "tend to the breach of the laws."
Its real purpose was to flush out nonconformist clergymen. To
Joss Glover, an upright-downright Puritan, the Sabbath was the
Lord's day. Playing sports was blasphemy. So, in 1638 he decided
to quit the liberal shores of England and sail aboard the *John of
London* to the New Jerusalem being built in Massachusetts.

Before sailing from Greenwich, Glover smuggled aboard a
printing press, sixty pounds' worth of paper, and some crates of
Dutch printer's ink. He also brought with him a printer. For legal
reasons sufficient to the time, the name of the printer has not
been recorded. A royal charter of the Stationers' Company ex-
pressly prohibited anyone who was not a member of the com-
pany from printing anything, anywhere. Printers who broke the
licensing acts were subject to severe penalties. "I thank God," Sir
William Berkley, the royal governor of Virginia, wrote in 1671,
"that there are no free schools nor printing and I hope we shall
not have these hundred years; for learning has brought disobe-
dience, and heresy and sects into the world, and printing has
divulged them. . . . God keep us from both." It was against atti-
tudes like this that the Puritan poet John Milton wrote his mag-
nificent polemic, *Aeropagitica.*

Unfortunately, both Joss Glover and the anonymous printer
perished at sea, but their dream of founding an American press
did not die with them. In 1638 the locksmith Stephen Daye and

his sons set up what came to be known as the Cambridge Press. Three years later Daye was rewarded with a grant of three hundred acres of good Massachusetts land for "being the first that set upon printing," as a contemporary document quaintly calls it.

When, more than one hundred and fifty years later, in 1792, a printer named Isiah Thomas found what he believed was Daye's original press in New London, Connecticut, one can only imagine his excitement. For the Cambridge Press occupies an exalted place in the history of American printing. Up until its foundation in 1638 all books and pamphlets were published in England and shipped across the Atlantic. Now, for the first time, Americans could choose for themselves what could or could not be published. Without it America's first newspapers, like the *Gazette* in Boston, the *American Weekly Mercury* in Philadelphia, and the *New York Gazette*, would never have been established. And though its output was small, the press that Daye founded would produce some of the most valuable printed books in America, like the John Eliot Indian Bible, a copy of which sold at auction in 1999 for $180,000.

Why the Oath of a Freeman was chosen as the first document to be printed on Daye's press is not entirely clear. The fact that it was short, only one page, and without too much graphic complexity, certainly made it suitable for putting the press—and the neophyte printer, Stephen Daye—through their paces. More likely it was the symbolic political content of the document. Trade guilds in England had been administering oaths like this to their members for centuries. Like most English legal documents they always began with an acknowledgment of the Crown's authority. This oath, however, intentionally omitted all reference to the king's authority or laws. "I (AB) being by God's providence an Inhabitant, and Freeman, within the Jurisdiction of this Commonwealth," it began, "do freely acknowledge my self to be subject to the Government thereof." It was the first whisper of what would become a shout for freedom, an act of

civil disobedience that would culminate in the Declaration of Independence and the speeches of Martin Luther King.

It was also the fulfillment of the promise Stephen Daye had made to the Reverend Glover as he lay dying on the *John of London* while it tossed and rolled on the cold, dark seas of the Atlantic. A printing press was as important for the cultural foundation of what would become the United States as the creation of Harvard College. And one can only imagine the cheers that went up that day in 1639, in Cambridge, Massachusetts, as, having inked the plates and set the type with his printer's stick, Stephen Daye, surrounded by his family and colleagues, peeled the first imprint of the Oath of a Freeman from the press and held it aloft.

Then the scene goes dark. At some point later—no one knows when—the original Oath, and the plates it was printed from, vanished. Only four facsimiles, each with slight variations, survived. The earliest was the one adopted by the Governor and Company of Massachusetts on May 14, 1634. Another version was also entered into the Company's manuscript records. The third was printed in an anti-American pamphlet, *New-Englands Jonas Cast Up at London,* which was published in the British capital in 1647. The fourth was printed in what was known as the Massachusetts *Book of the General Laws and Libertyes,* in Cambridge, in 1648.

The Oath became the black tulip of printed Americana, the document every library and collector dreamed of finding. When Charles Evans, author of the definitive history of the book in America, *American Bibliography,* discovered that there might be a copy in the British Museum, he hurried across the Atlantic. He would later describe, in the language of sexual arousal, his feelings as he waited for the Oath to be brought to him in the British Museum's Reading Room. He was, he wrote, like a man about to enter "into the holy of holies of delight, when the body thrills with suppressed emotions, the eyes moisten." Evans never penetrated his holy of holies. The Oath was no longer on the shelves and was presumed lost.

Although Evans never saw it, when he completed *American Bibliography* after thirty-five years of monumental labor, a twelve-volume catalog of the 39,162 items printed in America between 1639 and 1800, the Oath was at the very head of the list. If it were ever found, it would be one of the most important discoveries of the twentieth, or any, century. It would also be one of the most valuable pieces of printed Americana: more valuable than the first sporting book, a sermon on the pleasures of fishing published in 1743; or the first edition of Thomas Paine's "Common Sense" in 1776; more valuable than the first, 1777, American edition of John Milton's *Paradise Lost*; or even the first American edition of a Shakespeare play, *Hamlet*, which was published on this side of the Atlantic in 1794.

Like the Holy Grail, the Oath of a Freeman hovered on the horizon of every bibliophile's dreams, tantalizing, improbable, yet perhaps, after all, out there. Perhaps it was lying in some attic in New England among old piles of *National Geographic*. Perhaps an amateur collector had bought it at a flea market, not knowing what it was, and it was now stashed away in a storage locker in Poughkeepsie. Perhaps it had made its way back across the Atlantic and was glued into the back of a book on a dusty shelf of a private library in an English country house. Perhaps.

Ironically, Hofmann had first come across the Oath in a Sotheby's catalog. Lot 32 of a major sale of books and manuscripts from the renowned Sang Collection, in March 1985, was the version of the Oath printed in London in 1647, under the title *New-Englands Jonas Cast Up at London*. At the same auction a rare first edition of *Uncle Tom's Cabin*, inscribed by Harriet Beecher Stowe, was also being offered. Hofmann wanted to acquire the book and had traveled to New York to attend the sale preview. While there he expressed an interest in purchasing the *Uncle Tom's Cabin* first edition, to his agent in New York, Justin Schiller.

Schiller, a rotund, bespectacled bookseller with offices on Park Avenue, who is widely regarded as one of the world's leading authorities on the history of the children's book, had met

Mark and Doralee Hofmann the year before, and had already helped them acquire a number of major items for the collection of rare children's books they were building, including a first edition of *Pinocchio*, in the original Italian, and a two-volume *Heidi*, in German. "We met Hofman and his wife at a book fair," he remembered, "and he chose us over several other dealers to build an important collection of children's books. He told us it was for his three children. A heritage in literature."

Schiller remembers Hofmann as polite, understated, and extremely knowledgeable about books. "He was always very calm, so you couldn't read his excitement level," he continued. "He was very likable; very charming. He was simple: in the sense of not being garish. He dressed very conservatively, always with a white shirt, a tie, and a jacket."

What Schiller did not know was that he was being set up to help Hofmann try and pull off the greatest literary hoax of all time. A few days after the Sotheby's sale preview Schiller received a call from Hofmann in Salt Lake City. Hofmann told him that, while on the plane, a description of an item in the Sotheby's catalog had caught his eye. Had Schiller ever heard of a book by John Child called *New-Englands Jonas Cast Up at London*, published in 1647? According to the Sotheby's catalog this book contained the first reprint of something called the Freeman's Oath. Then came the punch line. Hofmann related that, while on the East Coast, he had happened to purchase a few miscellaneous papers and books at Argosy Bookstore, on East Fifty-ninth Street, one of New York's best-known antiquarian bookstores. Most of the stuff was worthless. But one of the items, Hofmann told Schiller, seemed interesting. It was a printed document, with a floral border, entitled "The Oath of a Freeman." Could this have any connection, Hofmann asked Schiller with faux naïveté, with the Oath of a Freeman in the Sotheby's catalog?

A few days later Hofmann phoned again to say that, after doing a bit of research at Brigham Young University, he had discovered that the Oath of a Freeman text he had bought at

Argosy Books was essentially the same as the one reprinted in the 1647 *New England's Jonas*. He said he had also tracked down a copy of a volume called the Bay Psalm Book, an extremely rare collection of the psalms, which New England's Puritans had used in their church services. The print and the decorative border of the Oath and the Bay Psalm Book appeared to match, said Hofmann.

The mention of the Bay Psalm Book was crucial. Not only was this specially commissioned translation of the Psalms the first book published in America—Cotton Mather had grumbled at the "many Detractions from, Additions to, and Variations of, not only the Text, but the very Sense of the Psalmist" contained in the original English version—it was also the fourth document printed on Stephen Daye's press, after the Oath and two almanacs. The first three had disappeared. But eleven precious copies of the Bay Psalm Book had survived, each priceless, and each containing a blueprint of the styles and techniques of America's first printing press. If the document Hofmann claimed to have discovered could be shown to bear strong similarities to the Bay Psalm Book, it would establish a crucial bridgehead on the road to authentication.

Hofmann told Schiller that, as he was returning to New York for the Sotheby's sale, he would bring the Oath with him. So in the middle of the afternoon, the day before the auction, Hofmann walked into Schiller's Manhattan bookshop with the Oath and a facsimile of part of the Bay Psalm Book. To Schiller's untrained eye the printing on both documents appeared to match. The endorsement on the back of the document, "Oathe of a Freeman," appeared to have been written in seventeenth-century handwriting. But what did he know? Schiller was a children's book specialist, not a connoisseur of early American printing. Before proceeding any farther he needed the opinion of an acknowledged expert on early American printing.

Michael Zinman, a businessman from Ardsley, New York, was at the time assembling America's largest private collection of

printed Americana. A short, intense man with ginger eyebrows that curl up at the ends, Zinman had made his fortune leasing equipment for gas and oil exploration. Since acquiring a three-volume octavo edition of Audubon's *Quadrupeds of North America* at the age of twenty-one, he had also become a voracious, indefatigable collector of printed Americana. Eventually Zinman would amass a collection valued at $8 million, which he has since bequeathed to the Library Company of Philadelphia.

When Schiller called him and told him that he might have found the Oath, Zinman jumped in his car and drove to New York. "Hofmann was standing there, a little bit off to the side," he said, "and Justin showed me the Freeman's Oath. I took a look at it, and I told them instantly, 'It's not right.' It was the border that bothered me. It was just too pretty, too structured. Nobody would have printed in that way. But I said, 'Where did you get it?' And Justin introduces me to Hofmann."

Zinman does not remember much about Hofmann's appearance. He was wearing a suit. He was slightly overweight and wore glasses. What stuck in his mind was Hofmann's aloofness. "He was really withdrawn," recalled Zinman, "but in a knowledgeable way, as though he knew what was going on." That evening Zinman went to dinner with Schiller and Hofmann. Over dessert Schiller asked Zinman what the Oath would be worth, assuming it were "right." Zinman told him a million dollars. "It could have been 'Gollywog's Cake Walk' or 'The Frog Chorus,' " Zinman said. "It was the first piece of printing in America, and it was worth a lot of money."

At the mention of a million dollars the heart of the quiet, aloof document dealer from Salt Lake City must have been in his mouth. But long training in the art of deception had taught Hofmann to show no emotion. As Zinman and Schiller discussed the Oath, he sat quietly watching and listening, his face a mask of stone. "He was opaque. I'm a reasonably acute reader of character. I can talk to people, and if I can't reach someone by talking

to them, it's very uncommon. My feeling about Hofmann was that he wasn't there," Zinman concluded.

By chance a copy of the Bay Psalm Book was on display at the New York Public Library, so early the next morning, before the crowds arrived, Schiller arranged to meet the curator of rare books, Francis Mattson, to make a comparison. The display case containing the Bay Psalm Book was unlocked and Hofmann watched as the pair studied the two items. Later Mattson took Schiller and Hofmann upstairs to compare the Oath with other examples of documents printed in the 1640s by Stephen Daye.

Experience had taught Hofmann that he didn't need to try and convince people of the authenticity of his documents. They would convince themselves. As Mattson and Schiller studied the Oath, he stood quietly to the side. Everything seemed right. There were the same irregular line endings, the same contraction marks, the same uneven print quality. The handwriting on the back of the document looked like genuine seventeenth-century handwriting. What really convinced Mattson was a tiny detail of the border surrounding the Oath. Such a detail occurred only once in the Bay Psalm Book. It seemed that the black tulip of printed Americana had been found.

Schiller next telephoned James Gilreath, at the Rare Books and Special Collections Department of the Library of Congress in Washington, and told him of the existence of the Oath. It was an audacious move. Founded in 1800, the Library of Congress is, with 121 million items on approximately 530 miles of bookshelves, the nation's greatest repository of the printed word. Its collections of rare books and manuscripts includes one of the world's three perfect copies of the Gutenberg Bible, and one of the smallest books in the world: a miniature edition of "Old King Cole," whose pages are so small they have to be turned with a needle.

Gilreath was a dynamic, ambitious specialist in American history. He was a talented fund-raiser who enjoyed meeting the congressmen and film stars who came to the library's special

events. He also had a flair for the wheeling-and-dealing side of book and manuscript acquisition. He liked the adrenaline rush of bidding at auctions. He enjoyed horse-trading with dealers. By the time the Oath arrived, he had already brokered several high-profile acquisitions, including an exceedingly rare manuscript by Michel-Guillaume-Saint-Jean de Crevecoeur, whose *Letters from an American Farmer*, published in 1765, was one of the defining texts of early American history. In his years at the Library of Congress he had never come across anything as exciting as this.

Armed with a small ultraviolet lamp and a magnifying glass, he hurried to New York to inspect the Oath. One of the first things Gilreath noticed was a light golden-brown halo around many of the letters, on the verso of the document. Such halos are caused by the binder in the ink leaching into the paper around the edges of individual letters. Gilreath knew that this only happened over a long period of time. More important, the printing types used in the Oath seemed to match the type used for the Bay Psalm Book. This was crucial because, except for a half dozen examples dug up under—of all places—the privy used by Henry Dunston, the president of Harvard College, in whose house Stephen Daye had eventually set up his press, those printing types had disappeared. Was it really conceivable, wondered Gilreath, that a forger could cut and cast a completely new font of types that exactly matched those of the Bay Psalm Book?

There was one potential problem: Even though it was known that the Oath was the first document printed in America, how could anyone be sure that this actual sheet of paper was the first one that came off Stephen Daye's press? The Oath would proba-bly have been printed in a run of several hundred, if not thou-sand. Who was to say that this was not number nine hundred and sixty-four? Hofmann knew that such facts would not get in the way of the romance of the documents he created; that the desire to believe in them was so strong that questions like this would be swept aside in a heady wave of excitement. He also

knew, from his own experience, what a powerful drug publicity was. The Oath of a Freeman, if it were genuine, would transform numerous people's lives. Justin Schiller would come away with one of the biggest commissions of his life and publicity no money could buy. The reputation of the Library of Congress would be enhanced. James Gilreath would become a star. Every newspaper, magazine, and television station in America would run a story about the discovery of what he was soon calling "a national treasure."

Before the Oath could be purchased, though, it would have to be subjected to rigorous scientific examination. For a month the Conservation Office and Testing Office of the Library of Congress irradiated it with X rays, bombarded it with infrared light, poked, prodded, and pored over it for any sign of forgery. The paper looked right. Mostly made of flax, with a few traces of cotton, it suggested a manufacture prior to 1800. The presence of zinc and manganese, elements almost never found in modern paper, also suggested a date prior to 1800. Admittedly, it was not exactly the same as the paper used in the Bay Psalm Book, but there was no reason it should be. The paper that Reverend Glover had brought to America in the hold of the *John of London* had probably been produced at several different mills in England, and the Bay Psalm Book itself contained a great variety of watermarks. The surface of the paper seemed lighter than the Bay Psalm Book, but there seemed to be an explanation for this too. The Oath had a number of folds in it and appeared to have been glued, in a folded state, to some sort of secondary support, like a scrapbook page. Hinging it like this would have protected it from wear and tear.

The uncanny similarity of the type used in the Oath and the Bay Psalm Book seemed most suggestive of authenticity. Type was produced from sheets of lead in seventeenth-century England. The letters were cut out by hand, then cast in an iron mold. The man who did this job was called the punch cutter. Numerous foundries performed this operation and each punch

cutter had a slightly different way of cutting his letters, depending on whether he was right-handed or left-handed, how experienced he was; even how heavy.

Gilreath had noticed that the Bay Psalm Book contained a number of idiosyncratic letter forms. The lowercase *o*, for instance, was unusually thick at the edges of the circle, so that it looked rather like a misshapen doughnut. The Oath also had this idiosyncrasy. Under closer examination it also became apparent that numerous other letters and letter ligatures in the Oath and the Bay Psalm Book contained the same telltale "earmarks," little anomalies that strongly suggested that they had been made by the same punch cutter. The Library's manuscript experts also discovered, as Francis Mattson had at the New York Public Library, that parts of the ornamental border around the Oath perfectly matched the heading of Psalm 42 in the Bay Psalm Book, strongly suggesting that both documents had been printed on the same press using the same matrices.

Printing in Puritan New England was an imprecise business. Type was in short supply. If letters got worn or damaged, there was no express courier service to get replacements shipped from England. Printing frames, or chases, as they were called, were made of wood and liable to get bent or damaged. Movable type of the sort used by Stephen Daye could also never be perfectly adjusted. Each letter was fitted into the printing frame by hand, using a printer's stick, and inevitably there was considerable variation of heights. This produced an uneven finish, as some letters bit into the paper more deeply than others.

The Oath had just these sorts of irregularities. The print did not have the crisp, flat look that the level line cut of a modern printing plate would give it. It looked authentically uneven. There was one slight anomaly, though. In printing, a letter whose stroke points downward, like a *p*, is known as a descender. One that points upward, like a *d*, is known as the ascender. Under magnification the bottom of the letter *j*, in the word *subject*, in the fourth line of the Oath, seemed to encroach on the same space as

the top of the letter *d* in the line below it. Similar occlusions occurred elsewhere. Several experts would later seize on this detail as proof positive that the Oath was a forgery. Just as water cannot flow uphill, an ascender, they argued, can never reach higher than a descender.

James Gilreath interpreted this as another sign of Stephen Daye's inexperience. Daye had been trained as a locksmith, not a printer, and subtleties like spacing eluded him. He squashed letters together within an individual line, or clumsily broke a word in two, rather than adjust the spacing so that a line break could occur at the end of a syllable. He also frequently allowed the lines of type to wander very near to each other. The Bay Psalm Book contained many examples of ascenders and descenders impinging on each other's spaces like this. Sometimes it even appeared that Daye had tried to stop one letter from occluding another by simply taking a file to them.

The report on the Oath of a Freeman prepared by the Conservation Office of the Library of Congress concluded that "no evidence has been revealed that would contravene a mid-seventeenth-century date for the broadside." Later, it would pass a carbon 14 dating test at the Crocker Nuclear Laboratory, at the University of California at Davis. For Hofmann it was the ultimate accolade. A bumpkin from Utah had fooled some of America's most distinguished manuscript experts. Moreover, he had fooled them not with some obscure Mormon document, but an item of national importance whose discovery would be hailed as one of the greatest finds of the century. The name Mark Hofmann would be famous all over the world.

On learning of the contents of the report Justin Schiller, in consultation with Hofmann, began to turn up the heat on the Library of Congress. They claimed that a mysterious advisor had entered the picture, who had the ear of the document's owner; and that an investment group had been formed to market the Oath. (The group consisted of Hofmann, Schiller, and his partner, Raymond Wapner.) According to Schiller this advisor was

considering marketing the Oath to private corporations for $3 million. The Library of Congress had a month to make up its mind. The price was $1.5 million.

It was an extraordinary act of daring to forge the Oath of a Freeman. Hofmann was advancing into new territory—colonial American history—about which he knew very little. He was also advancing into a technology he knew little about: namely, printing. Such an important national treasure as the Oath of a Freeman would, he knew, be subjected to the most intense scrutiny. And Hofmann had prepared every step on the way to its creation, from the initial research, to choosing the materials and the printing, with the greatest care.

He had begun by unearthing everything he could about the Oath and early-seventeenth-century printing. Using the library at Brigham Young University and several other Salt Lake City libraries, he read up on the Stephen Daye press. He then tracked down the four variants of the Oath. For the Anthon Transcript he had used particular symbols and hieroglyphs to make it appear as though his was the original version from which subsequent variants had descended. He did the same for the Oath, building into the text a series of linguistic clues that would lead researchers to conclude it was the ur-version. "What I did was research the early days of the Massachusetts Bay Colony," he later told investigators. "My purpose, of course, was to make the first printed version. It differs from any of the other single sources that I used, and that was my intention."

The next step was to make copies of a facsimile of the Bay Psalm Book. He had located a rare photomechanical reproduction from the 1930s at the Marriott Library in Salt Lake City. Such a valuable book could only be consulted at the library. But Hofmann removed the metal identification strips at the back of the book and took it home. This little act of larceny must have given Hofmann particular satisfaction, for the Marriott Library had been established by one of America's best known and

wealthiest Mormons, the billionaire Stephen Marriott, founder of the global hotel chain.

From the photocopies he made of the Marriott Library's copy of the Bay Psalm Book, Hofmann was able to determine the exact nature of the type that had been used by Stephen Daye, and construct an alphabet. Book Four of the Bay Psalm Book also provided him with the design for the decorative border. He cut and pasted these elements onto a sheet of paper, then took them to an engraver's in Salt Lake City called DeBouzek, where he had a zinc printing-plate cut. He gave his name as Mike Hansen. "It was a simple matter of Xeroxing from the facsimile of the Bay Psalm Book several Xeroxes of the pages which I wanted to copy the flourishes or designs," he would later claim, with characteristic false modesty. By emphasizing the ease with which he had created his forgeries, Hofmann accentuated his talent. "I then used a razor blade or X-Acto knife to cut out the letters and the designs I wanted. I glued them on a piece of paper . . . and then after they were glued on a piece of paper I Xeroxed my composure and that was the artwork I took into DeBouzek."

It was actually far more complicated than that. Hofmann had to be careful not to use exactly the same letters as occurred in the Bay Psalm Book. After all, it had been printed a year later, in 1640. The fonts that would have been used on the Oath would have become worn. Hofmann used only anomalous, slightly deformed letters from the Bay Psalm Book. "After cutting out the letters, pasting them on a sheet, then making a Xerox of the artwork," he explained, "I used a technical pen . . . to actually deform some of the letters the way I wanted, which are different, the deformations, than what exist in the Bay Psalm Book."

Hofmann took even greater pains altering the zinc printing plate. He had read that printers in the seventeenth century often used a wooden mallet to hammer type into the matrices, a practice that frequently deformed the letters. Using a small drill equipped with a grinding tip stone, he ground down several letters to make them appear damaged. He then spent hours rubbing

the printing plate with steel wool to round out the corners of the letters.

He had already acquired a piece of paper that he was confident could be dated to within five years of the paper used by Stephen Daye. At the New York Public Library he had studied a microfilm copy of the Bay Psalm Book of sufficient detail to allow him make out the chain lines on the paper. These thin horizontal lines, also known as laid lines, appear on handmade paper when you hold it up to the light. Chain lines are created by the copper wires stretched across the bottom of the mold in which paper is produced. Papermaking molds varied enormously from mill to mill and so the chain lines serve as a kind of fingerprint of the paper's identity. While at the New York Library, Hofmann had made a template of the laid lines he had found on the microfilm copy of the Bay Psalm Book, and had then began to hunt for a piece of paper that matched.

Eventually, on the fourth floor of the Brigham Young University library, he found a seventeenth-century book from England. Hofmann knew that the paper used by Stephen Daye had all been shipped across the Atlantic. The chain lines were almost exactly the same as the ones on his template. There were a few blank pages at the back of the book. Waiting until no one was watching, Hofmann took the book and, with a swift, sharp motion, ripped out several pages. "I succeeded rather well in tearing," he would recall with typical smugness, "so that it was rather difficult to see where the page was removed. Very close to the spine."

All that remained was the ink. As ever, Hofmann's greatest challenge was to simulate the action of time. He anticipated that the printer's ink used on the document might be subjected to a carbon 14 dating test, so he took immense pains in manufacturing it. To acquire carbon black, a common ingredient in printer's ink at the time of the Daye press, he burned a sheet of seventeenth-century paper stolen from Brigham Young University in a glass tube with a small chimney attached to it. He then

mixed the ashes with pure linseed oil, which he had boiled and burned to the right consistency. To create tannic acid, another key ingredient in historic printing inks, he cut the leather binding from a seventeenth-century book and boiled it in distilled water until it turned brown. Finally, he added some beeswax.

It was about midnight when Hofmann started to print the Oath of a Freeman. His wife, Doralee, and his three children were sleeping upstairs. Being careful not to wake anyone, he crept downstairs to his basement workroom, locked the door, and set to work. He first made a few test runs using modern paper. When he was satisfied with those, he rolled ink onto the plate, laid the antique paper on it, placed a piece of felt underneath the plate, and another thick metal plate on top of it, so that the whole resembled a sandwich, with the paper as the filling. He then applied pressure with a C-clamp.

The minutes ticked away. Unscrewing the clamp, Hofmann pulled the printed document from the plate and hung it to dry. When it was dry, he set about creating the inscription on the back of the document. He had already specially made a quill pen from a turkey feather. He had also prepared a separate batch of ink from the ink he had used to print the document. Picking up the quill pen, he inscribed the words "Oathe of a Freeman" on the verso of the document in an elegant Elizabethan hand.

The inscription had two purposes. It made the Oath look more authentic, by giving it a human touch. Hofmann was by now so confident of his art that he also wanted to provide the experts with something else to test, to corroborate the authenticity of the printed Oath. Turning the page, he used a suction pump to draw the ink through to the other side, making it appear as though, over the course of three centuries, it had leached deep into the fabric of the paper. He then repeatedly folded the Oath to cause hairline cracks in the paper. Finally, he created foxing marks, the little discolored patches caused by fungus reacting with the paper that you can find on the pages of most old books.

Hofmann went to equally elaborate lengths to create a false provenance for the Oath of a Freeman. First, he forged a sales receipt from Argosy Books in New York, where he claimed to have discovered the Oath, listing its price as $25. At a later date he returned to the bookshop with the receipt and a photocopy of the Oath and talked to the sales assistant who had allegedly sold it to him. It was a ruse he had used with the Anthon Transcript. It worked again. "She claimed to have recognized the Oath," he said, "and I felt like that source was, or that provenance was secure as far as that's where I obtained it."

To make sure that the sales assistant remembered him and the document, he even pretended to be interested in locating other, similar material. "I told her I was interested in this Oath and I would be willing to buy further copies of it, and she said she would look. She went through some material for a while with me or pulled out some material for me to go through and then afterward I told her that I thought it was a valuable item and explained to her that the first item printed in America was the Oath of a Freeman and this might be the first one. And she said, that's nice, or something like that."

The Library of Congress wanted more provenance information, however, and asked for a complete chain of title, showing all the previous owners of the document. Of course, Justin Schiller could not give one. He also refused to give the name of the consignor. A few phone calls by James Gilreath unearthed Hofmann's name—and some troubling information. Hofmann, Gilreath learned, had a reputation for bouncing checks and not returning phone calls. He also appeared to have some unsavory friends. It was even rumored that he had links to the Las Vegas Mafia. On June 5, 1985, the Library of Congress informed Justin Schiller that he could pick up the Oath from Washington.

From Washington it went to the American Antiquarian Society in Worcester, Massachusetts. By chance, on the day it arrived, a seminar on the history of the book in America was under way, and many of the nation's leading bibliographers were in

attendance. Together they examined the document. The fact that the Oath was printed as a vertical rectangle seemed troubling. A version published in 1939 had shown it printed on the horizontal. There was also unease about the way several ascenders and descenders overlapped. For every argument, though, there seemed to be a counterargument. It was like the sensation Mark Twain described in *The Innocents Abroad*, when he visited what was rumored to be the biblical Adam's grave near Jerusalem: you can't prove that it is, and you can't prove that it isn't.

Robert Mathiesen, a professor at Brown University in the Department of Slavic Languages, puzzled over a tiny speck of dirt that had been found in one of the folds of the document. Did it lie under the printer's ink or over it? If it lay over the ink, Mathiesen argued, then the Oath was probably genuine. If the dirt lay under the ink, then the Oath must have been printed after the paper had been folded, and was therefore a forgery. These were not scientific evaluations, however. They were the subjective opinions of academics with no forensic training, and they were no match for Hofmann. After examining the document and reviewing the reports from the Library of Congress, the American Antiquarian Society offered the Schiller-Wapner Gallery $250,000 for the Oath. Meanwhile, back in Salt Lake City, Mark Hofmann had already set about marketing the ultimate illusion: a forgery that did not even exist.

CHAPTER THIRTEEN

A Dirty, Nasty, Filthy Affair

William McLellin was born in Tennessee in 1806. He first came into contact with Mormon missionaries while teaching school in Paris, Illinois, at the age of twenty-five. Impressed by their devotion, he had himself baptized in the waters of the Missouri River, near the town of Independence. "I felt very happy, calm, and pleasant," he wrote in his journal. A few days later, on the way from Missouri to Illinois, McLellin fell sick. "I lit from my horse in the prairie and lay down on my great coat and blanket." By Christmas, McLellin's lungs were inflamed and he had been confined to bed. On December 28 he met for the first time the man who would later refer to him as "a prince and savior to God's people." "In the morning," wrote McLellin, "Brother Joseph came to my bedside and laid his hands upon me and prayed for me and I was healed so that I got up and eat breakfast." Four years later McLellin received the equivalent of a cabinet position when he was appointed by Joseph Smith to be one of the Twelve Apostles of the Mormon Church.

Within a year he had begun to have serious doubts about Smith's character, however, and the veracity of the religion that he had joined. He was excommunicated in 1838. A campaign of

vilification ensued. McLellin was accused of robbing Smith's house, of assaulting him, and spreading "foul and libelous reports." "Such characters God hates," wrote Smith with characteristic bile. "The world hates them, and we sometimes think that the devil ought to be ashamed of them."

What Smith really hated was that McLellin had left the inner caucus of the early Mormon Church with some deeply damaging insights into his former colleagues. He is also known to have assembled an important collection of manuscripts and documents about early church history, including his own journals, letters, and diaries. At his death these papers passed into the hands of a man named J. L. Traughber, who was then living in Texas. In 1901 an anti-Mormon lawyer contacted Traughber about purchasing the materials. The two men corresponded, but Traughber insisted that he was not interested in selling the collection piecemeal. "If I dispose of any of it," he wrote the lawyer, "I want to make a clean sweep and wipe my hands forever of all that pertains to the matter." Negotiations broke down and William McLellin disappeared off the radar screen of history.

In early 1985 rumors began to circulate in Salt Lake City that the McLellin Collection had been located. The author of the rumors was Mark Hofmann. Soon a reporter from *The Salt Lake Tribune* was telephoning the LDS Public Communications Department for information. Hofmann's intention was, as ever, to inflict maximum damage on the LDS church, not just by selling them a forgery that blew holes in their theology, but by showing them to be secretive and manipulative. His experience with the Salamander Letter, which the Church had bought for $40,000, had taught Hofmann that they would be desperate to buy the McLellin Collection before it fell into "enemy" hands. He also knew that all negotiations would have to be conducted in secret. By leaking rumors about the negotiations he ensured that the contents of these highly controversial documents would become public. The LDS church would again be caught trying to suppress the truth.

The most controversial aspect of the McClellin Collection was its potentially damaging revelations about Smith's character. McLellin knew Joseph Smith as well as anybody. They had ridden across the prairies together, eaten together, slept in the same hotels, prayed together in the temple. Was the McLellin Collection going to be the *Primary Colors* of early Mormon history: an up-close and personal account of what went on behind the scenes among Joseph Smith and his colleagues?

What was known of McLellin suggested it would. In an account of a trip to Cleveland by Smith and fifteen of his followers, which McLellin sent to Smith's son in 1872, the prophet emerges as an unstable high roller. "They put up at a first class hotel," writes McLellin. "Called in the wine etc. Some of them became high, and smashed up things generally." The consumption of alcohol is strictly forbidden to Mormons. But the next day, according to McLellin, Smith and his followers got drunk again, this time over lunch at an expensive restaurant called Euclid. On the way back to Illinois they then had a drunken horse race, which ended with several buggies being turned over and smashed.

In the same letter he describes this insalubrious scene in the Kirtland Temple during what was supposed to be a twenty-four-hour fast. "We . . . partook of some bread and wine in the evening," wrote McLellin, "and some partook so freely, on their empty stomachs, that they became drunk! I took care of S. H. Smith in one of the stands, so deeply intoxicated that he could not nor did sense anything. I kept him hid from the crowd in the stand, but he vomited [in] the spit-box five times full, and his dear brother Carlos would empty it out of the window."

Throwing up in temple was bad enough. Illicit sex in a barn was much worse. "Now Joseph I will relate to you some history, and refer you to your own dear Mother for the truth," McLellin writes to Joseph Smith Jr. in that same letter of 1878. The "history" to which McLellin is referring came from an interview McLellin conducted with Emma Smith, the prophet's wife, four

years after Smith was murdered in the Carthage jail. According to her account, one night in 1835, when the Smiths were living in Kirtland, Ohio, Emma Smith noticed that her husband and the serving maid, Fanny Alger, "a Varry nice and Comly young woman," as a contemporary describes her, were missing from the house. Tiptoeing down to the barn, Emma Smith discovered the pair in flagrante delicto. Smith was twenty-seven. Fanny Alger was nineteen. "She looked through a crack and saw the transaction!!!" writes McLellin breathlessly. "She told me this story too was verily true." In a letter written in 1838 another key early Mormon leader, Oliver Cowdrey, one of the three witnesses to the Book of Mormon, would refer to Smith's carryings-on with Fanny Alger as "a dirty, nasty, filthy affair."

McLellin had also leveled charges of forgery against Joseph Smith. He claimed, for instance, that a key vision of Smith's, known as the Endowment, in which angels were supposed to have appeared to Smith in the presence of several hundred worshipers at the Kirtland temple in 1836, was a fabrication (another key witness, David Whitmer, called it "a trumped-up yarn"). He also questioned the authenticity of several key Mormon documents. Chief among them was the Book of Abraham, a supplemental work of scripture that Smith claimed to have translated from a piece of papyrus. "I don't believe in the book of Abraham," William McLellin wrote in the 1840s, "translated (pretended to be) from Papyrus taken from the bosom of an Egyptian Mummy."

Hofmann claimed that among the three boxes of documents he had located in Texas was that same piece of papyrus. It had first appeared one day in 1835 when a horse-drawn wagon had pulled into Kirtland, Ohio, site of Joseph Smith's first Mormon colony, loaded with a most unusual cargo. The wagon belonged to an itinerant Irish peddler named Michael Chandler, one of those wily hucksters who thrived on the American frontier. Among the clutter of curios in the back of Chandler's wagon were eleven Egyptian mummies and some rolls of papyrus. The

price, $2,400, the equivalent of $50,000 today, was steep. But how often did some Egyptian mummies and papyrus turn up in Ohio? Joseph Smith bought the lot. "I commenced the translation of some of the characters or hieroglyphs," he wrote soon afterward, "and much to our joy found that one of the rolls contained the writings of Abraham, another the writings of Joseph of Egypt, etc. . . . Truly, we can say the Lord is beginning to reveal the abundance of peace and truth."

The Book of Abraham became what Mormons call a Pearl of Great Price: a rare and valuable document that substantiates important aspects of their faith. Smith claimed that the five short chapters with facsimiles and explanations, which he published in 1842, were nothing less than the lost writings of Abraham, written in the patriarch's own hand during Abraham's exile in Egypt. They were particularly exciting because they provided materials about Abraham's life that did not exist in the Bible (Hofmann would follow Smith's example by salting his forgeries with startling new details that did not appear in the Book of Mormon). They also rewrote scripture, introducing some of the fundamental tenets of the Mormon faith, like the preexistence of human souls and the most hotly disputed institution of the new religion: polygamy. The Book of Abraham said it was in accordance with biblical scripture for men to have more than one wife. It was also used to justify the exclusion of anyone who was not white from the priesthood. This restriction was only revised, after intense pressure from the federal government, in 1978.

Smith went to great lengths to make the Book of Abraham appear genuine. He included three facsimile copies of the original papyrus. Later he even published a so-called "Egyptian Alphabet and Grammar," showing the original hieroglyphs found on the papyri. Unfortunately, the two could never be compared, as the papyri, like so many other Mormon relics, mysteriously disappeared. Legend has it that they were consumed in a fire at a Chicago museum in 1871. But in 1967, when Hofmann was thirteen years old, some of the papyri unexpectedly turned up at the

Metropolitan Museum of Art in New York, with a bill of sale from Emma Smith Bidamon, the prophet's widow. Among the scraps of papyrus was the one published by Smith in the Book of Abraham as Facsimile #1. Facsimiles #2 and #3 were still missing.

When the papyri were examined at the Metropolitan it became clear that they had nothing to do with Abraham or Joseph. They were Egyptian funerary documents from c. 100 B.C., roughly two thousand years after the death of the biblical patriarch. The hieroglyphs on the papyri were indeed the ones that Smith had published in the "Egyptian Alphabet and Grammar," but his English translations bore no relation whatsoever to their actual meanings. What Smith had done was what forgers throughout history have done: having fabricated one document he fabricated another to authenticate it. I.E.S. Edwards, an Egyptologist at the British Museum, said that Smith's Grammar reminded him "of the writings of psychic practitioners."

The person Hofmann chose to tell about the McClellin Collection was the same person who had arranged the purchase of the Salamander Letter, Steve Christensen. Hofmann told Christensen that he had located the collection in Texas, and that among the documents was the original papyrus of Facsimile #2 of the Book of Abraham, "one of the most famous relics in Mormondom," as the *Salt Lake Tribune* would call it. Hofmann also claimed that he had contacted Gordon B. Hinckley about buying it for the Church. The asking price was $195,000. Hofmann said he had already put a down payment of $10,000, but that his option would run out at the end of June if he did not come up with the rest of the money. To make the Church jump even faster he told Christensen that a group of anti-Mormons were after the Collection.

Christensen called a friend of his, Hugh Pinnock, a Church elder with close connections to Salt Lake City's banking community, and within a matter of days Pinnock, in consultation with other leading officials of the LDS church, had arranged for Hofmann to receive an unsecured loan of $185,000 from First Inter-

state Bank to buy the collection. Pinnock even offered to provide an armored truck to transport the documents from Texas. Not surprisingly, Hofmann declined. He would send them, fully insured, via registered mail.

Every criminal has a weakness, some flaw in his plan or character that eventually leads to nemesis. Ironically, Hofmann's flaw was an all-consuming passion for antiquarian children's books. Entries in his notebooks record some of the purchases: $6,300 for a first edition of Tolkien's *The Lord of the Rings;* $1,500 for *The Tailor of Gloucester,* signed by Beatrix Potter; $1,500 for a rare edition of *The Hunting of the Snark,* signed by Lewis Carroll. It cost even greater amounts of money to acquire such gems as Hans Christian Andersen's fairy tales, in Danish; the original paintings for the first edition of the fables of La Fontaine, in French; or a first edition of *The Arabian Nights,* printed in the early eighteenth century. In the world of rare books these were legendary items, and eventually Hofmann would assemble one of the finest collections in America, including the first known copy of *The Adventures of Sherlock Holmes* (1892) in its original pictorial dust jacket.

Justin Schiller, who purchased many of these books at auction for Hofmann, believed that Hofmann had a genuine passion for antiquarian books. "If the eyes twinkle when someone is looking at a book, you know they really have affection for it," he said, "and Mark's eyes twinkled. It was a romance." The ostensible purpose of Hofmann's collection was to create a legacy for his children. He also used them as collateral on bank loans. Hofman's passion for children's books also had another, nefarious, purpose. Why else would he ask Justin Schiller to acquire multiple, unsigned copies of the first edition of *Uncle Tom's Cabin,* like the one, signed by Harriet Beecher Stowe, which Schiller had purchased on his behalf? By forging an inscription in the front of each one, he could multiply the value of the book a hundredfold.

In all it is estimated that Hofmann spent more than $300,000 on antiquarian books. By 1985, his passion for books

had become a mania. He needed large amounts of money, and he needed it fast. He had tried to create a few of the Lost 116 Pages of the Book of Mormon, but the task of forging such a long document was so daunting, even for him, that he had had to shelve the project. The Oath of a Freeman had not come through with the payday he had hoped it would. As a result Hofmann began to push the fictional McLellin Collection even harder. Ten days, after he had received the $185,000 loan, Hofmann informed Christensen and Pinnock that the collection had been purchased and was secured in safe deposit boxes in Salt Lake City.

Days turned into weeks but still Hofmann had not handed over the documents, nor had he returned the $185,000 bank loan. To make matters worse, rumors of the loan, most of them set in motion by Hofmann himself, had begun to filter out to the press. It would be a public relations disaster if it became known that leading members of the Mormon Church had arranged an unsecured loan to buy controversial documents. "It looks like I'm in trouble," Hugh Pinnock, the man who had arranged the loan, confided to a colleague in mid-August. "Mark hasn't paid the loan and he seems to have disappeared."

Christensen had already begun to be suspicious of Hofmann. He had made inquiries, checked with others who had had dealings with him, and heard stories of his notorious unreliability. Gradually, he began to perceive a pattern of deceit. First Interstate set a new deadline for the loan to be repaid: September 3. That morning Hofmann walked into First Interstate and wrote a personal check for $185,000 plus the interest. A week later it bounced.

Hofmann did much of his thinking while driving. He liked driving, and he liked cars, particularly the blue Toyota sports car he had bought for himself. On sunny days he would head out into the canyons that surround Salt Lake City. Muslims say that you are closer to God in the desert. Hofmann had no God, but the wild, open spaces with their austere, almost biblical beauty

gave Hofmann a feeling of freedom and helped him focus his thoughts.

As the summer of 1985 turned to fall, his thoughts centered on the hundreds of thousands of dollars he had borrowed. Anticipating the sale of the Oath of a Freeman, he had put down a deposit on a half-million-dollar house in the suburbs of Salt Lake City with a tennis court and a built-in aquarium. He was traveling frequently to New York, where he stayed at expensive hotels, ate at fine restaurants, and schemed to create more forgeries. An entry in one of his notebooks places him at the former Omni Park Central Hotel in downtown Manhattan. Under a list of things to do while in New York is a reminder to order *The American Jewish Album: 1654 to the Present,* by Allen Schoener, from Rizzoli's. It seemed that Hofmann intended to mine a rich new seam by forging documents relating to American Jewry.

The success of his forgeries and his exceptional ability to deceive had by now made Hofmann believe that he was invulnerable: that he was simply too smart to be caught. And he began to take ever greater risks as his financial situation worsened and his room for maneuver contracted. Previously, he had been able to ward off his creditors by dashing off a forged inscription in a book, or faking a Daniel Boone autograph, then selling it for a few thousand dollars, but he was no longer dealing in thousands of dollars. He was dealing in hundreds of thousands. Forgery could not generate enough income. It also took too much time, and time was something Hofmann no longer had.

So, instead of creating and selling forgeries, he began to invent fraudulent investment schemes. Named after an Italian-American, Charles Ponzi, who moved to Boston in 1919, a Ponzi scheme works by using one investor's money to pay back another. Ponzi would promise investors a huge return, often as much as 40 percent, on their money. To make the transactions he pretended to be conducting on their behalf appear legitimate, he would then pay them their return. What these investors did

not know was that the money Ponzi was paying them had been raised from other investors.

Hofmann began to offer investments on fraudulent rare book and manuscript transactions, using the imminent sale of the Oath of a Freeman as a promise of payment or his own valuable children's book collection as collateral. One of the investors Hofmann lured into his web was a Salt Lake City businessman named Thomas R. Wilding. Wilding had first become involved with Hofmann in early 1985, when he and a group of other investors put up $22,500 for the purchase of a collection of rare books. A month later Hofmann reported that he had resold the books for twice the amount. Wilding's group invested a further $23,600 for some Brigham Young papers. A month later Hofmann informed them that he had resold the papers at a 42 percent profit. It was like playing the casinos in Reno without the long drive.

What Wilding did not realize was that Hofmann was merely pretending to make these profits, so as to draw him farther in. Wilding and his group upped their ante and invested $160,000 for Hofmann to purchase one of the gems of nineteenth-century literature: the original manuscript of Charles Dickens's *The Haunted Man*.

Dickens's description of the central character staring into the embers of a fire in his inner chamber, "part library and part laboratory," must have struck a chord with Hofmann. He was, by the summer of 1985, very much a haunted man himself. First published in 1848, the manuscript had for many years been one of the highlights of the Carl Pforzheimer Collection in New York. Hofmann intended to purchase *The Haunted Man* at auction and resell it. The purchase price was $300,000. Having taken $160,000 from Wilding and his group, Hofmann began selling shares in the Dickens manuscript to investors and manuscript collectors all over America. An Arizona businessman named Wilfred A. Cardon put up $110,000. George Smith, one of America's wealthiest Mormons, whose holding company owns UPS and

Signature Books, put up a further $55,000 for a one-sixth ownership. Hofmann took their money. *The Haunted Man* remained in New York.

Hofmann was successful because he understood the power of greed. He proposed to the Wilding group that they invest in an even bigger project, something, he told them, that, if he could raise the money to buy it, would make them all rich: a second version of the Oath of a Freeman. The first version, Hofmann lied, had already been sold to the Library of Congress for $1 million. This second version, Hofmann told them, could be worth at least as much. Wilding and his group jumped in with $173,000.

Ponzi schemes are like brush fires. They feed on themselves. The fire starts to burn out when the number of investors looking for a return exceeds the number of new investors putting money in to fuel the scheme. By the summer of 1985 that was happening. The money Hofmann was taking from one investor was immediately going out to another. He had already sold a share of the Oath of a Freeman to Justin Schiller in New York for $150,000. He now resold half his share for another $150,000. He also began selling shares in the McLellin Collection. None of it was enough.

For the first time in his life Hofmann was also beginning to lose control of the plot. One of the secrets of his success had been his ability to keep different strands of the labyrinthine stories he concocted to deceive people isolated from each other, like volatile chemicals stored in sealed containers. Two plot lines now began to converge, like the arms of a pincer. On the one side Steve Christensen began to press Hofmann increasingly hard for delivery of the McLellin Collection, or the repayment of the $185,000 loan that had been arranged for him at First Interstate Bank. On the other side Thomas Wilding and his group began to squeeze Hofmann for the repayment of the nearly half a million dollars they had by now invested.

Hofmann had dealt mostly with bibliophiles. It was a safe,

unthreatening world united by a common love of books and manuscripts. But Hofmann's ever-increasing need for money to finance his rare book purchases, and the escalating luxury of his lifestyle, took him outside this genteel society into a tougher, less trusting world. Investors like Wilding had no interest in books per se. They were interested in money, and they did not take kindly to being deceived.

One of the investors in Wilding's group was a rancher from just over the Wyoming border named Sid Jensen. Jensen had lost an arm in a farming accident and had received a substantial insurance payment, which he hoped to turn a profit on. Hofmann had told Wilding and Jensen that he was flying to New York with the $173,000 they had invested to buy the second version of the Oath of a Freeman (which did not exist). When Jensen and Wilding checked the flight number and time that Hofmann had given them, they discovered that no such flight existed. They drove to the airport. Hofmann's car was not in the parking lot. Hofmann was nowhere to be found.

Jensen and Wilding decided to stake out Hofmann's house the next morning. Wilding arrived at 5:30 A.M. in his pick-up truck and waited outside Haus Hofmann. The date was Friday, the thirteenth of September. An hour and an half later, Jensen, who had driven down from Wyoming, joined him. At 7.30 A.M., they knocked loudly on the door. Hofmann's wife, Doralee, answered. Hofmann was in the shower. When he came to the door his hair was still wet.

"What's the big deal?" he asked.

"We'll tell you what the big deal is," replied Wilding. "There's a lot of things that don't jibe that you've been telling us and we need to get them straight."

Wilding and Jensen told Hofmann that because of the inconsistencies and problems in his story, they wanted their money back. Hofmann said he would meet them at his bank at 10:00 A.M. Wilding refused and a few minutes later they set off together. Once they arrived at Hofmann's bank, Wilding and

Jensen discovered that their "partner" only had $18,000 in his checking account, a tenth of what they had given him the day before. Hofmann promised Wilding that he would return the money later that day. But Wilding was not so easily put off. Making sure Hofmann was not out of his sight even for a moment, he drove him around Salt Lake City as Hofmann desperately tried to borrow money. They went to the coin dealer, Al Rust. But Hofmann already owed Rust $150,000 on another fraudulent transaction. They went to see Kurt Bench, at Deseret Books. But no one was willing to lend Hofmann any more money. His credit had finally run out.

That evening Wilding drove Hofmann to his office. Sid Jensen joined them. For two hours the two men interrogated Hofmann. Hofmann told Jensen and Wilding that he had already sent the money to New York to purchase the Oath. He promised to find other investors to repay them. Wilding would later describe Hofmann's attitude during the meeting as "detached arrogance." It was almost certainly this that caused Jensen to lose his temper. Raising his one good arm, he slugged Hofmann in the face.

The weeks passed, and still Hofmann had not repaid any of the money. He tried to buy time by telling Wilding and Jensen that he was in the process of selling an important collection of documents to the church for $185,000 via Steve Christensen. He promised to turn that money over to Wilding on October 11, the date that had been set for the closure of the deal.

That deal was the sale of the fictional McLellin Collection. Meanwhile, his failure to produce the collection, combined with his increasingly unreliable behavior and evasiveness, had begun to arouse the suspicions of the LDS hierarchy. Several leading members of the Church had already concluded that Hofmann was double-dealing. No word had reached President Hinckley's ears. But that could change. "They're planning to tell Pres. Hinckley tomorrow what's been going on," Curt Bench, the owner of the Deseret Bookstore, had recorded in his journal in late

September, "which could very well result in [the] Church never buying anything from Mark again." Hinckley's trust was vital to Hofmann. Without it he would not have the unprecedented access to the inner sanctum of Mormon power he had enjoyed for five years.

Steve Christensen had his own reasons to feel jumpy. The CFS investment bank, of which he was a vice president, was melting down and Christensen faced financial ruin. If he could not deliver the McLellin Collection, his reputation with the Church could also be ruined. In one of the many tragic ironies of this story, he began to talk about becoming a full-time historical documents dealer himself. Hofmann's increasing unreliability had, he thought, perhaps opened a niche. At a meeting with Hugh Pinnock he even discussed finding that fata morgana of all Mormon manuscripts, the Lost 116 Pages of the Book of Mormon.

Christensen agreed to set back the date for the delivery of the McLellin Collection, or repayment of the $185,000 loan, until October 3, then to October 7. "Hold his feet to the fire," Hugh Pinnock told the loan officer at First Interstate. Pinnock also had much to lose if Hofmann defaulted on the loan. He had offered himself as the unofficial guarantor. If Hofmann defaulted, Pinnock could end up losing his house.

Thomas Wilding was holding Hofmann's feet even closer to the fire. Having gotten hold of Hofmann, Wilding hung on to him like a bulldog. He forced Hofmann to sign an agreement converting his investments and owed profits into unpaid loans totaling $455,155. He then made Hofmann sign an agreement invoking massive penalties if he defaulted on repayment of the debt. Starting on October 14, Hofmann would have to pay Wilding a penalty of four thousand dollars a day. First Interstate Bank had already threatened to repossess Hofmann's house. This would bankrupt his family for years to come. As a final caution Wilding threatened to go to the police.

Hofmann had always managed to squeeze out of the tightest of corners, but as the clock ticked away toward the deadline

Wilding had set, he began to sense that, this time, he was in a box. The McLellin Collection had not been delivered. The threat of exposure suddenly loomed large. Hofmann felt angry, restless, and vengeful. For years he had manipulated the people who had manipulated him. He had waged a secret war against the Church, and he had always been one jump ahead of them. Now, though they did not know it, they had him in a box. He began to drink heavily. He couldn't sleep. Even self-hypnosis no longer worked.

His last hope was the Oath of a Freeman. At the beginning of September the American Antiquarian Society had offered $250,000 for the document. But Hofmann's debts were so huge that even a quarter of a million dollars could not save him, and he turned them down. It was a fatal moment of hubris. Hofmann had overreached. In a final twist of fate the deadline Steve Christensen set for the delivery of the McLellin Collection was the same date Wilding had set for the repayment of the nearly half a million dollars Hofmann owed him. By October 14 Hofmann would have to produce a set of documents that did not exist—or repay the $185,000 he did not have. He would also have to repay half a million dollars to Wilding, or start paying four thousand dollars per day in penalties. Hofmann desperately needed to come up with one last conjuring trick.

The most exciting and controversial artifact in the McLellin Collection was that "piece of papyrus plucked from the bosom of an Egyptian mummy." So, in early September, Hofmann called Kenneth Rendell, the Boston-based historical documents dealer who, twelve years later, Sotheby's would claim had authenticated the Dickinson poem. Hofmann asked him if he had any papyrus for sale. By chance Rendell had. It was a piece of Egyptian papyrus measuring twenty-four inches by nine. Hofmann cut the papyrus in two, mounted one piece, measuring four inches by nine, between two sheets of Plexiglas, and gave it to Steve Christensen. The other he kept for a rainy day.

Hofmann told Christensen that the papyrus was the legendary Facsimile #2 of the Book of Abraham. Christensen photographed it and showed it to the LDS Church as proof positive of the existence of the McLellin Collection. Not being a scholar of Egypt, Christensen had no way of verifying whether the papyrus was genuine. And by now he had become increasingly suspicious of Hofmann. He had learned, for instance, that Hofmann had tried to sell part of the McLellin Collection to someone else, and that Hofmann might use the proceeds from the sale of the McLellin Collection to pay off Wilding, not the loan at First Interstate that Christensen had helped arrange for him. Perhaps the piece of papyrus stored in his safe deposit box was a fake. Christensen decided to seek the advice of an expert.

When Christensen called Kenneth Rendell in Boston, he had no idea that Rendell was the person from whom Hofmann had bought the papyrus; or that the Egyptian artifact locked in Christensen's safe deposit box had originally belonged to an Englishman named Solomon Pottesman, and that it had been acquired by Kenneth Rendell at the esteemed London manuscript dealers Bernard Quaritch Ltd. Only one person knew all this information. And that was Mark Hofmann. And when Hofmann heard that Kenneth Rendell was flying to Salt Lake City to meet with Christensen, his heart stopped beating in his chest.

It was the moment Hofmann had always been dreading. Like a playwright he had wielded almost absolute control over his characters. Now two people from different parts of the script were about to come face to face. If they did, Hofmann would be exposed for what he was: a fraud and a cheat. His parents and family, his friends and children, and the world at large, would see that his interest in history, his encyclopedic knowledge and passion for books and manuscripts, were a sham. More dangerous still, exposure would blow apart the volatile psychological structures on which he had built his life. Since his early childhood, forgery and deceit had become Hofmann's way of surviving in the world. By living a double life Hofmann could prevent the

painful contradictions he carried inside—his desire to hurt and injure his parents and the Mormon Church, while at the same time not losing their love and respect—from disabling him. Now, the protective mantle of deceit and lies he had woven about him was about to be torn away. He could think of only one way out.

CHAPTER FOURTEEN

The Kill Radius

On the Friday before the Columbus Day weekend, 1985, Hofmann climbed into his sports car and headed west on I-80, toward Skull Valley, on the edge of the Great Salt Lake Desert. He had already driven out to the desert the day before, but it had been snowing and he had had to abandon the test. On the way back he had been stopped for speeding. As the state trooper appeared at the window, his heart had started to pound. What if he had searched the trunk?

Today he was not going to be so stupid. He made sure that he was in the middle lane, behind a truck, and that he was doing less than fifty-five miles an hour. At Grantsville he exited the highway and drove down a back road to a secluded gully. He parked the car, popped the trunk, and took out a length of half-inch-diameter galvanized pipe. Next, he took a can of gunpowder, filled the pipe, and inserted a rocket igniter into it. He then joined the wire of the rocket igniter to a fifty-foot extension cord and walked back down the gully.

A buzzard mewed overhead. Hofmann looked up, then connected the end of the extension cord to a battery pack. The bomb exploded with a puff of smoke, blowing a small hole in the

ground. Hofmann walked over to inspect it. To kill someone, he mused, kicking a jagged piece of pipe into the bushes, the bomb would have to be twice as big. Rolling up the extension cord, Hofmann walked back down the gully, threw the extension cord into a saltwater drying pool, got back into his car, and drove home to his wife and children.

Hofmann had found a recipe for constructing pipe bombs in *The Anarchist Cookbook*. While visiting a gun show with Shannon Flynn, he had also bought several books on bomb making. He had then set about assembling the equipment. On October 5, at a Radio Shack store at the Cottonwood Mall in Salt Lake City, he purchased a mercury switch, some C-size battery packs, and a circuit tester, under the name Mike Hansen. Hofmann had been using the alias Mike Hansen since 1978. He had used it to study, and sometimes remove, books and manuscripts from the Special Collections Library at Utah State University, the LDS church Archives, and the New York Public Library. He had used it to order printing plates for forged Deseret currency in Kansas and Denver; and at DeBouzek Engraving in Salt Lake City, where he had ordered the printing plates for the Oath of a Freeman.

On that same day, October 5, he had bought more batteries and some Estes rocket igniters from a store called Hammond's, in downtown Salt Lake City. The pipes—two twelve-inch lengths of one-inch diameter—he acquired at the Holiday Hardware and Lumber Store. While waiting for the pipes to be cut and threaded for him, he bought a pair of rubber gloves and a Magic Marker. At another store he bought the end caps, nails, and Hercules Bull's Eye gunpowder. At Mail Box USA, on 3300 South, he bought duct tape and two shoebox-sized packages that he would use to house the bombs. He paid for everything in cash.

Hofmann still hoped that, somehow, he would be able to wriggle free of the box he had got himself into. On Friday, October 11, three days before Christensen and Wilding's deadlines, as the bomb-making materials lay under a blanket in his basement workshop, he had gone to see President Hinckley at LDS

headquarters, claiming that he had located some important new Mormon artifacts, the Kinderhook Plates. Hinckley declined to get involved. "There stirred in the back of my mind," Hinckley would write in his journal later, "a faint recollection of these having been shown to be fraudulent back in Nauvoo days."

As Hofmann was trying, one last time, to deceive Hinckley, Hugh Pinnock and Steve Christensen were trying to reach him about the McLellin Collection.

"Couldn't reach Hofmann," Pinnock wrote in his diary. "So papers will close next week." The date was set for Monday, October 14, but that was Columbus Day, and the banks would be closed. The final deadline for the delivery of the McClellin Collection was therefore set for 10:00 A.M. on Tuesday, October 15. Starting that same day, Hofmann would also begin paying $4,000 per day to Thomas Wilding.

Hofmann spent Columbus Day with his wife and their children. They rented some movies, ate pizza, did chores around the house. In the afternoon they went for a drive. In the evening Hofmann went over to a friend's house with Shannon Flynn. Hofmann drank wine and talked about polygamy, railing at the hypocrisy of the church. At 11:30 P.M. he drove home. His children were sound asleep, but his wife was still up. They talked for a while, then Dorie went to bed. A few minutes later Hofmann went downstairs to his basement workshop.

All the rage and pain he had felt throughout his life, his feelings of animosity toward the Mormon Church, his anger at his parents, were now focused on a twelve-inch length of galvanized lead pipe. He constructed the bomb with which he was going to kill Steve Christensen with the same meticulous attention to detail he had used to create his forgeries. Taking the metal pipe, he drilled holes into the end of it to connect the firing mechanism: a mercury switch placed into an electrical circuit between the improvised igniter and the battery pack. He then packed Hercules Bulls Eye smokeless powder into the pipe, and sealed the ends with metal end caps. He did not just want to kill Chris-

tensen. He wanted to maim him. Having filled the lead pipe, and sealed the ends, he taped a mass of one-inch-long cement nails around it. When the bomb exploded, the nails would tear into Christensen's flesh like shrapnel from a grenade.

To ensure that the bomb did not go off while he was transporting it, he took an ice pick, poked a hole in the side of the box, and threaded the wires leading from the battery pack through the hole. He then taped each wire to the outside of the box so that they could not accidentally touch. Finally, he picked up a felt-tip pen and, on the outside of the box, in a forged hand that did not resemble his own, wrote Steve Christensen's name. He then placed the bomb in a box that he had bought at a Mail Box USA. Just before placing the bomb he would twist the two wires together, being careful not to "tilt" the mercury switch and explode the bomb.

Hofmann's forgeries had worked through the power of suggestion. They created false histories, but with enough verisimilitude to suggest they were authentic. If doubts were raised, he would resort to a ruse that all forgers have used: he would create a second document that appeared to validate the first. Hofmann now applied the stratagems of forgery to the taking of human life.

He realized that he would be an immediate suspect in Christensen's murder, and so he set about constructing a second, identical bomb for Steve Christensen's business partner, Gary Sheets. Sheets had no connection to the historical documents world—he had never even met Hofmann. However, as the director of Coordinated Financial Services, he was closely connected to Christensen. CFS was in the process of filing for bankruptcy. Christensen, fearing financial ruin, had quit the company in August. By killing Sheets, Hofmann would make the police think that the two murders were the work of disgruntled investors bankrupted by CFS.

It was about 2:30 A.M. when Hofmann finished preparing the two bombs. He then set about clearing up his basement,

throwing all incriminating evidence—the Marks-A-Lot pen he had used to write the names on the boxes containing the bombs; the drill bits used to make the holes in the pipes; a soldering iron and solder; the tape he used for the nails; the unused rocket igniters—into garbage bags. He carried the two bombs and the garbage bags out to his van and drove to the Sheets residence in an affluent suburb of Holliday, in southeast Salt Lake City. He reversed into the driveway, got out of the van, and placed the package about five feet from the garage door. He then bent down and removed the tape securing the wires to the outside of the box and joined the ends together. The bomb was primed. The moment someone picked up the package, the mercury switch would be jolted, and the bomb would explode.

Hofmann arrived home at about 3:30 in the morning and took a nap. While he was napping downstairs, his youngest daughter woke up. Doralee called to him, asking him to attend to the little girl. Hofmann soothed her back to sleep, then, at 6:00 A.M., left the house again to drive to the Judge Building, in downtown Salt Lake City, where Steve Christensen worked. Having parked his van outside, he went up to the sixth floor to check if there was anyone around. Then he returned to the van to get the bomb. Taking the elevator to the sixth floor, he walked along the corridor and placed the package outside Christensen's office.

Bomb experts call the area in which a bomb is lethal the kill radius. When Steve Christensen picked up the package Hofmann had left for him, he placed himself at the center of the circle. He was found lying on his back outside his office, crying in excruciating pain. His face was covered in soot. There was a gaping hole in his chest. His right thigh had been torn open. One foot had almost been blown off. His body was covered in shrapnel wounds from the masonry nails Hofmann had packed around the pipe. One of them had gone straight through Christensen's eye and into his brain.

For five years Hofmann had been waging a secret war against

the LDS church. Now he had assassinated one of its rising stars, a man some people believed might one day become a General Authority, one of the highest positions in the Mormon Church. His forgeries had manipulated history. He had now exercised the ultimate act of control: power over life and death.

A few hours later, at approximately 9:30 A.M., the second bomb exploded outside Gary Sheets's house. But it did not kill Sheets. It killed his wife, Kathy. She had arrived home in her red Audi from a shopping trip when she spotted the package in front of the garage. Having parked her car in the driveway, she walked toward it and picked it up. As she shifted her weight, the mercury tilted, and the bomb exploded. The blast was so powerful that it demolished the corner of the garage.

When a neighbor found Kathy Sheets lying in the driveway, she thought that it was a Halloween joke. She was lying on her back with her mouth open. Her face was calm, almost serene. Her eyes stared up into the sky. Her skin was untouched. Where her shoulders were, the material of her parka had been ripped in such a way that it looked as though she had sprouted wings, like an angel. There were white feathers all over her clothes and hair. Her front was covered with what looked like piles of congealed candle wax. But when the neighbor bent to look more closely she realized that this was no Halloween prank. One of Kathy Sheets's breasts had been blown off. The red, white, and yellow substance she had thought was candle wax was the fatty tissues of her stomach.

Hofmann believed he had committed the perfect crime. So, he must have watched in horror then as the evening news ran reports of a witness who had been in the Judge Building, where Christensen was killed, at the same time as he that morning, and had seen a man go up in the elevator carrying a parcel. The physical description was vague. According to the witness, Bruce Passey, the man had dark hair and glasses. But Passey had noticed one crucial detail. The man carrying the package, Passey claimed, was wearing a green "letter jacket" with gray sleeves.

Hofmann was well known to frequently wear such a jacket, with leather elbow patches on the sleeves. Indeed, many people associated him with this old high-school memento.

Though the second bomb set up a smoke screen behind which Hofmann hoped to hide, it did nothing to solve his problems. The day after the bombs went off, Hofmann received a call from Hugh Pinnock, pressing him for repayment of the First Interstate Bank loan of $185,000 or delivery of the McLellin Collection. Pinnock arranged to meet with Hofmann to discuss the McLellin Collection at 2:30 in the afternoon. But Hofmann never made it to the meeting. Instead, he was found sprawled on the ground near the bombed-out remains of his blue Toyota sports car.

It was generally assumed that Hofmann himself was the intended target of the bomb that exploded in his car, and that this third bomb was somehow connected to the other two murders. The fact that Hofmann had been seriously wounded only served to increase people's sympathy for him. Many took it as proof that he could not have been the bomber. Hofmann himself would later tell investigators that it was a suicide attempt aimed at sparing his family pain and humiliation. The police conjectured that the bomb was intended for Brent Ashworth, Hofmann's most frequent customer and the man who had nearly bought the Emily Dickinson poem in the early eighties, but that it had gone off by accident. This version of events, which is still widely believed, even by Ashworth himself, was strengthened when Hofmann, changing his story about suicide, told a fellow inmate in prison that the third bomb was intended for someone to whom he owed $30,000. Hofmann owed Brent Ashworth just that amount.

The truth was far more complicated. By establishing an illusory connection to the CFS Bank, the second bomb had created a smoke screen behind which Hofmann hoped he could hide until the Oath of a Freeman had been sold. It would buy him time. But before the bodies of Steve Christensen and Kathy Sheets

had grown cold, Hofmann received a call from Hugh Pinnock, pressing him for repayment of the First Interstate Bank Loan for $185,000, or delivery of the McLellin Collection. "Christensen's murder made no difference," explained Hofmann's former colleague, Shannon Flynn. "The Church was on him so hard that even Christensen's murder did not make any difference. It just delayed the meeting for twenty-four hours."

Like the bomb that killed Kathy Sheets the bomb that blew up Hofmann's car was intended to throw up a smoke screen of deception. Wednesday was the day Hofmann usually met Brent Ashworth at the Crossroads Mall in downtown Salt Lake City. For years Ashworth had bought almost any historical document Hofmann had sold him, particularly Mormon documents. But toward the end Ashworth had grown suspicious of Hofmann.

A few months earlier, Hofmann had sold Ashworth what purported to be Joseph Smith's last letter, *a cri de coeur* from the Mormon leader written in jail on the day he was killed. Hofmann had promised Ashworth the letter, but had then sold it to a collector in Arizona. Ashworth was furious. Anxious that he was about to lose the trust of his best "mark," Hofmann asked Deseret Books to buy the letter back from the collector in Arizona so he could sell it to Ashworth, as promised. The price was now $100,000, though; and as Hofmann had received only $18,000 worth of documents from Ashworth as a partial trade, he would be out of pocket $80,000. He did not have the money. He was also being hounded by Wilding and his numerous other creditors. In order to pay Peter, he robbed Paul, using some of the money Wilding and his group had invested to buy back the Joseph Smith letter so that he could give it to Ashworth.

The bomb would not only get Ashworth off his back, it would solve the problem of the McLellin Collection. Even more importantly, it would throw the police off Hofmann's trail by creating the impression that he had nothing to do with the first two bombs: that this mild mannered, well-educated documents dealer was the intended victim of a serial killer still at loose in

the City of Saints. It was to be Hofmann's final manipulation of reality; his last illusion. Hofmann had spent the previous evening burning a pile of historical documents in his fireplace, before putting them in the trunk of the car. After the bomb went off, and the documents were destroyed, he was going to disappear, fly to Mexico or Brazil, with this wife and children, an innocent man running from the forces of evil.

As he had for the first two bombs, Hofmann used a mercury switch as a firing mechanism for the incendiary bomb he now constructed: a small, vial-shaped gadget he had bought at Radio Shack. When the switch was tilted, the mercury confined within the glass vial would flow to the lowest part of the vial and create a connection, causing the bomb to explode. To prevent this from happening as he transported the bomb, Hofmann taped the wire leading from the battery pack to the outside of the box. He then drove from his home in the suburbs to downtown Salt Lake City and parked on Second North Street, outside the Deseret Gym, where he sometimes went to exercise, a few blocks from the Mormon Temple. It was a beautiful fall afternoon, and from where he parked Hofmann could see the golden statue of the angel Moroni, glinting in the sunlight on top of the Temple. He connected the wires to the battery pack. Then he pushed them back through the holes he had made in the box with an ice pick. The bomb was now primed and ready. The moment it was moved, the mercury switch would tilt and the bomb would explode.

At that moment, Brent Ashworth was buying a newspaper at the bookstore in the Crossroads Mall, a few blocks away. Hofmann's plan was to meet him there, then entice him back to the car. They usually met at the mall on Wednesdays. If Hofmann had something interesting, they would often then go to his car to look at it, and haggle over the price. This time, Hofmann would pretend he had left something in the gym, or needed to use the restroom; any excuse would do, so Ashworth would go

to the car alone and wait for him there. The box would be lying on the passenger seat. Ashworth would move it. Boom.

This time, however, Hofmann made a mistake. Having primed the bomb, he decided to move it. It was almost like a dare, as though he wanted to show himself that he could do it, that even after all that had happened in the last forty-eight hours, his nerves were strong enough, his hand steady. It was like one of those games where you try to guide a ball through a labyrinth by gently tipping the surface of the board. Move it too much, and the ball drops in the hole. Move it too little, it stays put.

Hofmann put himself into a trance as he lifted the box from the seat and began to move it, millimeter by millimeter, through the air. He breathed quietly, focusing all his attention on keeping it perfectly balanced. There was no beginning or end. Each movement flowed into the next. But as he was about to set it down again, the box slipped.

The blast tore the clothing from his body, so that when he was found lying on the grass near the car by a passerby he was almost naked. His skin was blue with shock. He had a gaping hole in his knee where one of the end caps from the bomb had lodged. The middle finger of his right hand had been blown off, exposing the bone. There was a deep gash in his head. His chest was bleeding. The car had been demolished. Its roof was blown off, and pieces of charred and blackened historical documents were strewn across the ground. One of them was the fragment of the Egyptian Book of the Dead Hofmann had bought from Kenneth Rendell.

As he lay there, drifting in and out of consciousness, Hofmann remembered an incident from his childhood. He was twelve years old, and he was playing a game with his cousin in the furnace room of his cousin's house, with some gunpowder and chemicals. There had been an explosion, and his shirt had caught fire. He had run to the bathroom to douse it with water. He remembered how he had stood watching himself in

the bathroom mirror, as the flames licked at his face and neck. He did not feel any pain. It was as though he was looking at himself from the outside, calmly, and with a certain fascination. Then he had smelled burning hair, and he had begun to scream.

He could smell burning hair again, but this time he did not scream. He felt at peace. The years of lying and pretending, the double-dealing and deception: they were all finally over.

CHAPTER FIFTEEN

Cracked Ink

More than one hundred investigators from five different agencies, including the Bureau of Alcohol, Tobacco and Firearms, the FBI, and the Salt Lake City Police Department, assembled, sorted, and analyzed a mountain of evidence to put Hofmann behind bars. But two people, more than any others, were responsible for seeing that Hofmann would never forge or kill again. One was a Salt Lake City detective named Ken Farnsworth. The other was a forensic documents expert named George Throckmorton.

Though Ken Farnsworth drives a Jeep Cherokee and packs a 9mm Glock, he seemed to belong on a wiry quarter-horse galloping across the badlands in search of outlaws like Butch Cassidy and the Sundance Kid, dressed in a long black leather coat, with a grimy neckerchief over his mouth and a Winchester slung across his saddle. A tall, long-limbed man with a chiseled face, graying hair, bushy moustache, and dark brown eyes that smolder like coals, Farnsworth has the tough, resolute nature of his British forbears who dragged carts and sleds across the Utah desert in hundred-degree heat as they journeyed toward the new Zion. They were driven by religious zeal. Farnsworth, an

ex-Mormon, is driven by an all-consuming passion for putting killers behind bars.

He had been a detective in the Salt Lake City homicide squad for only a year and a half when he joined the team investigating the murders of Steve Christensen and Kathy Sheets. At first there appeared to be other, far more likely scenarios for the murders. One was that the murders were revenge killings by disgruntled investors in the CFS Bank. After all, Christensen was Sheets's partner and had taken over the running of the company just two months before the bombings. He was scheduled to testify at a grand jury hearing about the bank. According to some reports he was insured by the company for $5 million. By killing him a group of angry investors could recoup some of their money. Many of the investors in CFS were from Las Vegas, a city known for its Mafia connections. Was Hofmann, as he claimed, the victim of a murder attempt, not its perpetrator?

Or were the murders, and the apparent attempt on Hofmann's life, somehow connected to the Mormon Church? There were widespread claims in the nineteenth century that Brigham Young had ordered the assassination of enemies of the Church. But Farnsworth was convinced within a few days of the beginning of the investigation that Hofmann was the bomber and that the murders had something to do with forged documents. He had almost no experience in forgery cases, and none in the antiquarian documents trade, but he was a quick study. He traveled to New York to interview Justin Schiller about the Oath of a Freeman. He contacted dealers and collectors who had bought documents from Hofmann. He relentlessly followed the money trail. Some people said that he was consumed by a deep personal hatred of Mark Hoffmann. Hofmann's father accused him of manufacturing evidence.

A search of Hofmann's house turned up several pieces of paper with the name "Mike Hansen" on them. One was an envelope found in Hofmann's basement. It bore the address of a company called Utah Engraving. A Radio Shack receipt for the

purchase of a mercury switch and battery pack similar to the ones used in the bombs also bore the name "M. Hansen," and a phony address. Farnsworth was convinced that Mike Hansen and Mark Hofmann were the same person. He began an intensive search of all Salt Lake City's engraving and printing companies. At DeBouzek Engraving he found a number of orders for Mormon historical documents, including an early LDS hymnal edited by Emma Smith. He also found a negative for an engraving plate with Jack London's signature that matched one found in Hofmann's first edition of *The Call of the Wild*. Farnsworth also discovered that Mike Hansen, alias Mark Hofmann, had also ordered a printing plate for a rare historical document called the Oath of a Freeman.

To convince a jury that forgery was the motive for murder, Farnsworth would not only need to show that Hofmann had ordered printing plates and used a false name to buy some batteries. It would be necessary to prove that the documents he had been selling to the Church were forgeries. The LDS's own manuscript experts had failed to find any flaws in the Anthon Transcript and the numerous other documents they had bought. One of America's leading experts on forgery, Walter McCrone, had examined the Joseph Smith III Blessing and deemed it authentic. The FBI's forensic crime lab had found no sign of forgery in the Salamander Letter. After months of scrupulous tests even the Library of Congress, with its vast resources and accumulated expertise in rare books and manuscripts, had been unable to find anything wrong with the Oath of a Freeman.

But if there was one person in America who could find the fatal flaw a court would need to convict Hofmann, it was a forensic documents examiner named George Throckmorton. He had nearly twenty years of experience, including a contract with the American Express company to investigate forged signatures on traveler's checks. He was a convinced Mormon. He was stubborn, determined, and meticulous. And, unfortunately for Mark Hofmann, he lived and worked in Salt Lake City.

At the back of Throckmorton's office in the basement of the Salt Lake City Police Department is a "Wall of Shame": a poster-sized display showing police photos of some of Utah's most notorious criminals—"the baddest of the bad," Throckmorton called them. Mark Hofmann's photograph is below Charles Manson's, arrested en route to California for crossing state lines with a stolen car. A square in the row of fingerprints below Hofmann's photograph is empty. The bomb that blew up his car took off the top of the third finger of his right hand.

Throckmorton is a tall, debonair man with immaculately combed white hair. In his time as a forensic documents examiner he has seen every kind of deception: forged "quit-claim deeds" (legal contracts relinquishing a claim to piece of property) and wills; phony land deeds; as well as hundreds of forged historical documents. In recent years, Silicon Valley has become a black spot for forgery. To stop a top-flight computer software engineer from leaving for another company—and taking with them highly sensitive information—employers often forge a noncompetition agreement, prohibiting an employee from working for someone else for three of four years. In a health care industry where profits matter more than patients, hospitals and insurance companies alter their records to reduce their liability. Throckmorton has analyzed the handwriting on drug ledgers; the scribbled accounts, often written on napkins or matchbox covers, by which drug dealers tally their illicit sales. On one occasion, he had to work on a handwritten note fished out of a prison toilet. Two inmates had lured another prisoner out of his cell by forging a doctor's note requiring him to go for a medical examination. They then stabbed him to death, and flushed the note down the toilet.

Throckmorton was working at the Salt Lake attorney general's office when he was asked to examine a number of Mormon documents that Hofmann had sold to the Church. To ensure the impartiality of his findings a second forensic documents examiner named Bill Flynn was flown in from Phoenix, Arizona. Two

people had been brutally murdered. Somewhere in the documents they were about to examine was, they believed, the motive for those murders. Some tiny flaw, a momentary lifting of the pen, or the trace of a chemical that did not belong there, could put a murderer behind bars. But where was it?

Throckmorton and his colleague brought the full arsenal of their trade to bear on Hofmann's documents. They had a powerful zoom microscope, which could make the fibers in a piece of paper look as big as the hairs on the back of your hand. They had ultraviolet and infrared viewing devices to detect chemical alterations to the paper, and measuring grids to compare different examples of handwriting. They began with infrared light. In one pile they had Hofmann's documents. In another they had a control group of genuine Mormon documents. The infrared test showed no abnormalities, but under ultraviolet light Throckmorton and Flynn noticed a blue haze on many of Hofmann's documents. They also discovered that, on one Joseph Smith letter that Hofmann had sold to the church, the ink appeared to run in one direction, rather than haloing out evenly, as it should under normal aging circumstances. Were these the telltale flaws so many investigators and authenticators were looking for?

Throckmorton anticipated that the hand of a forger would show itself fairly quickly: that the forger would use a word that had not even been coined in the nineteenth century, or that, under the microscope, some elementary technical blunder would betray him. These documents showed no such obvious flaws. Either they were genuine, or the man who had created them was such a master of his art that he had left no signs of his crimes. Throckmorton concocted inks from the same recipes Hofmann had used, which he had derived from chemical analysis. He created his own forgeries and attacked them with chemicals to see if they behaved in the same way as Hofmann's documents.

One of the details he focused on was the way the ink was smudged on a number of Joseph Smith documents. Smith had written with a steel-nibbed pen that needed to be dipped in ink

at regular intervals. Examination of genuine Smith documents showed that Smith was almost certainly left handed. He would write a few letters, dip the pen in the ink, then continue writing. Because he was left handed, he would often smudge the letters he had just written with his shirt sleeve or his wrist when, having dipped the pen in the ink, he brought it back to the paper and continued writing.

Hofmann tried to mimic these characteristic smudge-marks by dragging his thumb across the surface of the paper after he had written a few letters. But Hofmann was right handed. When Throckmorton examined the smudge marks under a microscope he discovered that instead of going from left to right, as they ought to in genuine Smith documents, Hofmann's smudge marks went upward and to the left. "Forensic science is a very unique science," said Throckmorton, paraphrasing a passage from his favorite Sherlock Holmes story, Sir Arthur Conan Doyle's tale of Mormon murder, *A Study in Scarlet*, "because it is backward from any of the other sciences. Most sciences, you start with a series of experiments and work forward. But in forensic science we have the finished product and we have to work backward."

Iron gallotannic ink normally bites deep into the paper. However, when Throckmorton examined Hofmann's Salamander Letter the ink appeared to sit on the surface. To test whether the ink was genuine, Throckmorton took an eyedropper and deposited some ammonium hydroxide on a genuine historical document, then watched what happened under the microscope. "If it sat on the ink, and nothing happened, it would mean that the ink was old," he explained. "You don't know how old: but it's at least fifty to seventy-five years old. But when we did that to Hofmann's ink, we could actually see it immediately begin to dissolve. And the reason for that is that the ink was still resting on the surface of the paper."

When Throckmorton zoomed the microscope up to seventy power, he noticed something else about the ink on Hofmann's documents: it had numerous hairline cracks. "This cracking phe-

nomenon was very unique," recalled Throckmorton. "We called it alligatoring, because it looked like the skin of an alligator." Throckmorton and Flynn decided to play a game. They took a pile of genuine historical documents and a pile of Hofmann documents. Without saying which pile it came from, Flynn passed Throckmorton a document to scrutinize under the microscope. One after another, based on whether they had the alligatoring effect, Throckmorton separated Hofmann's documents from the genuine ones.

One document was of particular interest. It was a promissory note from Hancock County, Illinois, dated September 11, 1837, signed by a man named Isaac Galland. "I. Galland," the text on one side of the promissory note read, "to pay $504.26 plus interest to County of Hancock, Illinois, from September 11, 1837, until paid." On the verso of the document was an inscription in Joseph Smith's handwriting. "Oblige Joseph Smith Trustee in Trust for the Church of Jesus Christ Latter-Day Saints. Nauvoo, December 14, 1841." It was signed "I Galland his agent."

As usual Hofmann had chosen to forge a Mormon document with a sting in its tail. For Isaac Galland seems to have stepped out of the pages of Herman Melville's *The Confidence Man*. A horse thief, counterfeiter, and real estate speculator from Hancock County, Illinois, he would eventually become Joseph Smith's main land agent. Galland regarded the arrival of the Mormons in the Midwest, in the 1830s, as a golden business opportunity. His first sale was a twenty-thousand-acre parcel of land between the Des Moines and Missouri rivers, at two dollars an acre. The land did not actually belong to Galland. It was part of the so-called Half-Breed Tract, a swath of land that the federal government had set aside for the offspring of the mixed "marriages" common in that part of America. But having insinuated himself into Joseph Smith's confidence—the Mormon prophet was notoriously susceptible to flattery—Galland proceeded to suck the Mormons into a string of fraudulent real estate schemes. On one

occasion Smith exchanged Mormon-owned land in Missouri worth $80,000 for land in the Half-Breed Tract in Iowa to which Galland had forged the deeds. Later, Galland absconded with thousands of dollars raised from the sale of land belonging to Mormon converts on the eastern seaboard. Believing that they had found the path to heaven, they signed over chattel and goods to the tall, blue-eyed stranger who claimed he was God's prophet on earth.

Hofmann had sold this document to the LDS church in 1981, right at the beginning of his forging career, and he had probably not anticipated the sort of rigorous forensic scrutiny it was now receiving. On one side of the note the ink appeared to have aged normally. But on the other it showed the characteristic alligatoring effect indicative of artificial aging. Throckmorton knew that this was not possible. If the ink had been on two different documents, it could have been subjected to different environmental factors, and thus aged differently. One document might have been exposed to damp or humidity. One might have lain for a century in the bone-dry attic of an abandoned homestead in the Utah desert. Ipso facto: one of the inscriptions had to be forged. "The cracking effect could not have been caused by humidity or some other factors, because both sides would have cracked," explained Throckmorton. "But here, we had two different kinds of aged ink on one document. And that became our Rosetta stone."

Hofmann could get Emily Dickinson's voice and handwriting right. He could create a letter from Daniel Boone that is so convincing you can hear the crack of gunfire as you read it. He could manipulate ink and paper with consummate artistry. He could fake history and manipulate people. But he could not simulate time: the slow drip-feed of the days, and weeks, and months; the shift of the seasons, and with it the subtle changes in humidity, temperature, and light that alter the chemical composition of a document. It was the flaw that would send him to jail for the rest of his life.

Throckmorton examined nearly six hundred Hofmann documents over a period of sixteen months, both before Hofmann's conviction and after it. Among them was the Emily Dickinson poem, "That God Cannot Be Understood." He was under a gag order at the time, and his findings were not made public. But Dickinson's name did appear on a list of historical figures that Throckmorton presented to the prosecution. The list agrees substantially with the list found in Hofmann's jail cell. Throckmorton says that he would have made it available to Sotheby's if they had asked him. They did not, even though both Throckmorton and his colleague, Bill Flynn, had been involved in 1985, shortly after the bombings, in the exposure of another major Hofmann forgery: a Daniel Boone letter that had been sold at Sotheby's for $31,900. In that case, based on the publicity about Hofmann, the buyer had become concerned that Hofmann might have forged the letter, and Sotheby's had ended up refunding the money.

Throckmorton has examined at least one hundred more documents since Hofmann's conviction on behalf of collectors, dealers, and auction houses. When he realized that the dealers and auction houses were continuing to sell Hofmann documents despite his determination that they were forgeries, he refused to have anything more to do with them. "Every single document they sent me was a forgery," he said testily. "And I would tell them these things were forged, but they would still go ahead and sell them, without informing the purchasers. One time they even modified my report, leaving out the part where I said it was a forgery. I know of at least four or five major Hofmann documents that I said were forgeries and which I later heard have been sold."

Some of Hofmann's forgeries have even boomeranged back to Throckmorton several times. "Last year, a dealer sent me three documents, two of which I had already pronounced forgeries in the original investigation. I started to wonder: *How many times am I going to see these things?* But they don't care. They just want to sell

these things. I once asked an attorney who represents one of the auction houses, 'How can you sell a forged document, and yet guarantee it is authentic?' And he said, 'We don't guarantee it to be authentic. We guarantee it. We sell it, and if the customer does not like it, we'll give them their money back.' After that I have never worked for any of them."

Throckmorton continues to be sought for his expertise, despite himself. On one occasion a man called him from California to say that he was walking along the beach when he found a bottle that had been washed up. In it, he claimed, was a letter from Amelia Earhart's pilot explaining the mystery of the legendary aviator's crash. Would Throckmorton take a look at it? The same week he got a call from a couple in Texas. They said they had bought an old picture at a flea market. When they opened the back of the frame they found what they claimed was a handwritten copy of the Declaration of Independence. Not long afterward, Throckmorton was contacted by a man from Las Vegas who said he had bought an old car from a junkyard. When he took up the rubber floor mats, he found a yellowing envelope. Inside it? Another handwritten copy of the Declaration of Independence.

In the spirit of such hoaxes Throckmorton likes to keep an autographed baseball on his desk. It is signed by some of the greatest American sporting legends of the twentieth century, including Babe Ruth, Mark McGwire, Sammy Sosa, Willie Mays, Wilt Chamberlain, and Karl Malone. "It's a genuine baseball," said Throckmorton, with a wry smile. "But the signatures were all done by me. And I bet you it would pass the scrutiny of ninety percent of the people out there."

His sense of ironic detachment does not extend to Mark Hofmann. In a coded letter written from jail, which was intercepted by the FBI, Hofmann offered a bounty of $50,000 for his head. "I'm still afraid of him," admitted Throckmorton. "He's coming up for parole in 2006, and I hope he doesn't get out. Down at the prison they always say it's not the big weight-lifter

types that are the most frightening. It's the quiet, crazy guys. You never know what they are going to do."

Though he is appalled by his crimes, Throckmorton cannot help feeling grudging admiration for Hofmann's skill. "Hofmann is the best there ever was," he insisted. "Without question. He made his own ink and was in the process of learning how to make his own paper. He created letters and currency. He made seals, and postmarks. Most forgers specialize in a particular person. They do Lincoln or Washington. Hofmann forged over one hundred and twenty-nine different people that we know of. No one has ever done that before. That's what makes him great."

CHAPTER SIXTEEN

Victims

*H*ofmann did not just kill two people. He left numerous others emotionally and psychologically devastated. The families of Steve Christensen and Kathy Sheets will never fully recover from their loss. Numerous other people who were drawn into his web of lies and deceit have taken years to come to terms with what was done to them. At first, when people who had been involved with Hofmann talked about him, they would be cheerful, almost breezy, as though to emphasize how long ago it all was. There always came a moment however, when the wall they had erected between then and now, between their new lives and their old, would dissolve, like a sandcastle overwhelmed by a wave, as they spooled back down the corridors of memory to a place where they had been betrayed and deceived.

With Brent Metcalfe, the young Mormon historian whom Hofmann had used to publicize some of his most important forgeries, that moment came when he described his realization that someone he regarded as a friend and fellow searcher for truth was a fraud and a murderer. "The person who I thought was Mark Hofmann died with the bombings," he said, his voice

wavering with emotion. "The person I knew was a pretender, he wasn't real."

A tall, handsome thirty-nine-year-old, Metcalfe is what the French call *"bien dans sa peau"*: comfortable in his skin. He dresses in crisp white shirts, black sweaters, jeans, and hiking boots. In his right ear he wears two silver studs. Thinking back on the forgeries, Metcalfe still searches for reasons they worked so well. "The emotions the forgeries evinced were powerful. They evoked a will to believe. Hofmann knew how to play that like a symphony. He knew how to tell the story, and play the music to you, just the way you wanted to hear it. And that is probably more where his brilliance lies. He knew how to tell stories in such a way that they would appeal to the audience he was addressing."

Metcalfe believes that Hofmann's genius lay in his ability to deconstruct Mormon scripture and create fictional texts that fitted seamlessly into the historical record. Just as computer scientists take a piece of code and reverse-engineer it to discover how it was constructed, Hofmann reverse-engineered Mormon scripture to get at the underlying structures. "He would create these fictitious narratives that were sprinkled with enough historical verisimilitude that people concluded historicity from them," recalled Metcalfe. "And they, in turn, became pivotal documents that said how things are. Hofmann wanted to demythologize the founding parents. I think he was saying 'You've been told all these stories. But this is what really happened.' "

Metcalfe sees Hofmann as a ruthless nihilist whose ultimate goal was even more ambitious and diabolical than most people have assumed. "Steve Christensen was a rising star in the Mormon Church," he explained. "By murdering him Hofmann was disproving God's existence. Just as no divine inspiration had come to the aid of the church to expose his forgeries, so no higher being would step in and disconnect the battery wires to save Christensen. With the bombings Hofmann proved that there was no God-given revelation."

The ultimate proof of this, says Metcalfe, came, a day after the bombings, when Hofmann met with Apostle Dallin Oaks. According to Mormon doctrine Apostles like Oaks are meant to be in daily contact with the spirit of God. They are living oracles whose actions and thoughts are guided by divine inspiration. But Hofmann believed that he had so perfected that art of deception that, like his forgeries, he was invulnerable to detection. Just as most forensic experts could not "read" any sign of deception in his documents, he believed that no one, not even a Mormon prophet, could see inside his mind and soul. "He's just killed two people," said Metcalfe, with rising indignation. "And what does he do? He goes down to the church office building and meets with Dallin Oaks. I can't even begin to imagine the rush, given Hofmann's frame of reference, that this would have given him. To be standing there in front of one of God's appointed apostles, after murdering two people, and this person doesn't hear any words from God, doesn't intuit a thing. For Hofmann that must have been an absolute rush. He had pulled off the ultimate spoof against God."

It gives Metcalfe no pleasure to talk about how Hofmann outwitted the LDS church. He was a victim himself. "There was a lot of innocence that was lost in a short period of time," he recalled. "I had grown up to trust people I cared about, to believe in them. But the person I thought I knew never really existed. In a very real sense I lost two friends. Steve Christensen and Mark Hofmann. I wish that I could have kept them both. But the one was an illusion, and the other listened to the siren song of that illusion."

Deceit deforms everything it comes into contact with. This is why, of all the characters in Shakespeare, it is Iago, the man who destroys Othello by manipulating him into believing his wife is unfaithful, who is the most frightening. "He had a very magnetic personality," said Dorie Olds, Hofmann's ex-wife, recalling their first meeting in 1978, at the University of Utah. It was the first time she had ever spoken publicly about her

life with the twentieth century's most notorious forger. "He had very, very blue eyes. My daughter has his eyes. We became friends, and started talking. He was living with Jeff Salt at the time. They were fun to be around. They would laugh, and talk. Mark would talk about news of the day, or scientific research. It was interesting."

In a photograph taken at Hofmann's preliminary hearing in 1986, shortly before he was sentenced to life imprisonment, Olds strides along the pavement outside the courthouse, with a smile on her face, as her husband limps along on crutches. She has short black hair, large-framed glasses, and is dressed in one of those sober two-piece suits that a female bank manager might wear. In conformity with Mormon dress codes the skirt is cut below the knee. Fifteen years later everything except the glasses has changed. She has divorced and reverted to her maiden name. The short dark hair is now auburn colored and worn almost to her waist.

The middle child of five, she grew up in a conventional Mormon family. Her father had poor health, and the family had been supported by her mother, who worked full-time at a book-bindery. Having a mother who earned the family bread as a role model, combined with her Mormon upbringing, made it easy for Dorie to think of her role in Hofmann's life as a supportive one. "He was a very messy person," she recalled. "He'd come home and everything would be on the floor. There'd be piles of things all over the place, and I'd have to gather them all up: books, clothes, papers."

For his part Hofmann seems to have been a thoughtful, caring husband. He would go to elaborate lengths to get Christmas presents that suited her tastes. Long before it became fashionable, he was a hands-on father to his three small children. He pushed strollers, changed diapers, and attended local ward meetings with a baby on his arm. On summer weekends the family would go to Lake Powell, in southern Utah, where Hofmann's

family kept a boat. Hofmann was an expert water-skier. His favorite stunt was to ski with the rope clamped between his teeth.

Most people who know her say warm and generous things about Dorie Olds, but there are some in Salt Lake City who continue to maintain that she knew much more about her ex-husband's criminal activities than she has admitted. After all, the workshop where he executed his forgeries was in the basement of the family house. Is it possible that she did not know what he was doing down there? Others have sought to explain her ignorance as another reflection of a culture where women are taught to defer to their husbands in all matters and not ask questions. Dorie Olds was by nature trusting, generous, some would say naïve. Most of all, it seemed, she wanted to be a mother to his children.

Dorie insists that she was another victim of a master manipulator.

"The things that he created were things that I saw," she said forcefully. "He would come in and say, 'Look at what I've brought back, and what do you think is going to happen with this? And isn't this wonderful?' And I'd read them and be just wowed. I was his first, best audience."

What Dorie Olds claims she did not know at the time was that the documents Hofmann was supposedly bringing home from New York or Illinois were forgeries; and that he was using her as an alibi for the false provenances he was creating. "I was real good for him in that way," she said with a rare note of bitterness sharpening her voice.

Everyone who has ever been connected with Hofmann has an agenda. Whether they are dealers or auction houses, friends or former associates, they all want to paint themselves as the innocent victims of a master deceiver. Yet truth and lies are never easy to separate with Hofmann. Ironically, it was Dorie Olds who put her finger on the dilemma. "It's like his documents," she said. "Some were authentic, some were forgeries. How do you tell which is which? And that's how it is for me. How can I tell? I

can tell you what I feel was true and what wasn't. I like to believe that he loved me. I like to believe that he loved the children. And I do believe that was true. But do I really know? I don't."

Was Dorie the innocent victim she pretended to be? At a restaurant in Boston, shortly before the bombs went off, she and a group of friends watched as Hofmann reeled off signatures of George Washington and other historical figures on the tablecloth. Yet Dorie claims that she cannot recall the incident. And though she today uses hypnosis as one of the alternative healing techniques provided by her company, the Academy of Lifestyle Management, she insists that she knew nothing of Hofmann's interest in self-hypnosis and biofeedback. "If he was involved with that, he kept that piece of information from me," she said defensively. "I never believed in hypnosis, or had heard about it, until just a few years ago. I don't remember any hypnosis books being in the house. My training in that is something totally separate. I never knew there was a connection there."

Though Hofmann himself almost never showed emotion, Dorie Olds believes it was his acute receptiveness to other people's feelings and desires that made him so effective. "He was very, very cool," she recalled. "He would see where people's emotions were at, and what it was that would push their buttons, and then he'd use that to manipulate them. We talked a lot about what truth is, what is reality? Is truth illusion? I think his passion was disturbing the truth, deceiving people into having their truth shattered. It was very methodical. Very premeditated. And he wanted his name out there. He liked publicity. He liked people to know who he was. He liked the excitement. He liked to shock people and shake them up."

When Hofmann was convicted, Dorie found herself alone with three small children, $100,000 in debts, a frozen bank account, and no job. A year later she lost her house when it was reclaimed by Hofmann's mother. As is often the case the moment of her greatest misfortune was the prelude to rebirth and discovery. Her strong and continuing Mormon faith helped her.

Eventually, with another woman, she founded a holistic healing company called the Academy for Lifestyle Management, which uses alternative healing techniques to help others recover from trauma and grief. "I've had a very interesting life," she said. "I am not complaining. I learned a lot from this. And I became very strong. People say, 'Oh, you poor thing, how awful that must have been for you to go through that.' And I say: 'Don't you dare. Because it got me where I am today. And I like where I am.' "

For three years after Hofmann was convicted she continued to visit him in jail. Then, one day, she found herself in a prison rest room with another woman, being asked to smuggle something out of the jail on Hofmann's behalf. In January 1987 she filed for divorce. On the day the divorce was granted, Hofmann took a massive dose of sleeping tablets, which almost killed him. When Olds became engaged to a new partner, he tried to kill himself again. It was the only way he had left to control and hurt her. At the same time he continued to send her love letters and poems. Some were decorated with hearts and red roses painted by one of Hofmann's cell mates, a Mormon extremist named Dan Lafferty, who had killed his sister-in-law and her baby by slashing their throats after receiving a vision from God.

There can be nothing more frightening for a woman than to discover that the man whom she has loved and had children with was a stranger; that the eyes she had looked into were mirrors and the face she had loved was a mask, and that behind that mask was another. Dorie's way of surviving the shocking truth about her husband is to deny it. Though she believes that her ex-husband was a forger and a con man, she insists that he could not have murdered Steve Christensen because at the time he was reported to have been seen delivering the package containing the bomb, he was at home with her. "When the police came to interview me," she said, "they were telling me the time of when this happened, when it was that Mark was downtown, and he had been seen by an eyewitness. And I knew he wasn't gone at that time. The time frame they gave, he was home. He was

physically in my presence. It was early in the morning. I got up and he was there. And I passed five lie detector tests saying that."

To justify her claim that Hofmann was innocent, Dorie Olds prefers to believe in a conspiracy theory as complicated as an *X-Files* plot. According to her, far from being intended for Brent Ashworth, the bomb that blew up Hofmann's car was intended for Hofmann himself. When he survived, she claims, the person or persons who had killed Christensen and Sheets threatened to murder her and her children if Hofmann did not keep silent about what he knew. "I just go by my experience," she said, "and my experience tells me that he was the fall guy, that there were other people around that were involved somehow, and that have gone free. Whether they will ever be caught doesn't matter to me. I don't care. But I don't think he was the only one involved, and I don't think he was the one that did the bombings."

Dorie's most extraordinary claim is that Hofmann's confession to the police was itself a fabrication: that, to save his wife and children, he confessed to two murders he never committed. According to her, when Hofmann survived the third bomb, he became a liability and so he was given a choice: he could take the rap and never say a word about what he knew, or his wife and children would be murdered. Was this Hofmann's final forgery? Was the man who had so successfully manipulated Mormon history manipulating his own conviction by confessing to a crime he had never committed? Or was the truth so painful to bear that Dorie Olds had constructed a conspiracy theory that absolved him of guilt, and her of any complicity?

In the run-up to his trial Hofmann's lawyer, Ron Yengich, arranged for his client to undergo a polygraph test. The man who evaluated the test was Dr. David Raskin, a professor emeritus of psychology at Utah State University who has advised the CIA and Israeli Military Intelligence experts on the use of lie detectors for counterintelligence purposes. Raskin had also given lie detector tests in numerous celebrated cases, including those

of suspected terrorist Patty Hearst and serial killer Theodore Bundy.

Hofmann did not just beat the polygraph test. He sailed through it. Indeed, Hofmann's results came as such a surprise that Raskin sent them out for review to four other leading polygraph experts, including one at the FBI. Such reviews are done "blind." The polygraph tester does not know who the suspect is. All concurred that Hofmann was telling the truth. Since then more than a hundred federal, military, and law-enforcement polygraph testers have blindly scored Hofmann's charts. The vast majority have concluded that they indicate truthfulness. There were only two possible conclusions: Either Hofmann was innocent of murder, or he had somehow managed to outwit the lie detector.

Raskin suspected that Hofmann had managed to get hold of some of his research papers. One of them was called "The Effects of Countermeasures on the Physiological Detection of Deception." It had shown that individuals given special training in physical and mental countermeasures could beat polygraph tests. Had Hofmann read these studies to prepare himself for his test? When Raskin went to the jail to interview Hofmann he heard an even more extraordinary story. "Hofmann described using self-hypnosis the night before, and the morning before, the test," said Raskin, "to convince his subconscious that he was innocent."

One mystery remains: Why, after he had beaten a polygraph test, did Hofmann not continue the charade? After all, in the early weeks and months of the investigation, he was regarded by most people, including leading members of the Salt Lake City police, as a victim of violence, not its perpetrator. He was mild mannered, well spoken, and intelligent. He had a loving family and a stable home environment. His only obsession appeared to be a love of parchment and old books. The most serious offense on his criminal record was a 1970 arrest for shoplifting, which was never prosecuted. Not exactly serial killer material.

Other things spoke in his favor. Handwriting experts from

the Bureau of Alcohol, Tobacco and Firearms had concluded that the writing on the bags containing the bombs was not Hofmann's. Nor did it match that of Hofmann's closest associates: Dorie Olds, Shannon Flynn, and Lyn Jacobs also passed lie detector tests in which they said they knew nothing about the bombings.

But to many people's surprise Hofmann made an abrupt about-face and confessed. He then appeared for sentencing before the Utah Board of Pardons. If he did well at his hearing, and behaved himself in jail, he could expect to be back with his wife and children in ten to fifteen years. He was a supremely gifted liar and extremely intelligent. He had deceived numerous other people. Why not the Board of Pardons? All he had to do was express the remorse the parole board wanted to hear, even if he did not feel it.

Instead, he made a speech that has almost certainly guaranteed that he will spend the rest of his life in jail. "As strange as it sounds," he told the Board when he was asked about his motive for the murders, "it was almost a game. . . . I figured it was a fifty percent chance that it [the bomb] would go off and a fifty percent chance that it wouldn't; at the time I made the bomb, my thoughts were that it didn't matter if it was Mrs. Sheets, a child, a dog . . . whoever was killed."

Dorie Olds claims that this display of callous disregard for human life was a piece of theater; that having made his bargain with the devil Hofmann made the ultimate sacrifice: He traded the lives of his wife and his children for his own. "I was holding his hand, and he was trembling and shaking," she said. "He was saying what they wanted him to say, so that he would never come out of jail. It was as though he had practiced saying those words."

As ever with Hofmann, the truth was far more complicated. Though he did indeed confess to protect his wife and children, it was not for the reasons Dorie Olds had led me to believe. A "black chamber" operation—the term derives from World War I

when a secret chamber was used to read mail—conducted in the first year of his incarceration revealed that Hofmann had developed a secret code to communicate with her. The code was based on letters of the alphabet. One line of it read, "Anxsb Cnfxqni neun aegnf Arw." When the FBI decoded it, they found that it contained death threats to some of the prosecutors and judges who had put Hofmann in jail. The language and tone of the letters intercepted by the FBI also suggested that his ex-wife had been, if not an accomplice, then something more than an innocent victim.

By confessing, Hofmann averted a trial, which would not only have bankrupted his family for years to come but might have incriminated his wife. His subsequent statements to the Board of Pardons, that he did not care if he had killed a cat, or a dog, or a child, was a calculated rhetorical flourish designed to ensure that he was immediately sentenced, without a trial.

What role the LDS church played in the complex negotiations that went on behind the scenes will never be known. Certain it is that a trial would have been enormously damaging for the LDS hierarchy. Gordon B. Hinckley and other apostles would have been forced to testify. A trial would also have given worldwide exposure to Hofmann's forgeries and the questions they raised about early church history. It would also have shown that the LDS church was, in many ways, a mirror image of Hofmann: that, like him, it was engaged in the manipulation of history. Hofmann's plea bargain ensured that justice was seen to be done. A person who had embarrassed and deceived some of the most powerful people in Utah was punished and Gordon B. Hinckley, who would soon become the head of the fastest growing religion in the world, could sleep safe in the knowledge that Mark Hofmann could never again harm him or his church.

More out of impecuniousness than defiance, Dorie Olds continues to drive the battered, gold-colored Toyota van in which, the police claim, Hofmann delivered the nail bombs that killed Steve Christensen and Kathy Sheets. She does not believe he

did so. The truth is too terrible for her, and her children, to bear. A continuing faith in Mormonism and a new attachment to its contemporary equivalent, New Age mysticism, enable her to survive the contradictions. "I had angels helping me, keeping the faith," she said. "You see, the biggest disagreement between Mark and I was that he lived in the physical world. He believed in math, he believed in the tangible things. He doesn't believe that there is anything other than what you can see. And I know that's not the truth."

CHAPTER SEVENTEEN

A Spider in an Ocean of Air

Prisons are forlorn places at the best of times, but the Utah State Correctional Facility at Draper, where Hofmann is incarcerated, is a particularly bleak and lonely place. Situated on a drab, windswept plain about twenty miles to the south of Salt Lake City, in the shadow of the Oquirrh Mountains, its squat, 1950s concrete buildings, surrounded by razor-wire fences and guard towers, are reminiscent of Cold War–era Soviet gulags.

Deep inside the prison the man who manipulated and controlled so many people is now himself the object of the strictest control. He is housed in a cell seven feet long and five feet wide, his only light a dim bulb secured behind a grate in the ceiling. There are a toilet and a sink in the corner. The bed is made of steel. There is no desk or table, and he is not allowed writing instruments of any kind in his cell. One of his few prized possessions is a pink plastic cup.

In prison Hofmann has found his natural peer group: a Darwinian community ruled by predatory competition and brutality, in which only the fittest survive. As a murderer, particularly of an authority figure, Hofmann is one of the larger primates (pedophiles are the nematode worms of prison life and have to be

given round-the-clock protection). No one tries to "muscle" him or "take him over," as prisoners call the master-servant relationships under which protection is traded for favors, like sex or cigarettes. He is admired for the brilliance of his crimes. Above all, he is admired because he murdered an authority figure. The fact that he used bombs to kill his victims only increases his charisma. His prison nickname is the Mad Bomber.

Little remains of the plump, rosy-cheeked bookseller who once went to England as a Mormon missionary. Hofmann weighs 150 pounds. His right hand and fingertips are covered in scar tissue. He has skin grafts on his neck, shoulders, and right knee. One of the few things he can now control is his appearance. Sometimes he grows his hair long. Sometimes he has a shaved head. Sometimes he wears a beard. His only visitors are his aging mother and his four children. His father died, a broken man, soon after his son went to jail.

For his mother's sake he pretends that he still believes in Mormonism. But the seven-page transcript of a speech Hofmann was allowed to give at a 1996 LDS church service at the Timpanogos prison in Utah suggest otherwise. Entitled "Why I Am an Agnostic," it sets out to prove, in closely reasoned arguments, that all religions are based on a fallacy. Hofmann reveals himself as a pedantic son of Socrates. "I believe people have mystical or religious purposes," he writes. "I do not believe these experiences provide evidence for the conclusions often drawn from them. . . . Empiricism is the philosophical basis of the scientific method. Empirical knowledge requires such things as controlled conditions, repeatable observations, and independent observers . . . an overwhelming feeling of God's presence is evidence enough for admitting the genuineness of the feeling, but it is not evidence for the claim that a divine being, with substantial existence independent of the experience, is the cause of the feeling."

In a later portion of the speech, Hofmann contrasts eastern and western religious traditions. "Adherents of a major world religion, Buddhism, do not believe in the reality of the world, or of

physical objects. Their view is that since all we can experience are sensations, all we can know with certainty are those sensations, and they believe it requires an unwarranted leap of faith to say physical objects caused those sensations. The idea being that reality might just as well be a dream, or 'all in the head.' Since mankind cannot even agree about the reality of what can be seen, it seems to me there is little question that there is also uncertainty about the reality of what is unseen. An all-powerful God, if he exists, has the power to prove His own existence to His creation, in a manner at least as convincing as objects we directly perceive, yet He has not done so."

Hofmann ends his essay with quotes from Roman philosopher-emperor Marcus Aurelius and science fiction writer Stanislaw Lem. The citation from Lem concerns game theory. Hofmann defines it as "a branch of mathematics used to analyze such things as business and military strategy." It is also a description of his own strategies of deception and an apologia for his crimes. "If it is definitely unknown whether or not a thing exists, some merely asserting that it does and others that is does not, and if in general it is possible to advance the hypothesis that the thing never was at all, then no just tribúnal can pass judgment against anyone for denying the existence of this thing. For in all [systems of logic] it is thus: when there is no full certainty, there is no full accountability. This formulation is by pure logic unassailable, because it sets up a symmetrical function of reward in the context of the theory of games. Whoever in the face of uncertainty demands full accountability destroys the mathematical symmetry of the game. We then have the so-called game of the Nonzero sum."

A former prison guard named Chuck Larson remembers Hofmann as a lively conversationalist. Larson was working as a night sergeant when he met Hofmann, and the two men soon struck up a relationship. Hofmann was studying Latin, which Larson knew slightly from school, and they would discuss verb conjugations and grammar. "He was starved of intellectual com-

pany, recalled Larson. He craved discussions he could not otherwise have in the prison."

Sitting on a radiator outside Larson's office, the two men would talk for about an hour each day. "Hofmann liked the rhythm of his own thoughts," said Larson. "He talked about Nietzsche and Kierkegaard. We talked about history, and the Mormon Church, and about how he made the bombs. Hofmann was very congenial, and a fascinating conversationalist. Evolution was a big topic. He was contemptuous of people with religious faith. He felt they were easy to manipulate."

Larson has no illusions about the sinister nature of the gaunt, slightly stooping man who would sometimes wince from the pain still caused by his injuries. "He had no real conscience. Whether forgery, or killing someone to buy time, or cutting the page from a book, he had no moral sense of right or wrong. He once told me that if he could create a document that is so well done that the experts declare it to be genuine, then for all practical purposes it is, and there is no fraud involved. He genuinely believed that. But Mark's biggest crime was not the forgeries or the bombings, it was that he had offended powerful people here. He had made them look stupid."

Hofmann enjoys his notoriety. He has been courted by film companies, writers, and photographers. His refusal to yield up his secrets is one of his few remaining opportunities to control and manipulate the world, and so he has denied them all. In the years immediately after his conviction he received as many as a hundred letters a week from all over the world. Some disparaged him as a monster. Many praised his skill and dexterity. "I just love the fact that you kidded all the experts," wrote an English girl from Birmingham, with whom Hofmann corresponded for several years. "I would love to have the brains to do something like that." She goes on to praise him as "an eccentric artist who gave the public what it so desperately wanted at inflated prices, playing the buyers off against each other just as the galleries do

legitimately," and promised to send a "sexy" photo. She complimented Hofmann on his "little boy lost" appearance which, she claimed, many girls find attractive.

In a letter sent to his onetime friend Shannon Flynn, Hofmann describes his interest in poetry. "The poetry enclosed in my last letter, *Erotica*, is a selection I put together for a prison poetry contest," he writes. "Not having anything else to do with it, I sent it to you when I got it back. I am not sure if I remember all the poems that were included. I have written dozens of poems about sex. A psychologist would probably say because I miss it so much."

Though he managed to forge an Emily Dickinson poem, Hofmann's own verse veers between cloying sentimentality and mannered imitation of the classics. But it provides fascinating insights into his personality. In a long poem entitled "Steven" he contemplates a spider on his windowsill. "In the upper right corner of my cell," it begins, "There lives alone in his own citadel/A spider who seems constantly aware/Of what happens in his ocean of air."

Lying on his bed at night, as the prison lights dim, Hofmann watches as the spider devours flies that have strayed into his "fisherman's net." "For Steven this sport does more than amuse," he writes. "His survival rests on the flies that lose." As Hofmann drifts off into a troubled sleep, the spider's magnified shadows conjure visions from Dante's *Inferno*. "When I see his demonic silhouette/I literally shiver in cold sweat." At other times the spider's acrobatic maneuvers inspire in Hofmann a feeling of almost spiritual awe.

The poem ends with a chilling vision. Though Steven is a good cell mate, "quiet, clean, undemanding, private," Hofmann resents sharing his space with it. "But someday when I want to be alone," he writes, "And grow tired of his constant presence/Then he may witness my preeminence/For in rashness, with one swish of the broom/His universe may be swept from my room."

In a rare moment of vulnerability the realization of his power

over the spider leads Hofmann to contemplate the precarious-
ness of his own existence. "I wonder would he be consoled to
know/That I, too, wait for what fate may bestow?" the poem
concludes. "And wonder what broom may sweep me away/And
how, and why, and where, and on what day?"

In another poem, "A Circus," written under the effect of an
illegally obtained dose of the hallucinogen LSD, Hofmann
records drug-induced visions similar to the ones described by Al-
dous Huxley in *The Bird of Paradise*. As Hofmann walks through
the prison canteen, a "black-toothed smile" leaps off his tray, the
floor turns to a sea of melon juice, his hot dog becomes a kalei-
doscope of colors, his prison jumpsuit turns from orange to gray.
Then the prison starts to float into the air. "Only the guard tow-
ers," he writes, "like tent stakes, hold it down."

Hofmann spends most of his time watching television, espe-
cially nature and science documentaries, working in the prison
laundry, or creating crossword puzzles for his children. He is a
voracious reader, mostly books about game theory, English po-
etry, and mathematics. He has an IQ of 149 and is a member of
Mensa. "From your letter I see we have something in common:
an interest in art," he writes his English admirer. "My interests
seem to have evolved from the physical sciences to the biologi-
cal sciences to history, psychology, philosophy, and the social
sciences, finally, to literature, art, and poetry."

Ironically, Hofmann is not the only man of letters in the
Draper jail. One of his fellow inmates, a Utahan writer and histo-
rian distantly related to Butch Cassidy named Kerry Ross Boren,
was a friend of the celebrated British travel writer Bruce Chatwin.
Like Hofmann, Boren, who once traveled with Robert Redford
on behalf of *National Geographic* magazine, is now serving a life
sentence for murdering his girlfriend.

Hofmann has become an expert chess player in jail and
writes a regular column for the prison magazine called "The
Hofmann Chess Corner." One of his columns, on pinning, could
stand as a metaphor for his life. "A pin is an attack on a chessman

that screens one even more valuable," he writes. "There are two kinds of pins—absolute and relative. The pinned piece is generally helpless against added pressure and, consequently, makes a rewarding target. . . . One of the true signs of a master is the creation of a pin or some other tactical possibility where one does not already exist."

Hofmann lost the biggest game of his life. He was sustained in jail by the belief that eventually, he would be reunited with his wife and children. What he did not anticipate was that, free at last of his control, Dorie Olds would begin to write her own script. When she filed for divorce in 1987, it shattered the dream that he would one day regain control of her. It also rendered worthless whatever agreement they had made at the time of his plea bargain arrangement.

He will never forge again. The massive overdose of antidepressants he took soon after Dorie Olds filed for divorce left him lying unconscious for twelve hours on his prison cot with his right arm trapped under him. As a result of the blockage to his circulation, the muscles of his arm are atrophied. The forearm is withered almost to the bone. The fine motor control that enabled him to create some of the most skilled literary forgeries the world has ever seen has been irrevocably damaged. Today he writes with his left hand in a neat, backward-sloping script.

It is impossible to know how many of his forgeries are in circulation. George Throckmorton estimates that Hofmann forged as many as a thousand documents. A vigorous effort by the LDS church has ensured that most of his Mormon forgeries have been taken out of circulation. But no one in the historical manuscripts trade, whether the collectors who buy them or the dealers and auction houses who sell them, has had any interest in establishing the true extent of his non-Mormon forgeries. Instead a wall of silence and complicity has been erected. The list of forgeries that continue to circulate on the open market probably runs into the hundreds, including writings by Mark Twain, Jack London, John Quincy Adams, Walt Whitman, and George

Washington. There are probably two dozen Daniel Boone forgeries alone. Hundreds of forged coins are in circulation as well.

In a letter Hofmann wrote to Daniel Lombardo from jail he gives an account of the genesis and creation of the Emily Dickinson poem. The letter makes compelling reading and sheds considerable light on the mind and methods of America's most inventive forger. Among other things it shows Hofmann to be a perspicacious literary critic. "I picked Dickinson because her autograph material is among the most valuable of American poets," he writes. "And it was a challenge. My critique of Dickinson's poems is that a few of them are great, some are good, but many are inferior (some so much so I think she would have considered them drafts). My attempt was nowhere near her best, but is, I think, better than some."

Hofmann hints at the correspondences he found between himself and the object of his deception. "I either read in a bibliography or concluded from her poems," he says of Dickinson, "that she was agnostic, which provided us with a common outlook. And, of course, carpe diem is a popular poetic theme." The most astonishing claim in Hofmann's letter is that he composed and executed the poem in only three days. "Just before composing the poem I attempted to read enough of her material until I felt in touch with her muse," he wrote. "I may have made 3 or 4 working drafts. The only thing I remember about the composition is whether I should use the words *summer's grass* or *winter's sun*. None of these drafts are in existence—I destroyed all evidence—but the 'summer's grass' version was published (under my own name) in the *Mensa Bulletin* in I believe 1987. I thought the words *Aunt Emily* added a touch of veracity."

Is Hofmann telling the truth? Or is his claim that he created one of the most masterfully executed literary forgeries of all time in just three days another fabrication by a compulsive braggart and liar? He has no reason to dissimulate about something of which Sotheby's pretended complete ignorance: the poem's provenance. "I believe Todd Axelrod owned the forgery when I

was exposed in 1985, and assumed he took it off the market," he writes. "I thought it was common knowledge this poem was a forgery and was greatly surprised . . . to hear it was still on the market. I hope this time someone will write the word FORGERY! on it."

Homestead

*T*hree years after I had stood at the window of Emily Dickinson's bedroom, I drove back up Interstate 95 to Amherst to visit the Archives and Special Collections section of the Robert Frost Library at Amherst College, where half of all Emily Dickinson's manuscripts are housed. It was a warm summer morning when I arrived. Students were walking to class through the clear blue light. A sprinkler threw rainbows over the grass. The air smelled of pine resin.

Lengthy exposure to Hofmann's deception and lies had begun to erode my sense of certainty. I had begun to notice how, in small ways, and sometimes large, none of us always tells the truth; how, to protect our feelings or the feelings of others, we are often less than completely honest. And when I looked at the world at large, I began to see that, far from being the exception, Mark Hofmann was in many ways the norm. Whether it was fraudulent stockbrokers in Queens bilking newly arrived Korean immigrants of their savings; or the president of a Texas oil company illegally extracting oil from a National Park in Central America; a corrupt businessman buying political favor in the White House; or the chairmen of Sotheby's and Christie's fixing

price commissions—dishonesty seemed not an aberration but part of the fabric of our lives. Perhaps Mark Hofmann is not such a stranger after all. Perhaps he is the person staring back at you in the mirror.

Now I was about to come face to face with some of the most authentic works of art ever created: the poetic diary of one woman's courageous journey toward self-knowledge and truth. I had asked Dan Lombardo if he could help me find a way to look at poems written by Dickinson in the early 1870s, the date that Mark Hofmann had chosen for his forgery. The Jones Library only had a couple of poems from that period. So Dan suggested I go to Amherst College. After signing a form saying that I would not mistreat (or steal) the manuscripts, showing my driver's license, and removing all pens from my pockets, I was ushered into a brightly lit reading room. With a click the door was locked behind me. A few minutes later the manuscripts were brought from the vault.

The night before I had had a dream. In it I was walking across Amherst Common in a snowstorm with Emily Dickinson. My arm was around her waist. It was well below zero, but she was only wearing a thin white cotton dress. I told her that she would catch her death of cold, but she only laughed, with a high-pitched, giggling laugh, like a child. I reached out to touch a snowflake, and it turned to paper. Moments later the sky was filled with scraps of white paper falling to earth like tickertape. On each scrap of paper was a fragment of writing. Some were in pencil. Some were in pen. Some were in English, some in Greek and Latin. Emily began to try and catch the paperflakes in her mouth, like a goldfish. But the more she caught, the more fell from the sky. It was as though a giant feather bed were being emptied on us, until we were surrounded by a drifts of white paper. Falling to our knees, we began to gather up handfuls, pelting each other with balls of paper that broke apart as we threw them. Then Emily grew serious. Each scrap of paper, she explained, was part of a poem and these were her only copies.

Frantically, we began to try and fit the fragments together like the pieces of a jigsaw puzzle. Every time we thought we had managed to reconstruct a poem, the writing changed, like the shapes in a kaleidoscope, and we had to start all over again. The fascicle pages that were now on the desk in front of me were much smaller than I had expected. I had imagined large, album-sized sheets of paper. These were mostly eight inches by five inches, or less. Some were single sheets. Some were so-called bifolia: a sheet of paper folded in the middle. All were written in a feathery, almost illegible hand, in pen, in iron gall ink browned by the passage of time.

Before writing "Alone and in a Circumstance" in 1870, Dickinson had cut two tiny, oblong clippings from the May issue of *Harper's* magazine, and glued them to a sheet of notepaper, embossed, in the top left hand corner, with a queen's head. One had the name of the French novelist, George Sand, whose steamy love affair with the composer Frédéric Chopin, on the island of Majorca, had shocked and fascinated the poet and her contemporaries. The other bore the title of one of Sand's novels, *Mauprat*. Over these little slivers of paper Dickinson had carefully glued a sea-blue three-cent stamp, so that the clippings poked out from under its edges, like the tusks of a saber-toothed tiger. She then wrote the words of the poem, in pencil, around the stamp. I had tracked a forgery across America and found greed, and lies, and deceit. As I stared at this beautifully crafted object, written in the teeth of distress for no other purpose than to celebrate beauty and truth, tears welled up in my eyes.

By this point in her life the girl who had written so playfully twenty years earlier—"Hurrah for Peter Parley/Hurrah for Daniel Boone/Three cheers, Sir, for the gentleman/who first observed the moon"—was a lonely middle-aged woman weighed down with sorrow and regret. The splits and divisions that were beginning to overwhelm her personality are reflected in her handwriting. Resignation and hope, despair and energy, fight for control of her hand. The confident, upright script of her early

years has been replaced by an edgy, forward-sloping hand. Letters topple forward like broken chairs, or lie almost flat along the line, like grass beaten down after a storm. The crossbar of her capital *T* is an angry, downward-plunging razor slash an inch or more long. The pen makes violent changes of direction, shooting off in one direction, then doubling back on itself, as though every impulse is blocked by its opposite. Everywhere there is a feeling of failing energies, as though gravity is pulling her writing hand toward the line, and death.

The first stroke of the letter *M* in the poem "The Mushroom Is the Elf of Plants," a meditation on a plant she loved for its reclusiveness and secrecy, written in 1873, begins high above the line, like a ball tossed into the air, then sweeps backward and down, from left to right, in a taut, curving loop, like a fishing pole bent by a fish as it dives under the waves. As it touches the line, it bends back on itself and leaps toward the surface. But the upward motion is flagging, the energy failing, and the line travels almost horizontally across the page. As the stroke rises, it crosses the previous downward stroke, forming a slender oval shape—a momentary encircling of the self—before continuing its upward climb. Then it bends earthward again, looping back on itself, and down. As it touches the line, it struggles upward, crossing the downward stroke again making a slender oval space. This one is tighter, though, less open, as though the energy of the line is contracting in on itself. Almost immediately the upward motion is broken off in a sickle-shaped, downward-sloping curve that pulls the pen back toward the line, like the stem of a flower snapped off by a Weedwacker.

By this time Dickinson's handwriting had come to resemble a private ideolect: a cipher as impenetrable and idiosyncratic as Celtic runes or Egyptian hieroglyphics. Like a jazz musician she loved to improvise with her private alphabet, using different letter forms in different poems, and sometimes even within the same poem. Dickinson worked on the poem "Because he loves her/It will not harm her magic pace," for instance, between 1870

and 1871. The earliest surviving version was written in pencil in October 1870, in a letter Dickinson composed to her mentor, T. W. Higginson. She did not send the letter. But later in the year she scribbled another pencil version on the inside of an envelope addressed to a female friend. She continued to work on the poem, then, in 1871, she made the fair copy lying on the table in front of me. Within the space of four words—"if she is fair"—she writes two entirely different forms of the lower case *f*. One looks like a saxophone. But the *f* in the word *if* is entirely different. It resembles the conventional form, but the downstroke is far longer, and the letter is tipped sideways, so that it lies mostly beneath the line. The *y* looks like the leg of a broken rocking chair. Some words are simply illegible. The capital *N* in the word *Not*, at the beginning of the phrase "Not hoping for his notice vast," floats between the lines, like a squid propelling itself through the water. The *o* is a *c*. The *t* is a multiplication sign. If you don't know the code, the word reads, "3cx."

It is generally assumed that the radical shifts that began to make themselves visible in her handwriting at about this time were the result of failing eyesight. After an extended visit to a Boston eye doctor in 1864, she was forbidden the use of pen and ink. "Can you render my pencil?" she wrote to the man she called her "safest friend," Thomas Wentworth Higginson. "The physician has taken away my pen." Dickinson returned to using a pen after 1865. But many poems from this period, like "That God Cannot Be Understood," were written in pencil.

Poor eyesight? Artistic license? Or was this most secretive of women intentionally disguising her handwriting to hide her self? Drafts of her poems were written at this time in what I call her shopping-list hand: the letters are clear, and mostly legible, the writing firm and reasonably uniform. So, too, is the handwriting of the notes and poems she sent to friends and family. Ironically, at this point in her life Dickinson is writing as forgers write, drawing individual letters rather than linking them in a continuous flow of script. As she moved toward death in 1886, these

tendencies became more extreme. As though drifting back into childhood, her letters grow bigger and bigger, and more and more difficult to distinguish. In 1850 she could fit twelve to thirteen words on one line of a small sheet of notepaper. A quarter of a century later, in the poem "How News Must Feel When Travelling," written in 1875, she barely squeezes three words on a line. One word—"stupendousness"—sprawls across the width of the page.

Hofmann had to get all this right. As I looked from her original manuscripts to my copy of the forgery—the original is back in Las Vegas at the Gallery of History (but not for sale)—I was amazed by the sheer technical accomplishment of it. Hotel records found by the Salt Lake City police suggest that Hofmann may have visited Cambridge, Massachusetts, in the 1980s, specifically to study her manuscripts at the Houghton Library. But the main source for the forgery was Ralph Franklin's two-volume classic, *The Manuscript Books of Emily Dickinson*. The poem was a mirror in which Franklin's years of painstaking scholastic work were reflected back at him. When he saw it, he was dazzled. "I was just astonished if this were a forgery," Franklin had told me the last time we met, "because of these extraordinary characteristics—the mixed letter forms and so on—which I thought I was probably the only person in the world who came close to knowing."

Franklin parried all my attempts to ascribe emotions to him with curt demurrals. He told me I was looking for culprits, and that therefore I needed victims. He was not volunteering. "That good purposes can end up being used for a bad purpose doesn't alter anything for me," he said. "You want me to feel abused: and I don't feel abused."

His body language suggested that he did. He spoke fast and nervously, often with his eyes closed, while his hands kneaded each other in his lap. He repeatedly asked me to turn off my recorder. More than anything, I suspect, he feared that his failure to spot that the poem was a forgery would make him lose face

among his peers. Although he had rejected the suggestion, I also sensed that he felt deeply aggrieved at the way that Sotheby's had misused him and, by extension, the institution he works for. "Am I astonished at the skill?" he replied, when I asked him what he felt about the forgery. "Yes. Do I admire that? No." When I asked him how he felt when he discovered Hofmann had used his years of scholarship to create the forgery, Franklin leaned back and said, with an ironic grin, "He probably didn't buy one." He then broke into a long, unrestrained paroxysm of laughter that left him gasping and almost in tears.

Hofmann did not need to invent his own poem. He could easily have done what he did numerous other times: found out about a missing document and set out to create it. Numerous Dickinson manuscripts were destroyed or lost, and it would have been much easier to forge a missing poem, copies of which already existed. Creating his own fifteen-line poem that was good enough, technically, and in terms of its content, to get past the world's leading Dickinson scholar was not only a virtuoso act of bravura. Just as he had felt enormous satisfaction in fabricating documents that validated his own view of the Mormon Church, putting his own agnostic sentiments into the mouth of one of America's best-loved and most widely read poets must have given Hofmann an extraordinary feeling of power.

The poet and the murderer had diametrically opposed intentions, however. Hofmann labored to deceive others. Emily Dickinson wrote to record the truth, however shocking, about herself. Ultimately, Hofmann turned to forgery because he was a coward. As a young man he had wanted to write a book on the early history of the Mormon Church, but he had not had the courage to carry the project through. Instead, he had turned to falsehood. But deceit ensnares the deceiver as well as the deceived, and after a lifetime manipulating others Hofmann became entangled in his own web of lies. By facing down her demons Emily Dickinson found inner freedom, and peace of mind.

But there was one secret Emily Dickinson never gave up, and that was the identity of the person she loved more than any other in the world, and whose loss broke her heart. Among the papers she left behind at her death were three passionate love letters, which have become known as the "Master" letters. Several of her most passionate and sexual poems are also believed to have been addressed to this nameless lover, like this deliciously suggestive poem, written in 1860, when the poet was thirty years old:

> *Did the Harebell loose her girdle*
> *To the lover Bee*
> *Would the Bee the Harebell* hallow
> *Much as formerly?*
>
> *Did the "Paradise"*—persuaded—
> *Yield her moat of pearl*—
> *Would the Eden be an Eden,*
> *Or the Earl—an* Earl?

Dickinson and her family took great pains to ensure that her secret lover remained secret (there are suggestions that she had a clandestine abortion in Amherst in 1861). She did not include many of the poems addressed to her anonymous lover in the fascicles until much later, intentionally jumbling the chronology of the events that inspired them. In the three letters she wrote to her anonymous lover she was also careful not to refer to events, or people, which would betray her secret. The letters are written in such a compressed language, and packed with such oblique, internal references, that they resemble a secret code.

Is the "Master" a real person or a figment of her imagination? Some scholars have recently argued that he was a preacher called Charles Wadsworth. Feminist scholars insist that he is a she, the Master is a Mistress. There is no clear answer to this question, and I do not think there will ever be. Everyone has

their own Emily. In the absence of any firm evidence, you choose the story you prefer. My preferred candidate for Emily's affections is a newspaper editor named Samuel Bowles. They met when Dickinson was still a teenager. Bowles was a close friend of Emily's brother, Austin. He began to regularly visit Amherst in 1858, when Dickinson was twenty-eight. The Homestead, with its beautiful gardens and its conservatory, became a refuge from the bruising world of politics and journalism. We do not know how he felt (all his letters to her were burned), but it is clear that during this time Emily Dickinson fell madly, deeply in love with him. "The heart wants what it wants," she wrote in 1862, when Bowles left on a protracted trip to Europe, "Or else it does not care."

As the publisher of the *Springfield Republican*, a newspaper known for its support of poetry, Bowles—"the sole ear I cared to charm," she called him—had the power to make her dream of becoming one of the foremost poets of the day come true. Unfortunately, Bowles's tastes in poetry were boringly conventional. Instead of breaking the mold of American poetry, he filled his newspaper with sentimental works by women poets the world has long since forgotten. By the end of her life she had turned his rejection of her work into a virtue. Publishing, she wrote disdainfully, was "the Auction of the Mind of Man." I believe the rejection by Bowles, both as a woman and a poet, drove Dickinson to the edge of madness and opened the sluice gates of poetry. In four short years, from 1861 to 1865, she wrote nearly half her poems. In magnificent, heart-searing threnodies such as "Dare you see a Soul at the White Heat?" or "After great pain, a formal feeling comes," we can hear her working through the loss of the man she had wanted so badly. It was a loss from which she never fully recovered. "A not admitting of the wound/Until it grew so wide," she wrote in 1870, "That all my Life had entered it/ And there were troughs beside." Thirty-five letters, often addressed simply, "Dear Mr. Bowles," survive. Dickinson also sent him fifty poems. Among them is this one, written in 1861:

I've nothing Else—to bring, You know—
So I keep bringing These—
Just as the Night keeps fetching Stars
To our familiar eyes—

Maybe, we should'nt mind them—
Unless they did'nt come—
Then—maybe, it would puzzle us
To find our way Home—

The Master Letters were Dickinson's most open attempt to tell Bowles what she felt. In their desperation, self-abasement, and childlike desire to please they are painful, almost embarrassing, to read. In them a proud, independent, intellectually brilliant woman is reduced to a little girl begging forgiveness at her father's knee. There is no evidence Dickinson ever sent them. But throughout the long, lonely years of her later life, she never stopped thinking about the man who had inspired them. "We miss your vivid Face and the besetting Accents, you bring from your Numidian Haunts," she wrote him in 1875, a year after her father's death. "Your coming welds anew that strange Trinket of Life, which each of us wear and none of us own, and the phosphorescence of your's startles us for its permanence."

Bowles always made sure he was in Amherst, for the Commencement ceremonies at Amherst College. And it was on one of these occasions, in 1877, when Dickinson was forty-six, that he arrived at the Homestead. They had been corresponding for nearly two decades. But on this day Dickinson refused to come down from her room to see him. "Emily, you damned rascal!" Bowles is reported to have called up the stairs. "No more of this nonsense! I have traveled all the way from Springfield to see you. Come down at once."

According to her sister, Lavinia, the poet was never more sociable and fascinating than she was that day when, having de-

scended the stairs, she sat in the living room with Bowles, drinking tea and talking about the things they loved: books, travel, political gossip, family. A few days later she wrote him a letter. In it she enclosed a poem.

I have no Life but this—
To lead it here—
Nor any Death—but lest
Dispelled from there—
Nor tie to Earths to come,
Nor Action new
Except through this Extent
The love of you.

Beneath the poem she wrote, "It is strange that the most intangible thing is the most adhesive." She then signed it, "Your Rascal."

A year later Samuel Bowles died of overwork. Emily Dickinson followed him to the grave, when her kidneys failed, on May 13, 1886. She was fifty-five years old. Her tiny body was folded in a white wrap and placed in a white coffin in the hallway of the house she loved, in which she had spent nearly all her life. A knot of blue violets was laid at her throat. A wreath of the same flowers was placed on the coffin. There was a brief reading from the Bible. Then the coffin was shouldered by the six Irishmen who worked for the Dickinson family: Thomas Kelley, Dennis Scannell, Stephen Sullivan, Patrick Ward, Daniel Moynihan, and Dennis Cashman. "She asked to be carried out the back door," recalled the maid, Maggie Maher, "around through the garden, through the opened barn from front to back, and then through the grassy fields to the family plot, always in sight of the house."

A few days after I left Amherst, I got a letter from Dan Lombardo. He had just returned from a six-week trip to Sicily. On

Via Magenta, in the town of Canicattini Bagni, he'd found the house where his father had spent his early years, before emigrating to Connecticut. It had been abandoned. In the single room where his father's family had slept and eaten, chickens scratched in the dirt under a faded picture of the Virgin Mary. In a nearby street he found the house where his father had stood under his mother's bedroom window at night, when she was fifteen, and serenaded her with a mandolin.

After staying with his cousins in Canicattini Bagni, he set off in a rented Citroën, to drive across the island. Dickinson only left New England once, but she frequently referred to Italy, "the blue peninsula," as she called it in her letters and poems. As Dan hiked up Mount Etna he recited the opening lines of the poem, "Volcanoes Be in Sicily," in Italian: *"La geografia mi attesta che ci sono/vulcani in Sud America/e in Sicilia—"* At Lago di Pergusa he saw where Persephone was abducted into the underworld by Hades. He explored a cave filled with Neolithic paintings of bison and deer; and men and women performing a ritual dance. On his last night on the island he gathered his friends and Italian cousins together at a local restaurant for a meal of grilled swordfish, octopus in lemon, squid, and baby clams, served with bowls of pasta and bottles of red Sicilian wine.

When the story of his sleuthing became known in Amherst, Lombardo became a hero. A small New England community had shown Madison Avenue that they were no rubes. David had defeated Goliath. Beneath the surface, though, the events in which Lombardo had become entangled had had a deeply corrosive effect on him. He had lost faith in the profession he had worked in for seventeen years. He no longer trusted anyone. During a trip to Japan, six months after the poem had been declared a forgery, he called his wife from a train station to say that he was quitting his job.

It was the best thing he ever did. Lombardo had always dreamed of living the kind of life that his hero, Henry David Thoreau, had lived. Years of wise investing, using a system de-

vised by his father, Jimmy, had left him with a small but sufficient income. The house in West Hampton, which he and his wife had bought nearly twenty years earlier, was already paid off. Now they had the time and the money to enjoy it. They built a Japanese water garden and a conservatory at the back of the house, with an Italian-style tiled floor and big sliding glass doors. The rest of the time Dan spends at his cottage in Cape Cod, writing books on local history or contributing articles on Emily Dickinson to scholarly journals. When he is not working, he kayaks across the bay to Great Island. He has taken up Zen Buddhism. His journey to Sicily inspired him to learn another musical instrument. "I've picked up my father's mandolin," he wrote at the end of his letter, "and I'm learning to play the songs he played."

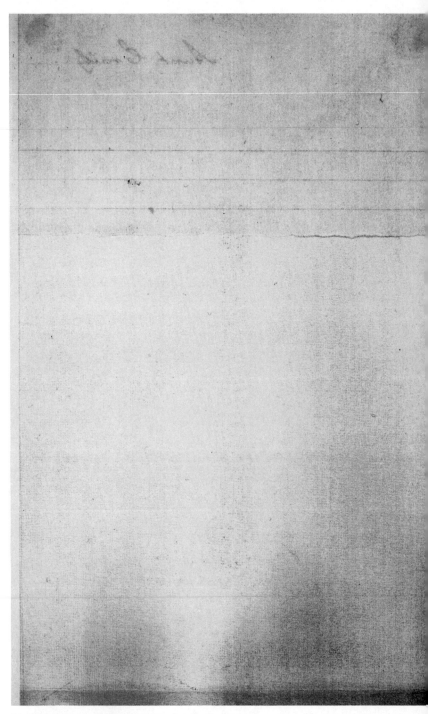

Mark Hofmann's original forgery of an Emily Dickinson poem. He claimed the poem had been written in 1871.

That God Cannot
be understood
Everyone agrees -
We do not know
his motives nor
Comprehend his
Deeds -

Then why should I
Seek solace in
What I Cannot
Know?
Better to pray
In winter's sun
Than to fear the
Snow.

 Emit

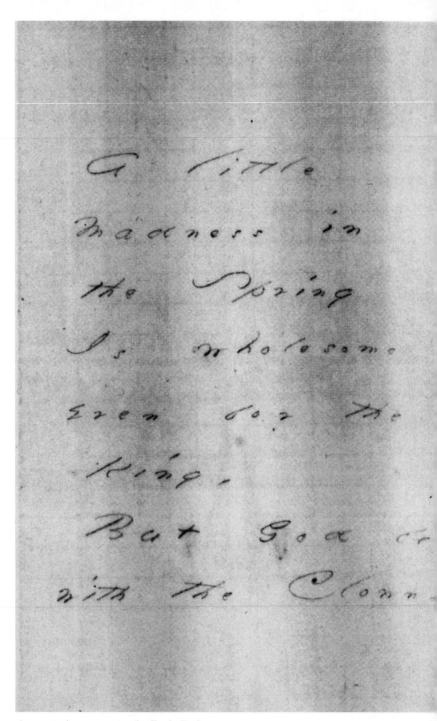

An original poem written by Emily Dickinson in 1871.

Who ponders
this tremendous
Scene —
this whole
Experiment of
Green —
As if it were
his own —

Emily —

ACKNOWLEDGMENTS

Many people helped make this book possible. Special thanks go to Daniel Lombardo, whose integrity and sense of civic responsibility ensured that the people of Amherst are today not the proud owners of a forgery by a double-murderer; and without whose tireless cooperation my task would have been infinitely more difficult. I would like to thank Lewis Lapham, of *Harper's* magazine, for initially commissioning the article from which this book grew; Bill Buford, at *The New Yorker*, for championing it; and George Plimpton, of the *Paris Review*, and Katharine Viner, of the *Guardian*, who had the vision and courage to publish it. I would like to thank my agent, Philip Spitzer, for his unstinting support; my editor at Dutton, Brian Tart, and his assistant, Amy Hughes; and my editors at Fourth Estate in London, Clive Priddle and Mitzi Angel.

Numerous people in Salt Lake City generously gave me their time and shared their, often painful, recollections of Mark Hofmann. Special thanks go to Brent Ashworth, Sandra Tanner, Shannon Flynn, Ken Farnsworth, Brent Metcalfe, George Throckmorton, and Doralee Olds. In Amherst, I would like to thank Cindy Dickinson of the Dickinson Homestead; Tevis Kimball, of the Jones Library; and Daria D'Arienzo, of the Robert Frost

Library

Library at Amherst College. Thanks also go to the staff of the East Hampton Library.

For insights into Dickinson's "workshop" I am indebted to Ralph Franklin. Jennifer Larson spent many hours helping me unravel the tangled web of Hofmann's non-Mormon forgeries. Joe Nickel, Walter McCrone, Beryl Gilbertson, Kathy Copenhaver, and Emily J. Will helped me understand forensic documents testing. For information on the historical documents trade, I was helped by Roy Davids, Rick Grunder, Justin Schiller, Michael Zinman, Kenneth Rendell, and David Hewitt. For their valubale insights into the neuropsychology of handwriting I am indebted to Professor AJN Thomassen of the Nijmegen Institute for Cognition and Information in Holland; Ted Wright, of the University of California at Irvine; and Arend van Gemmert of the Motor Control Laboratory at Arizona State University. Professor Ng Wai Ming of the University of Singapore shared his knowledge of literary forgery in Japan. Nicholas Barker did the same, apropos Europe, over tea in Cambridgeshire. Peter Reveen and Ricky Jay gave me valuable insights into the world of magic. Dr. David Raskin talked to me for several hours from his home in Alaska about lie detector tests. Jerry Taylor, a former Senior Explosives Enforcement Officer with the ATF, helped me understand bomb construction. Of the many books I consulted during my researches I am particularly endebted to five: *Victims* by Richard Turley; *Salamander* by Linda Sillitoe and Allen Roberts; *A Gathering of Saints* by Robert Lindsey; *Mormon America* by Richard and Joan Ostling; and *The Life of Emily Dickinson* by Richard B. Sewall.

ABOUT THE AUTHOR

Simon Worrall was born in England and spent his childhood in East Africa, Paris, and Singapore and graduated from Bristol University. After college he worked with the Royal Shakespeare Company and the Royal Court Theatre as a dramaturge. While living in Germany and China he was published in *Die Zeit* and *The London Magazine*. Since 1991, he has been based in America and has written for publications all over the world, including *Esquire*, *Harper's*, *The Independent*, *The New Republic*, *The New Yorker*, *The Paris Review*, and *National Geographic Magazine*. He lives in East Hampton, New York.